Hawkes' Eye View
LONDON
JASON HAWKES

AA

Photographer: Jason Hawkes
Author: Donna Dailey
Managing Editor: Isla Love
Senior Editor: Donna Wood
Senior Designer: Kat Mead
Picture Library Manager: Liz Allen
Image retouching: Michael Moody
Production: Stephanie Allen

Produced by AA Publishing
© Automobile Association Developments Limited 2007
© photographs Jason Hawkes 2007

ISBN-10: 0-7495-5227-1
ISBN-13: 978-0-7495-5227-5

ISBN-10: 0-7495-5538-2
ISBN-13: 978-0-7495-5538-2

Published by AA Publishing (a trading name of Automobile Association
Developments Limited, whose registered office is Fanum House, Basing View,
Basingstoke RG21 4EA; registered number 1878835).

A03257

The contents of this book are believed correct at the time of printing. Nevertheless,
the publisher cannot be held responsible for any errors or omissions or for changes
in the details given in this book or for the consequences of any reliance on the
information provided by the same. This does not affect your statutory rights.

Colour separation by MRM Graphics Limited, Winslow
Printed in Dubai by Oriental Press

<< **PREVIOUS**
Lockwood Reservoir, N17
Six and a half miles northeast of London's
financial district, Lockwood Reservoir borders the
inner-city area of Tottenham. It is one of the ten
Walthamstow Reservoirs, a series of connected
waterways alongside the River Lea. The marshes
and grasslands here provide habitat for wetland
birds, while the towpaths offer an urban escape
for cyclists, joggers, walkers and fishermen.

Hawkes' Eye View
LONDON
JASON HAWKES

AA

INTRODUCTION

People often ask how I got into the relatively obscure job of an aerial photographer. Quite by chance really. I had just finished three years studying photography and was assisting various fashion and still life photographers in London. A couple of friends and I decided to do something interesting one weekend, and found ourselves standing in a small field in Kent, waiting for our first microlight flight.

I had no idea what to expect, so stood there with some trepidation as a small flex wing microlight appeared on the horizon, flew a couple of circuits around the field and then landed beside us. It was tiny to say the least. I realised I was not as brave as I thought.

Five minutes later, strapped in, helmet on, and with my shaking legs around the instructor in front, we floored the throttle and shot off down the field.

Well, my fears (I had quite a few), soon disappeared as we took off and climbed 1,000 feet above the Kent countryside. It was freezing, windy and amazingly noisy, but what a buzz. I was hooked.

A month or so later we had bought a microlight of our own, and about a year after that, I found myself flying over London in a helicopter, shooting my first book.

Now if flying over open fields in a microlight in Kent is good, flying around London in a twin-engined helicopter is truly amazing. The layout of the City is never quite as you expected, and you'll always see something unexpected.

Obviously when I started out, I shot on film. Nowadays, however, I shoot digitally, with a Hasselblad medium-format camera mounted on a gyroscopic stabilizing mount. The camera is tethered to a laptop so that an assistant and myself can constantly monitor how the shots are progressing.

Apart from the odd occasion lifting from helipads on top of buildings in the City, I usually take off from just north of the capital, out near the M25. I spend the hour before take-off setting up the cameras and laptops, and chatting through the shoot list with the pilot. We normally fly with the door, which is about twice the size of a normal car door, taken off.

I use a normal climbing harness to attach myself securely to the helicopter, and once hovering over the City I tend to shoot from heights of 800 feet up to around 1,500 feet, shouting directions to the pilot through the headsets. Unlike outside controlled airspace, you are always tightly monitored by air traffic controllers, so apart from the odd tight bank round to get a particular angle, and the sickening feeling you get after looking through the viewfinder rather than at the horizon for a couple of hours, the flights are thankfully fairly uneventful.

Back at base it's time to get started on the rather more mundane task of processing raw files to tiffs, colour correcting and captioning, using at least three different programmes, on incredibly expensive computers that must be updated every couple of years in order to cope with the huge file sizes. Ten years ago you would process the

film and hand it to the client, now shooting the images is just the start of a very long creative process.

So what is London actually like from the air? Well, the first thing you tend to notice is how much smaller it looks: you can zip from Docklands up to Hyde Park in just a minute or so, as opposed to spending an hour on the ground in traffic.

It is also not unusual even for people who have lived in the City all their lives to still be amazed to see just how one part of London intersects with another.

As a photographer and on a personal level, the things I find most interesting are odd little quirks that you could never be aware of from ground level. For instance, take a look at the blue rowing boats tied up on the Serpentine in Hyde Park on page 40, the roof garden on Cannon Street Station on page 113, and on page 157, the top of Harrods, with its chimney and rows of pipes and sheds. The great store could almost be a little factory.

Jason Hawkes
www.jasonhawkes.com

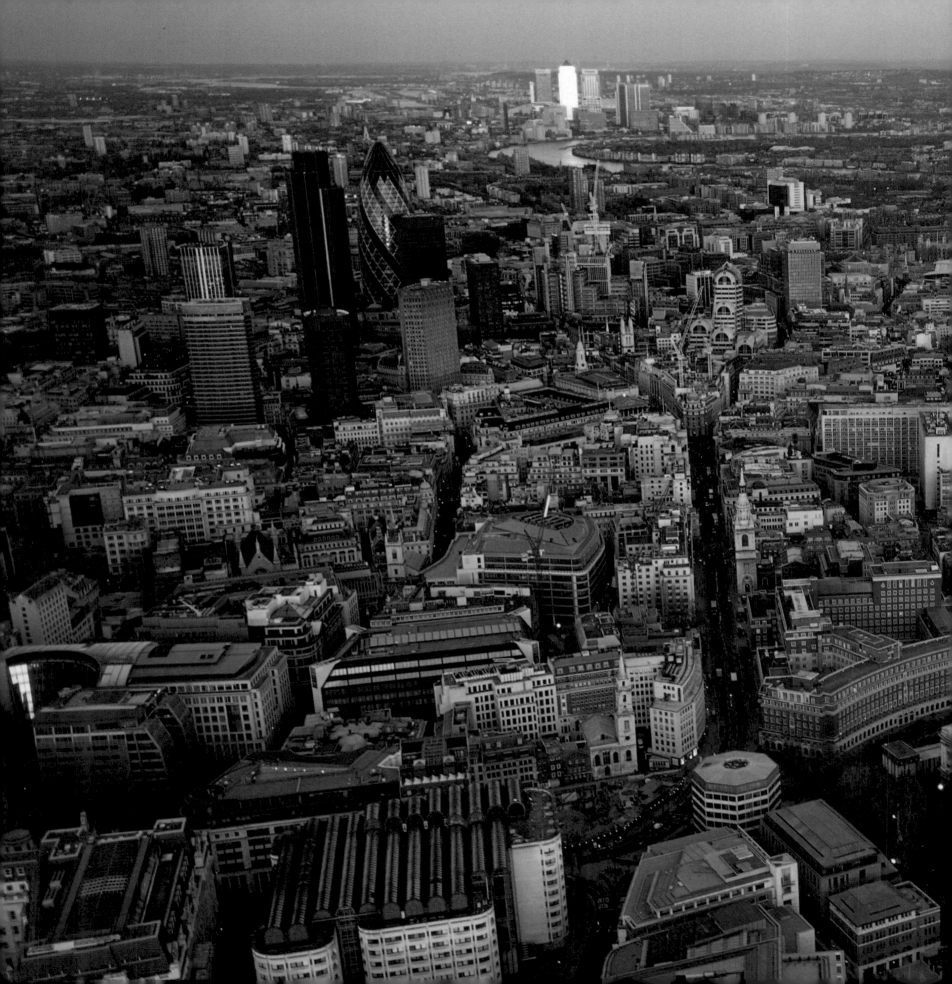

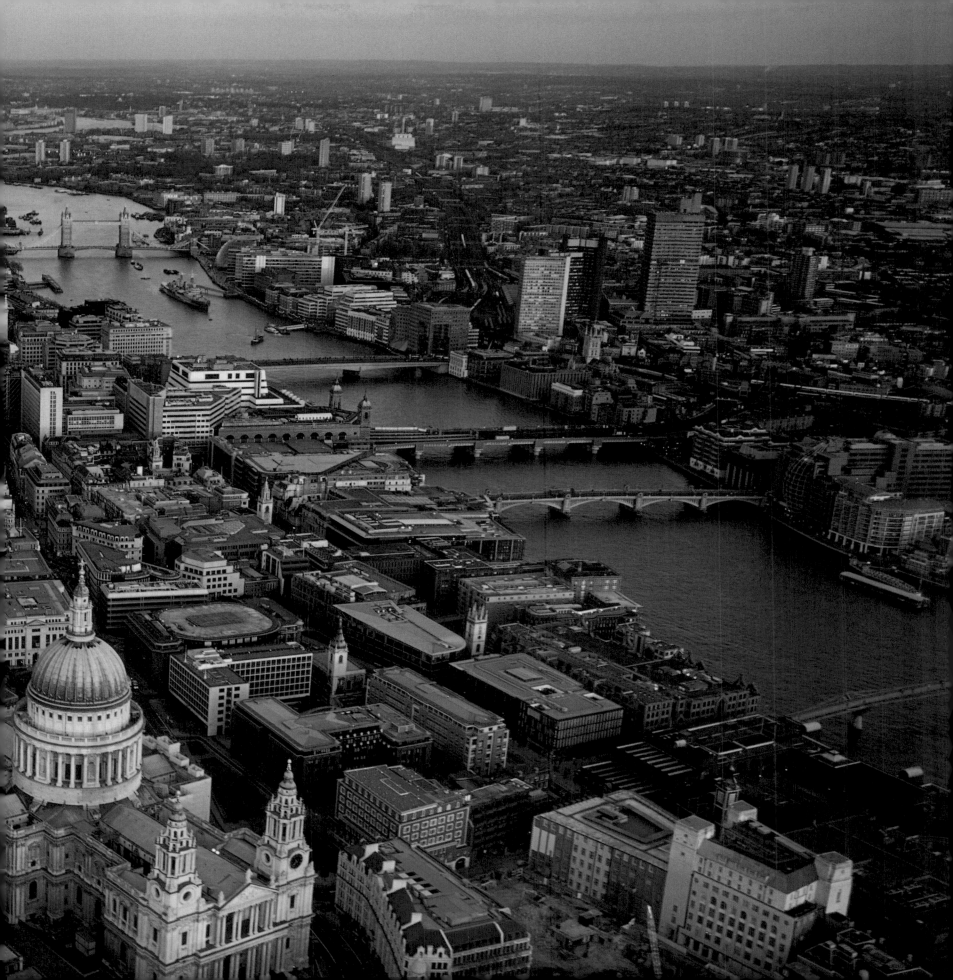

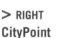

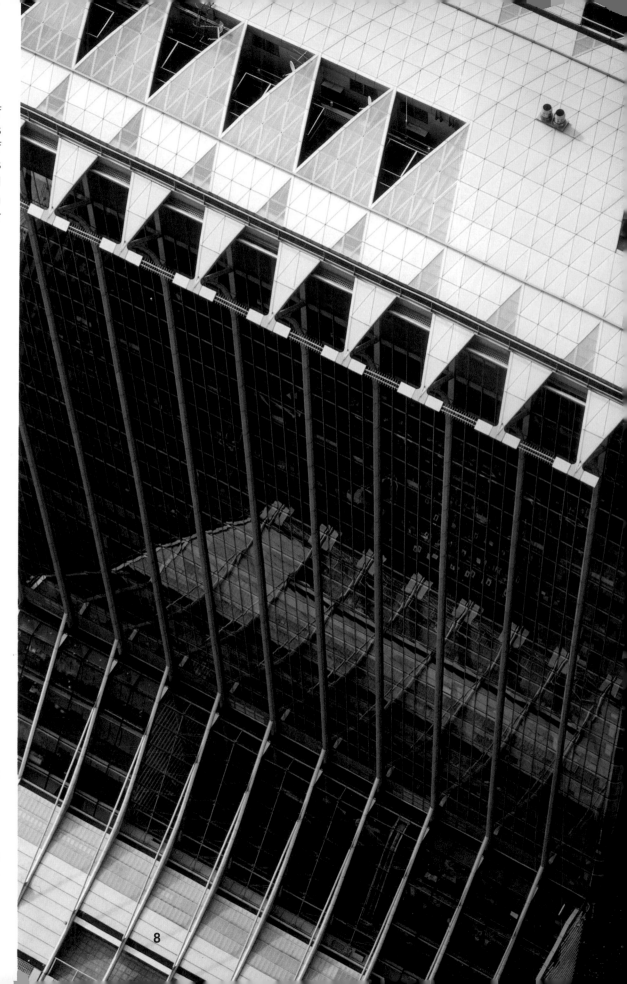

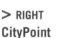

« PREVIOUS

St Paul's Cathedral, Bank, Mansion House, City of London and Tower Bridge at sunset

Sunset casts a rosy glow on the great dome of St Paul's Cathedral. While the surrounding areas have given way to the modern office blocks of Bank and Mansion House and the skyscrapers of the City of London, St Paul's remains an island of the past, unchanged since its completion in 1708. In the distance, the twin pillars of Tower Bridge form a gateway to the Docklands.

> RIGHT

CityPoint

Built in 1967, Britannic Tower was one of the first postwar skyscrapers in the City of London. The glass-slab building was for many years the headquarters of British Petroleum. By the 1990s, however, it was considered too bland for the City's high-rolling, high-style image. The firm of Sheppard Robson designed a new look and after a major reconstruction, completed in 2001, the building was renamed CityPoint.

Cruise ship on the Thames at the Isle of Dogs
For centuries the Thames has been a working river, sending and receiving goods from around the world. Now the river sees a new kind of cargo in the form of cruise ship passengers. In addition to London's Thames-side ports, the floating cruise terminal Welcome, the first of its kind in the world, was launched in 2004 to serve the growing number of cruise visitors to the city centre.

< OPPOSITE
St Martin-in-the-Fields

Though it now stands on a busy urban corner opposite Trafalgar Square, St Martin-in-the-Fields is one of London's best-loved churches. With its graceful spire and classical facade, designed by James Gibbs in the 1720s, it became a model for colonial churches in America and elsewhere. Since the end of World War I, the church has provided food and help to London's homeless.

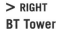 RIGHT
BT Tower

Standing alone on Cleveland Street in the West End, with no other tall buildings to obstruct its view, the BT Tower rises 620 feet (188m) to the top of its aerial. Until 1981, this was Britain's tallest building. Opened in 1965 and originally called the Post Office Tower, this was the first structure built specifically to transmit radio waves. Though its cylindrical shape was designed for wind resistance and stability, it gave the building great style and landmark status. The following year, the Top of the Tower revolving restaurant opened, affording the best aerial view of London of its day. Sadly, the tower was closed to the public following a bomb explosion on the 31st floor in 1971.

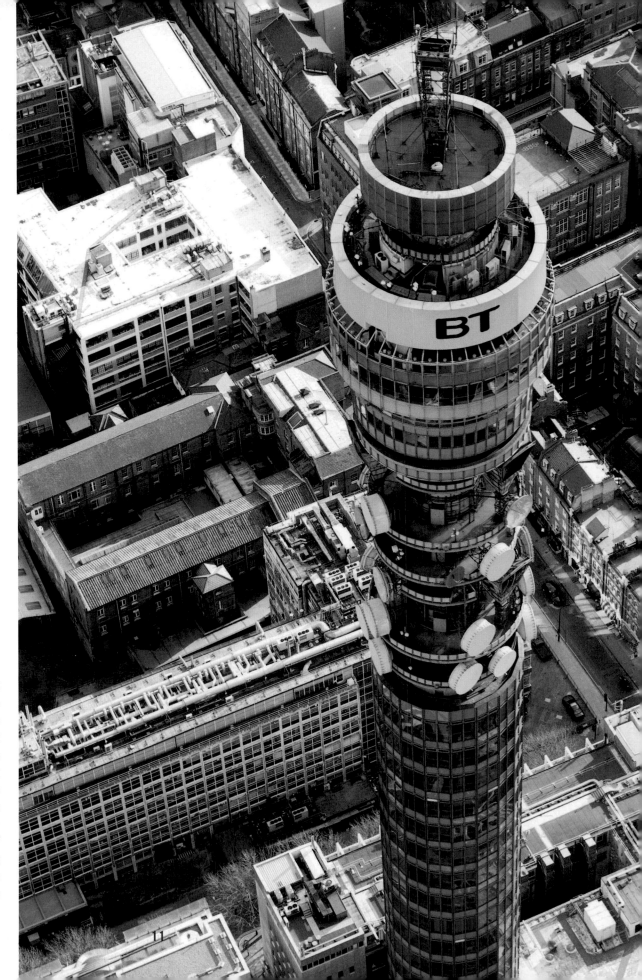

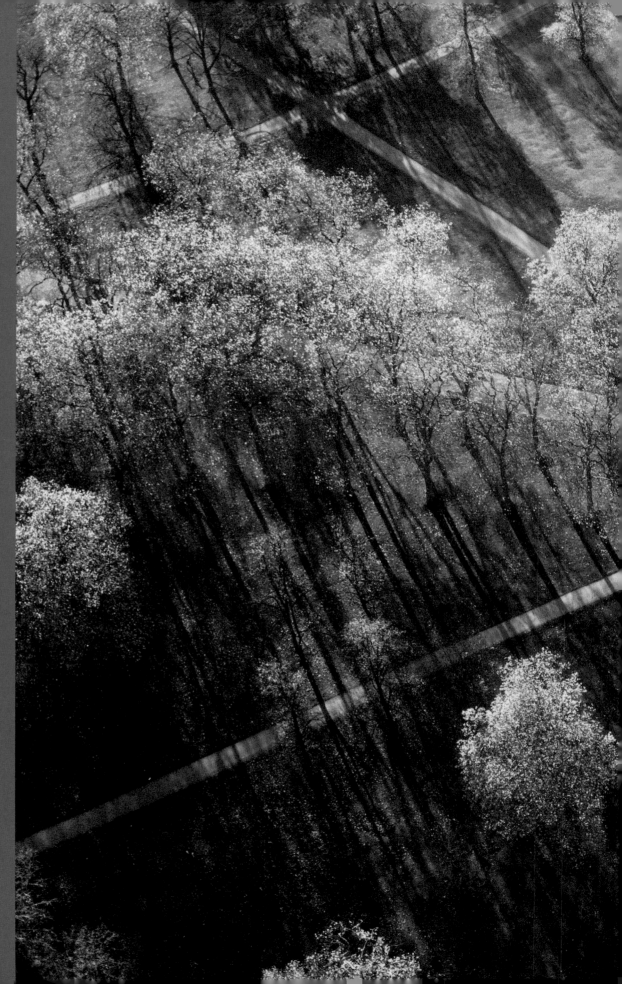

> **RIGHT**
Hyde Park in the autumn
Hyde Park might look leafy enough today, but it was once part of a thickly wooded and vast forest, where wolves, deer and wild boar roamed. At the time of the Domesday Book it was owned by the monks of Westminster Abbey, and it stayed in their care until the dissolution of the monasteries when it fell into the hands of King Henry VIII, who turned it into a royal hunting ground.

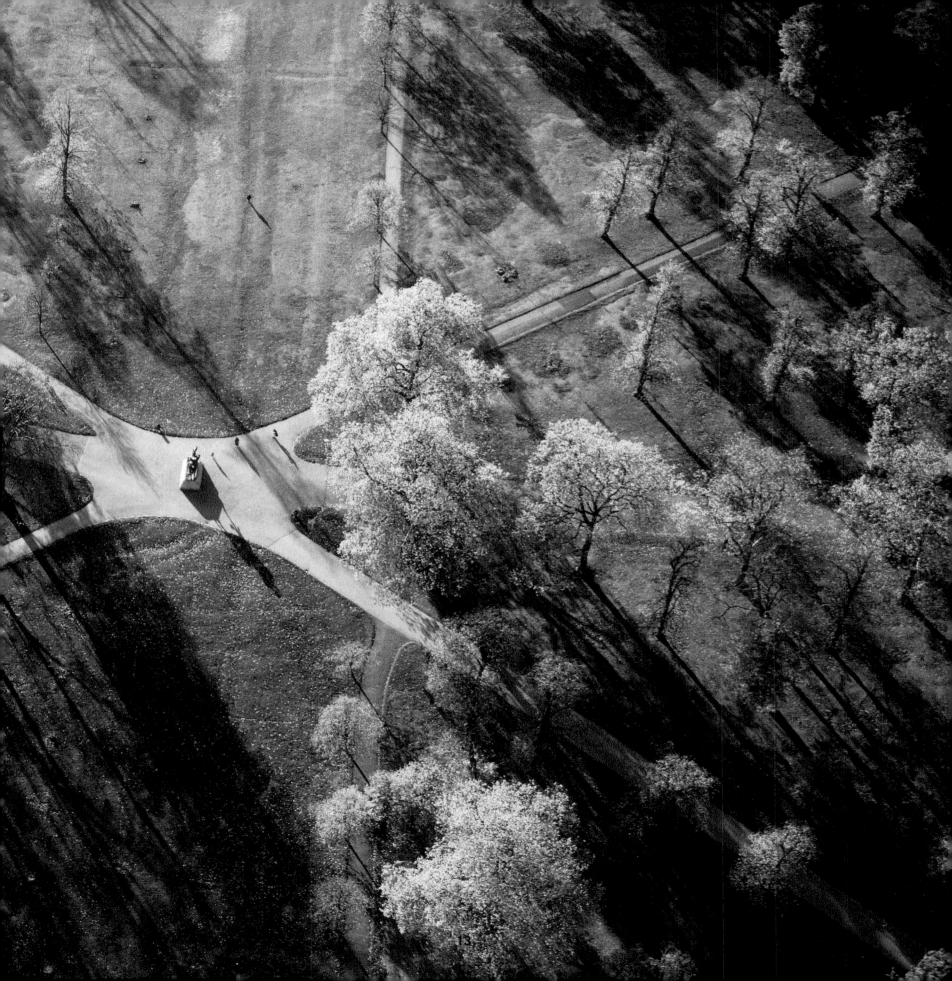

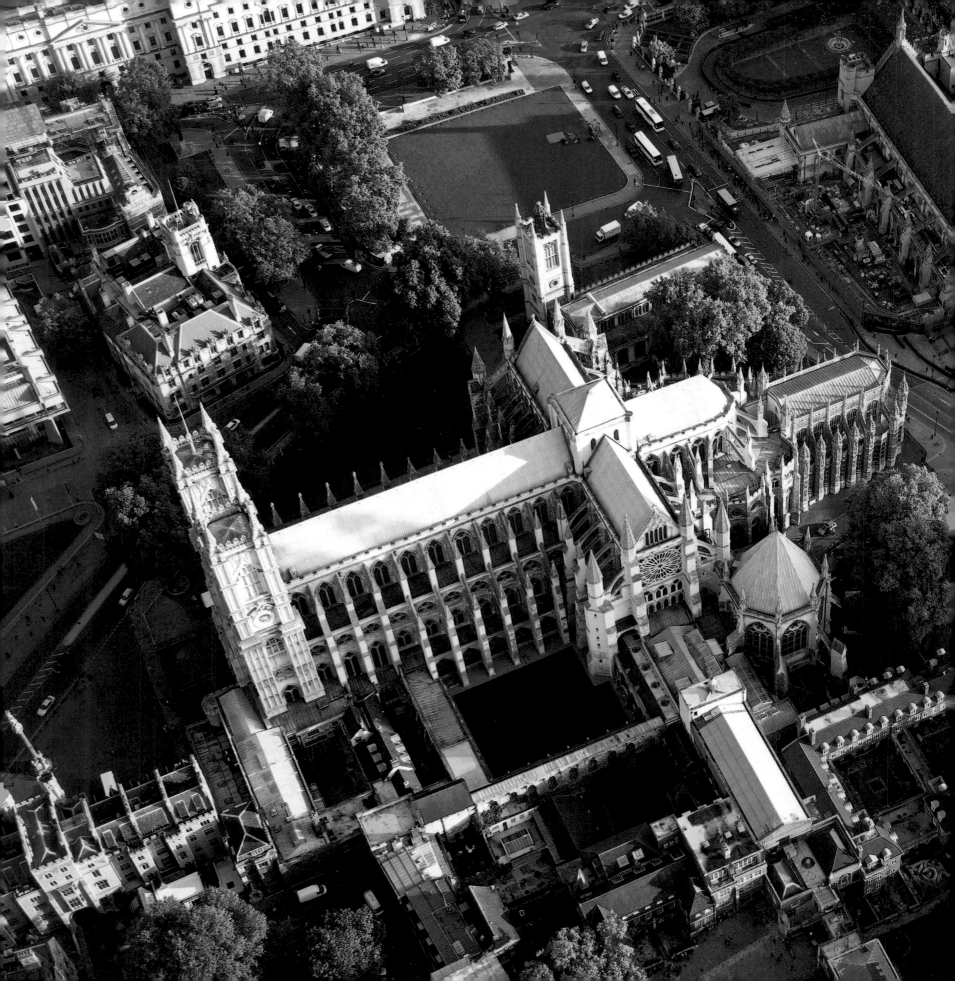

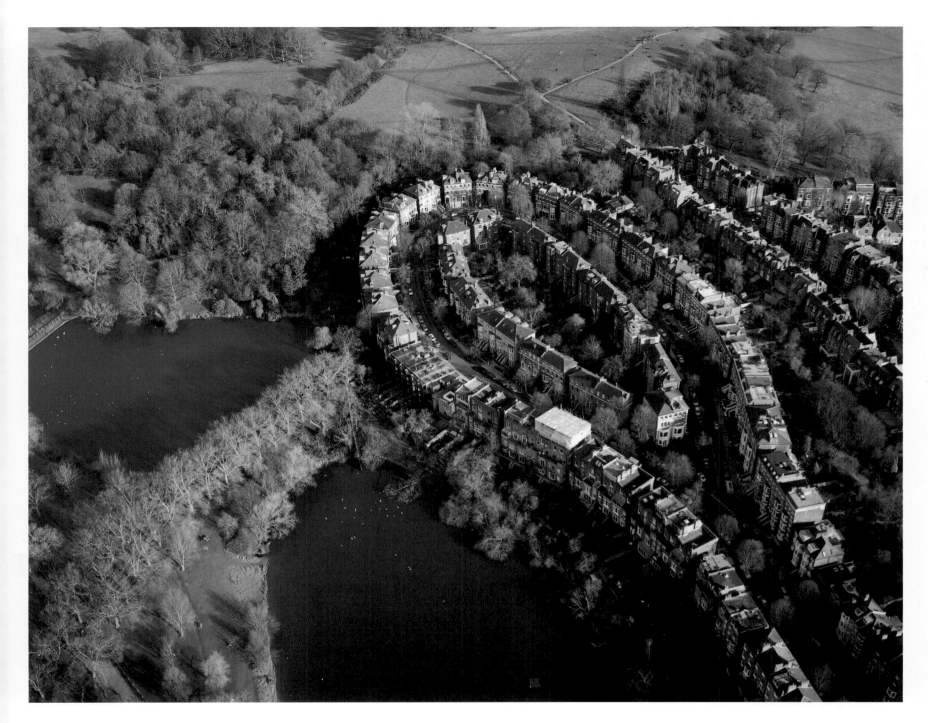

< OPPOSITE
Westminster Abbey
London's largest medieval church is as much a national monument as a place of worship. Since 1066, all royal coronations have taken place at Westminster Abbey. The abbey is the burial place for Britain's monarchs, and houses impressive tombs and monuments to its greatest writers, poets and historical figures. Its nave, at 102 feet (31m), is the highest in England.

^ ABOVE
South Hill Park
The sinuous loop of houses along South Hill Park back onto Hampstead Heath, the great green lung of north London. On the west side, the Hampstead Ponds are a favourite spot for swimming on hot summer days. To the east, the top of Parliament Hill affords some expansive views over central London. According to legend, the Iron-Age Queen Boudicca is buried here.

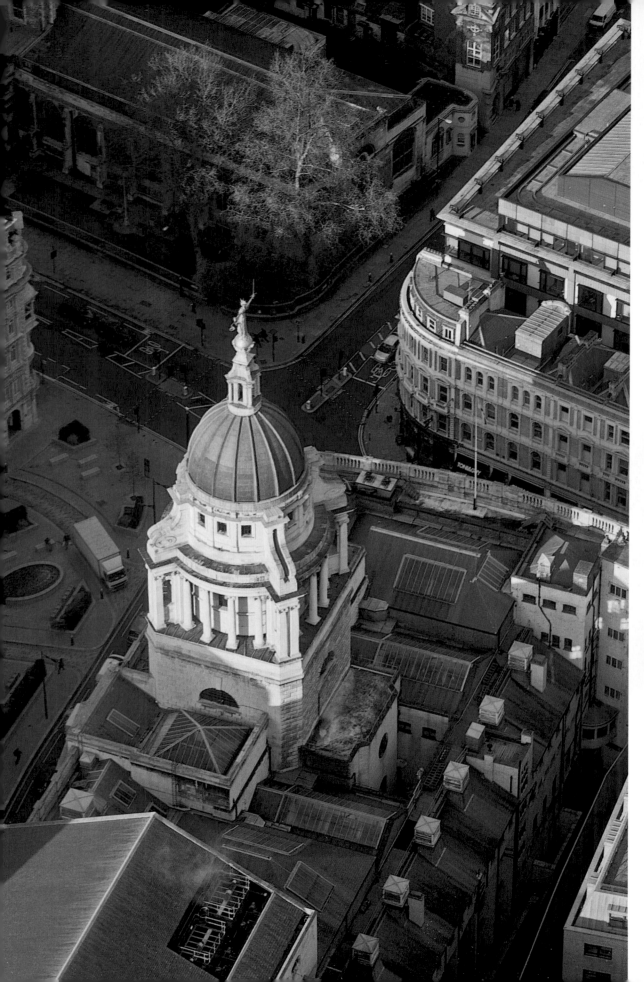

< LEFT
Old Bailey

London's Central Criminal Court is known as the Old Bailey. It was built on the site of one of the city's most notorious Victorian prisons, Newgate, where public hangings took place outside the gates until 1868. Faced in Portland stone, this handsome courthouse is topped with a copper dome and crowned by the gilded Lady of Justice, holding aloft her sword and scales.

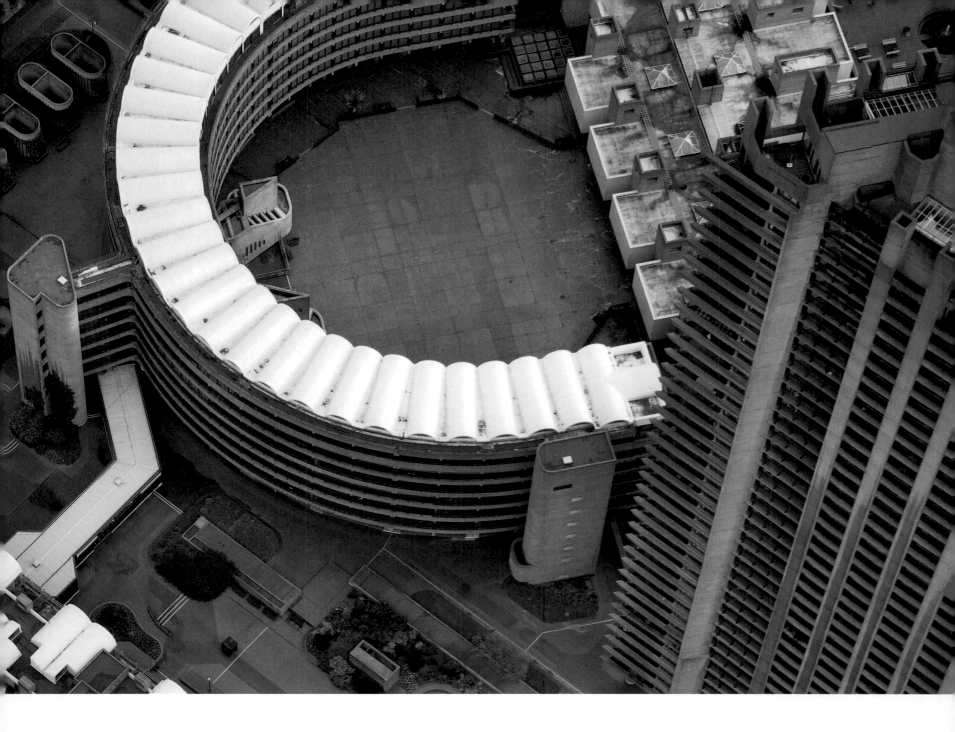

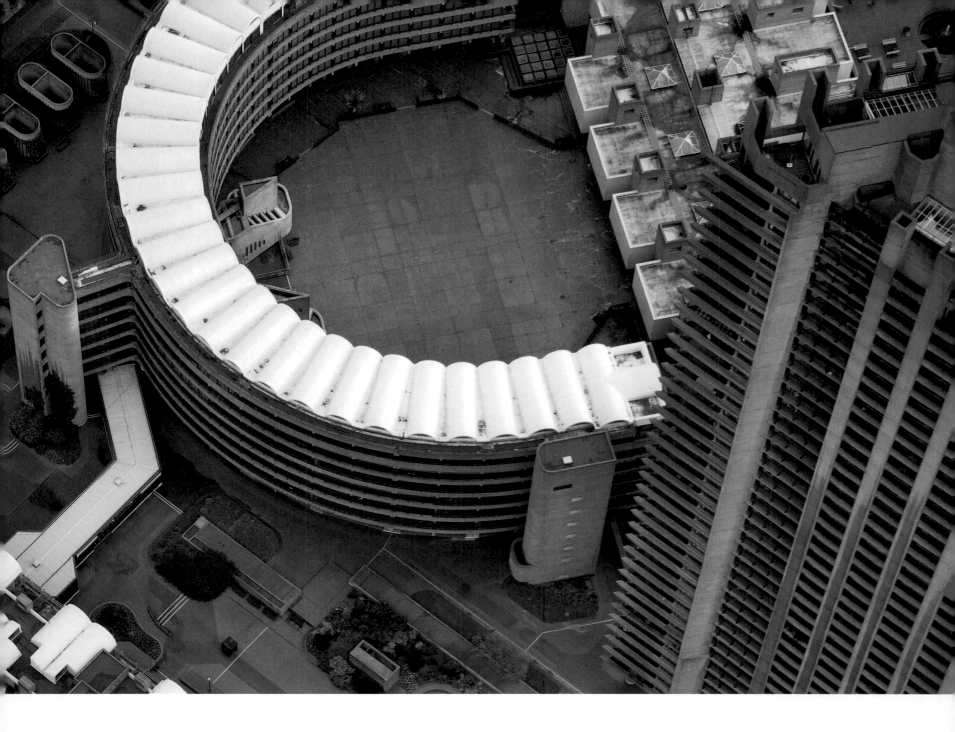

^ ABOVE
Barbican

Covering 40 acres on the northern edge of the City, the Barbican was built between 1962 and 1982 on the bomb-damaged site of Cripplegate. It incorporates residential apartment towers, businesses, schools, a conference centre and arts complex. The rounded arches on the roof are a continuing design motif, which helps to soften the stark modern architecture.

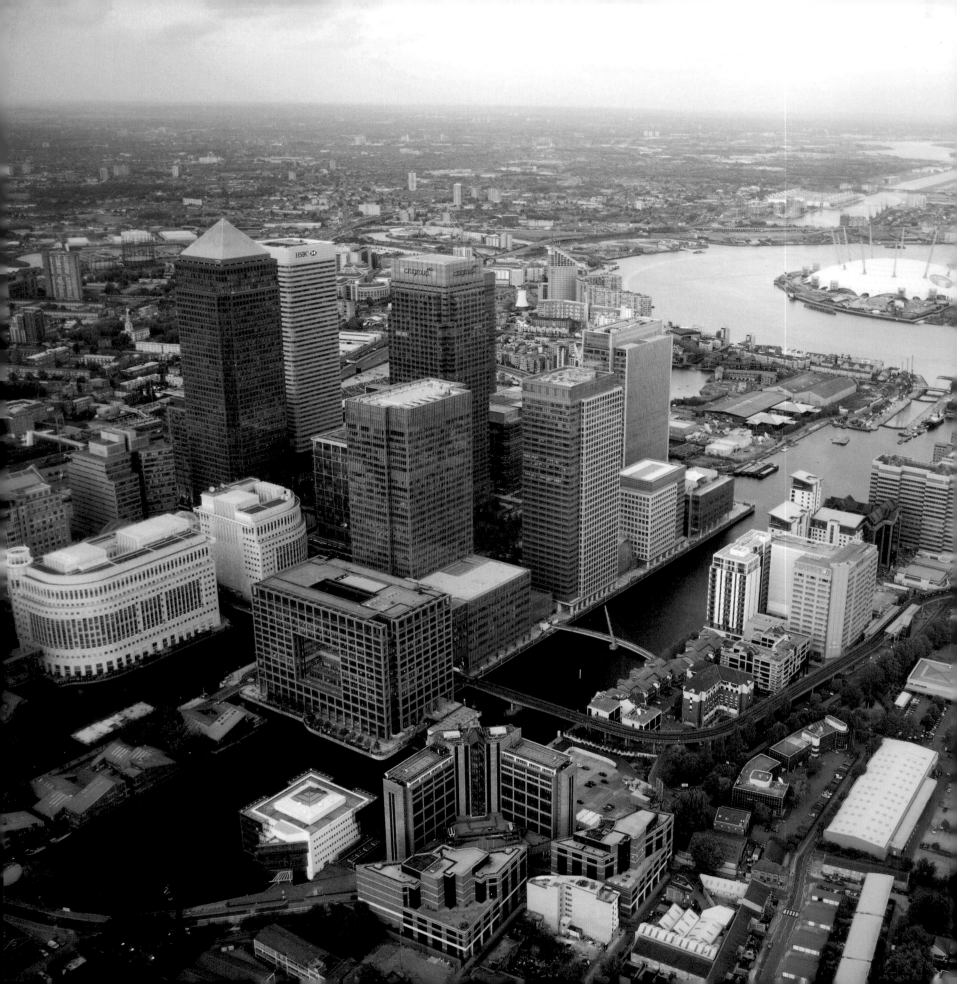

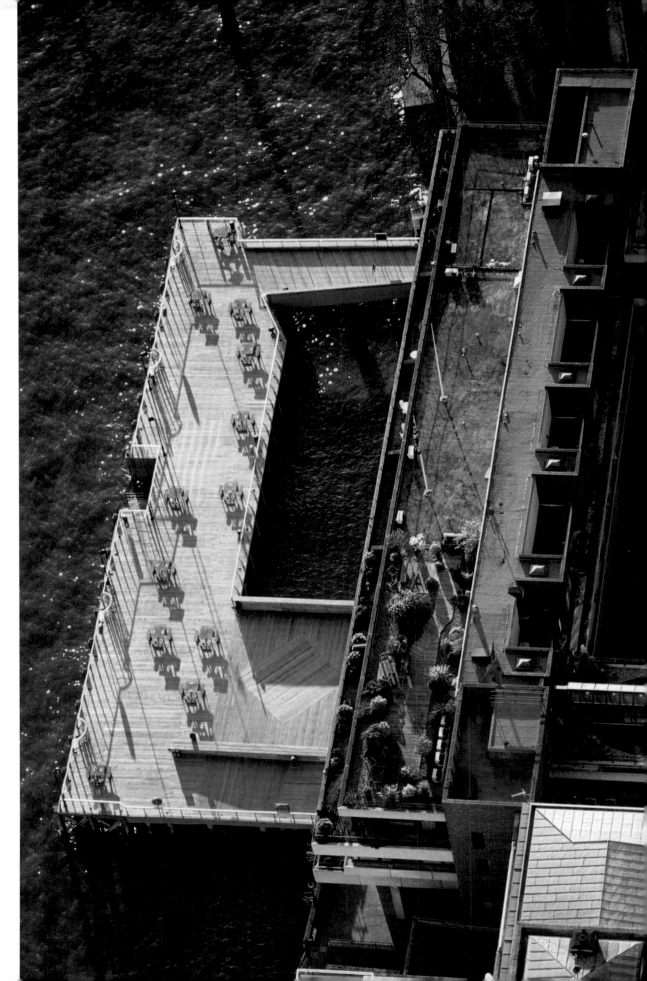

< **OPPOSITE**

Canary Wharf, Docklands and Millennium Dome

As London approached the end of the 20th century, expansion spread eastwards along the Thames. As the dilapidated warehouses and quays were redeveloped into new business and residential areas, the Docklands became a byword for the rejuvenation of London's East End. Two of its greatest symbols – Canary Wharf and the Millennium Dome – face each other across the waters of the River Thames.

> **RIGHT**

Pier at Sugar Quay

The Thames is a place for pleasure, too. The Waterfront deck at Sugar Quay is a summer party venue that affords splendid views of the Tower of London, Tower Bridge and HMS *Belfast*.

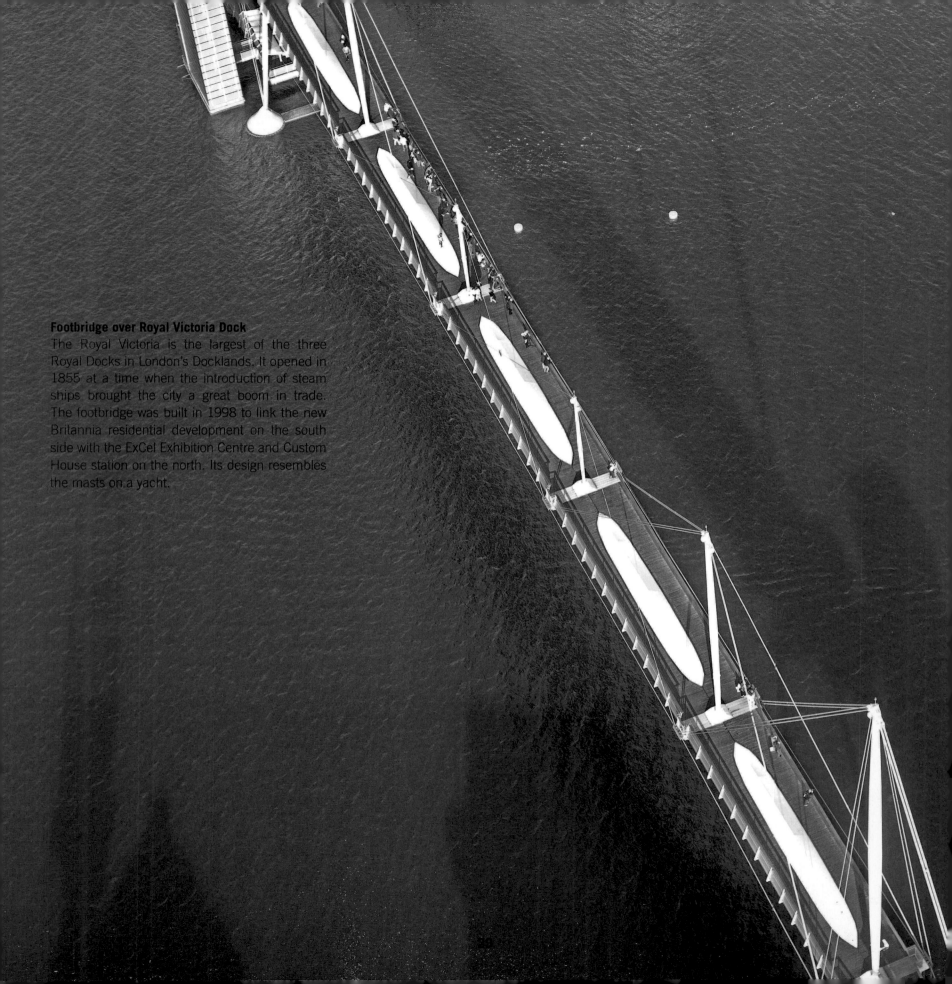

Footbridge over Royal Victoria Dock

The Royal Victoria is the largest of the three Royal Docks in London's Docklands. It opened in 1855 at a time when the introduction of steam ships brought the city a great boom in trade. The footbridge was built in 1998 to link the new Britannia residential development on the south side with the ExCel Exhibition Centre and Custom House station on the north. Its design resembles the masts on a yacht.

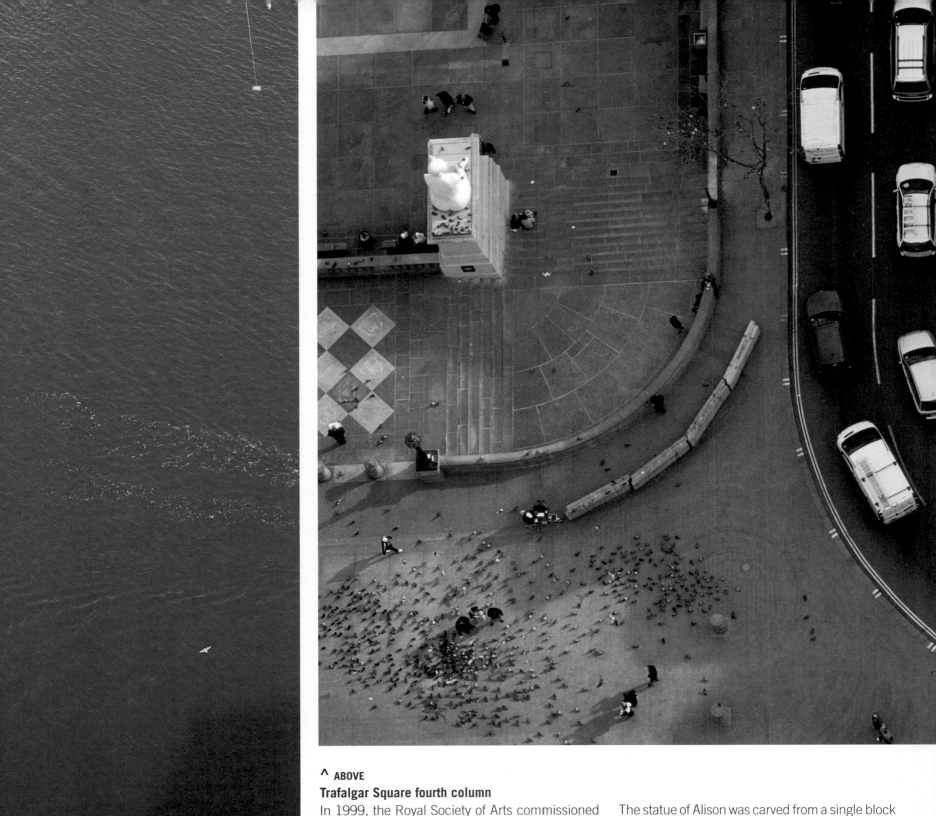

^ ABOVE

Trafalgar Square fourth column

In 1999, the Royal Society of Arts commissioned a series of temporary artworks to fill the fourth plinth in Trafalgar Square, which had stood empty for over 150 years. The most controversial of these by far was Marc Quinn's 2005 sculpture, *Alison Lapper Pregnant*. Lapper is a disabled artist who was born without arms and with shortened legs.

The statue of Alison was carved from a single block of white Carrera marble. It was displayed on the plinth for 18 months, until it was replaced in April 2007 by Thomas Schutte's *Hotel for the Birds*. One aspect of the square that never changes is the vast flock of pigeons that frequent it, shown here in the foreground.

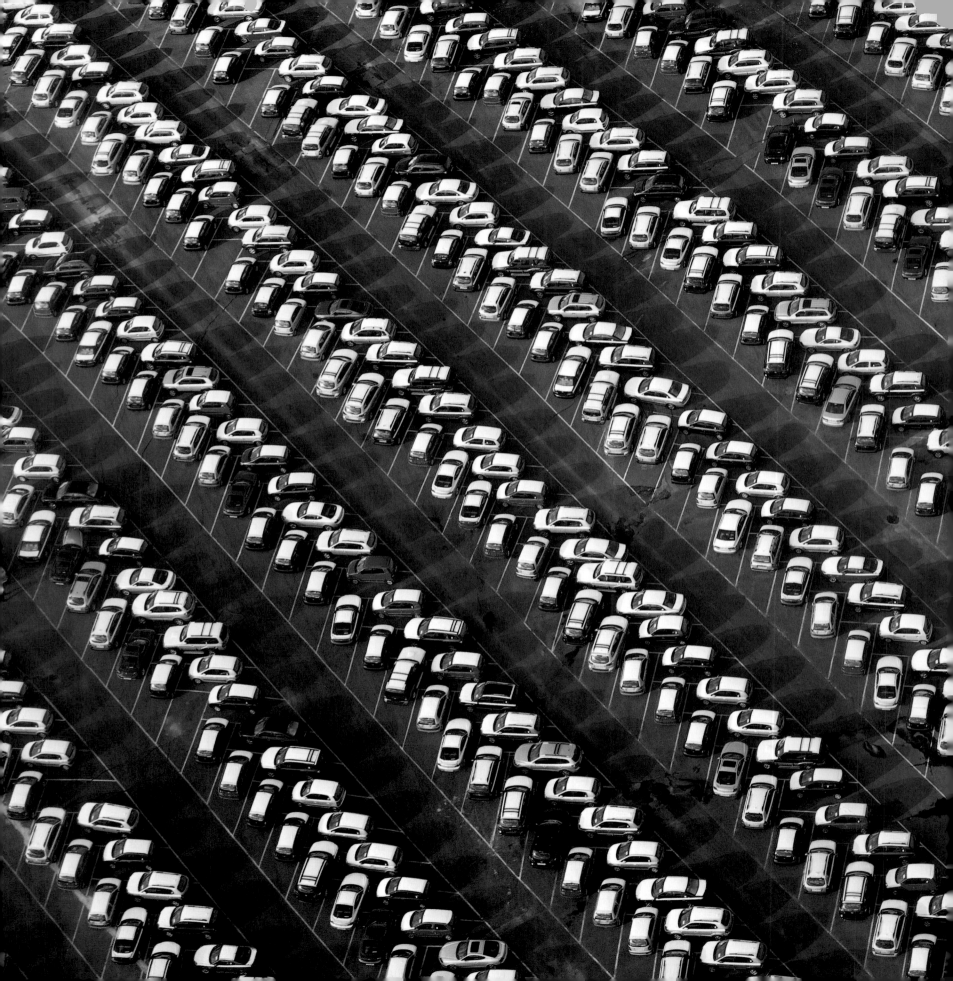

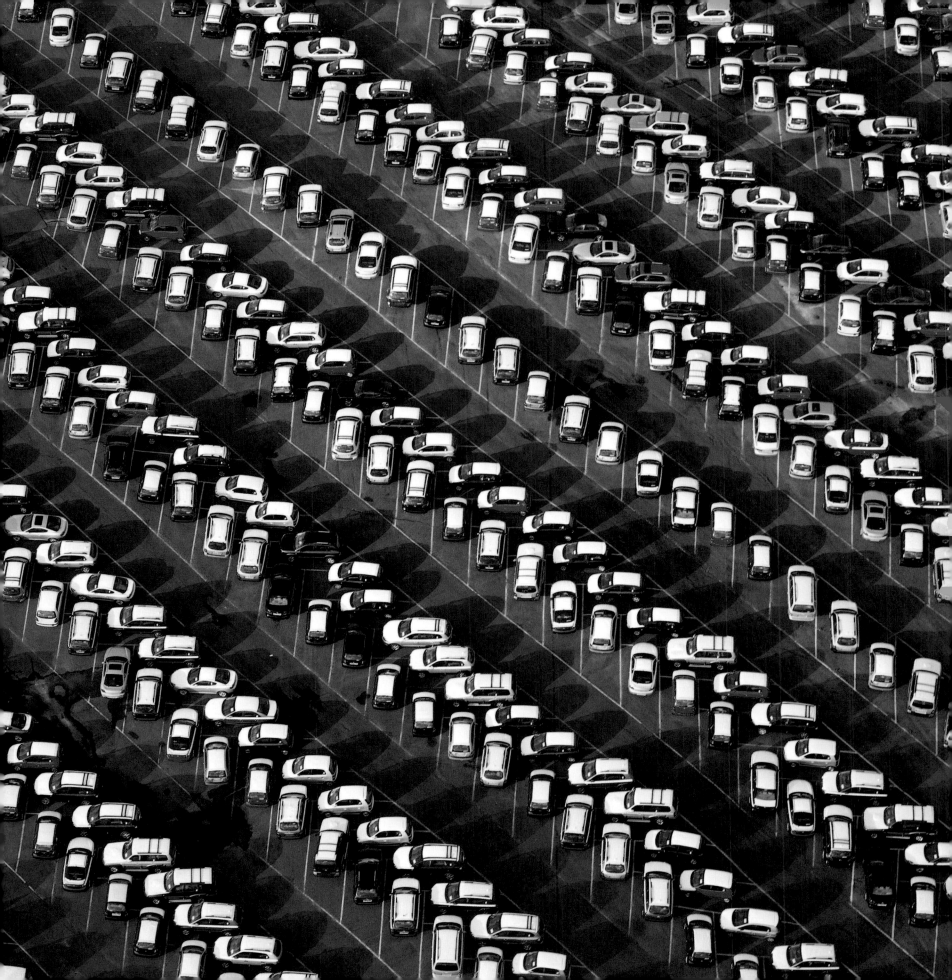

« PREVIOUS
Cars at Tilbury Docks

The cars of cruise passengers and dock workers fill the parking terminal at the Port of Tilbury. This deep-water dock, which lies 22 nautical miles downstream from Tower Bridge on the north bank of the Thames, was built for trade in 1886 and also attracted the great luxury liners of the era. Tilbury carries on that legacy today, as home to the London International Cruise Terminal, the city's only deep-water cruise ship facility.

> RIGHT
Train running into Waterloo

Spreading over 24.5 acres, Waterloo Station is the largest railway terminal in the United Kingdom. The original station, opened in 1848, was built during an age when railroads were rapidly becoming the new mode of inter-city travel. The mainline station serves destinations in the Southwest, while the Eurostar terminal, shown here on the left, services high-speed trains to France and Belgium though closes in 2007.

> OPPOSITE
Ice skating in Broadgate

Covering 9 acres to the west of Liverpool Street station, the Broadgate Centre is the largest of the office complexes built in the City during the 'Big Bang' era of the 1980s. The potential blandness of the corporate-style architecture was relieved by outdoor sculptures, gardens, elevated walkways and plazas. The central amphitheatre is used as an ice-rink in winter and an open-air entertainment venue in summer.

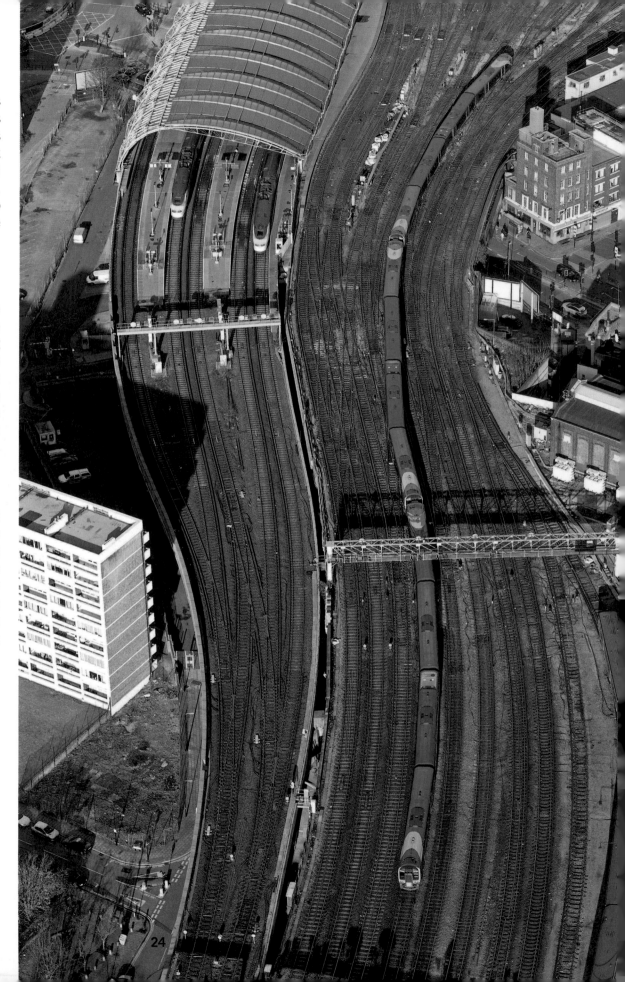

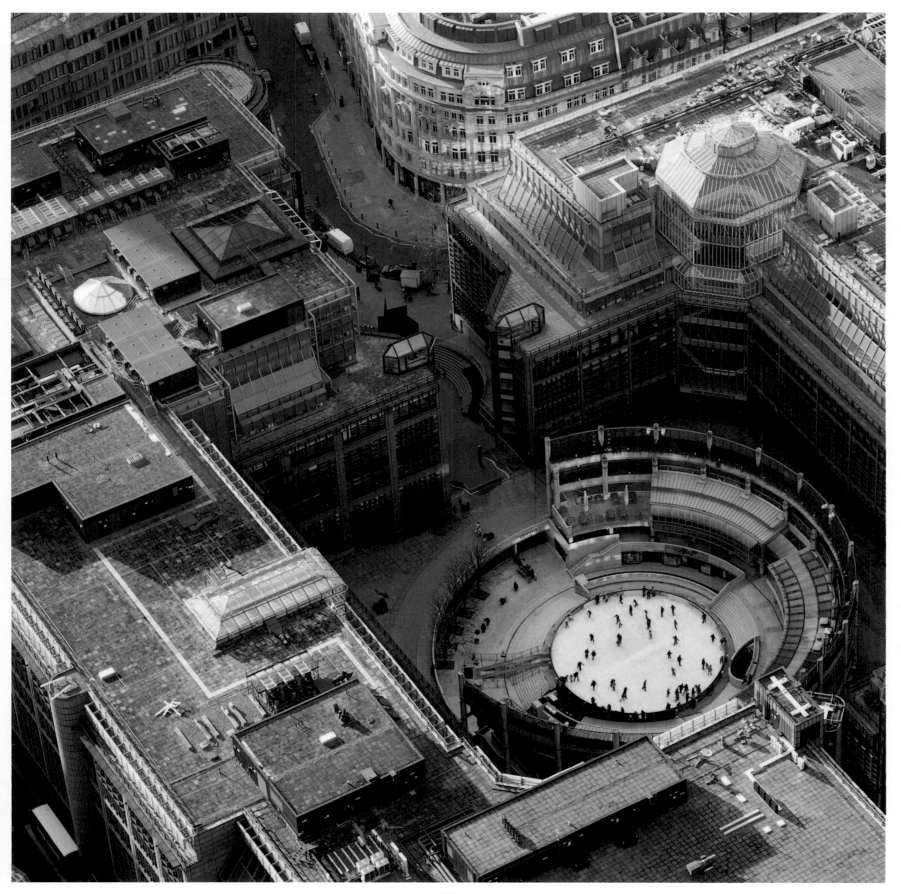

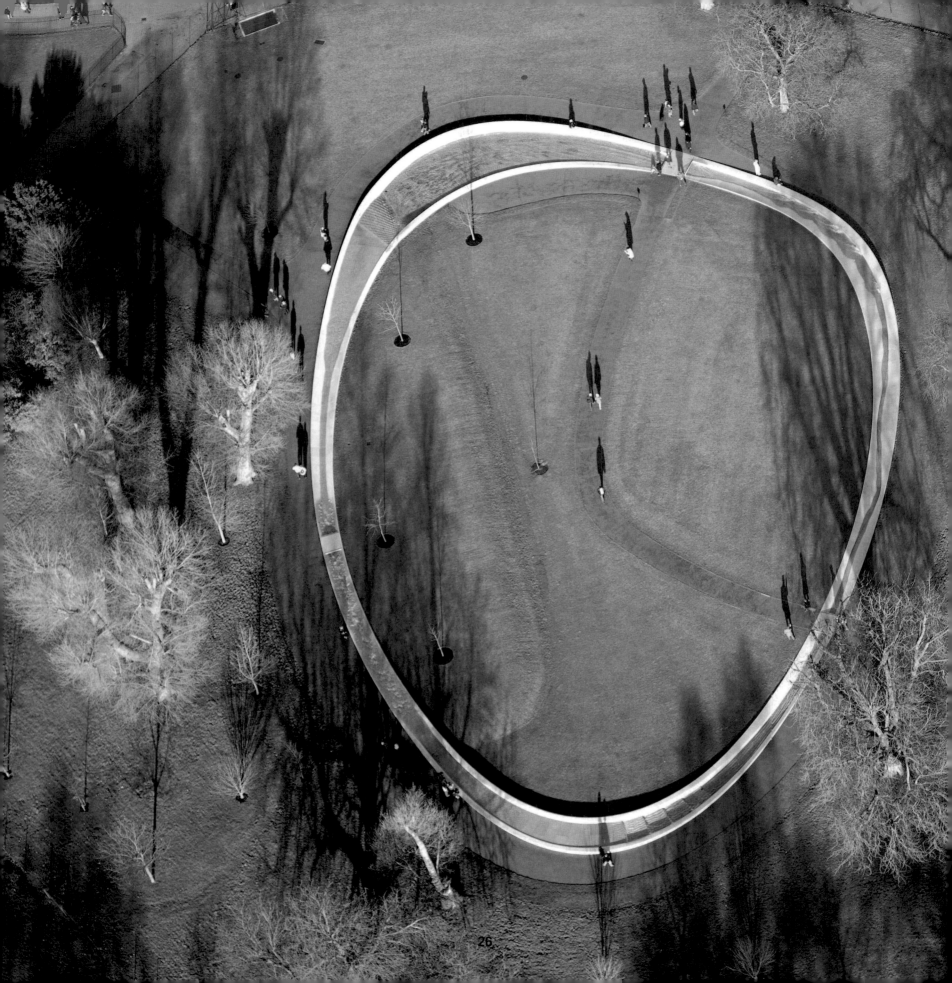

< LEFT
Diana Memorial Fountain, Hyde Park
After the tragic death of Diana, Princess of Wales in a car accident in 1997, debate raged over a suitable memorial. This circular fountain in Hyde Park was eventually chosen as a symbol of the princess's life. Designed by American architect Kathryn Gustafson, it is made of Cornish granite and resembles an oval ring. Water swirls and bubbles along the edges in two directions, to and from a calm reflecting pool. Three bridges cross the water to the fountain's grassy centre.

> **RIGHT**
Guildhall

Begun in 1411, the Guildhall is one of London's few medieval buildings to have survived the Great Fire of 1666 and the Blitz. It was built for the powerful trade guilds, who held their meetings and ceremonies here. Behind the 18th-century facade, sporting Gothic and Classical elements, are the original great hall with its stone walls, vaulting, stained-glass windows and monuments, and the largest medieval crypt in the city.

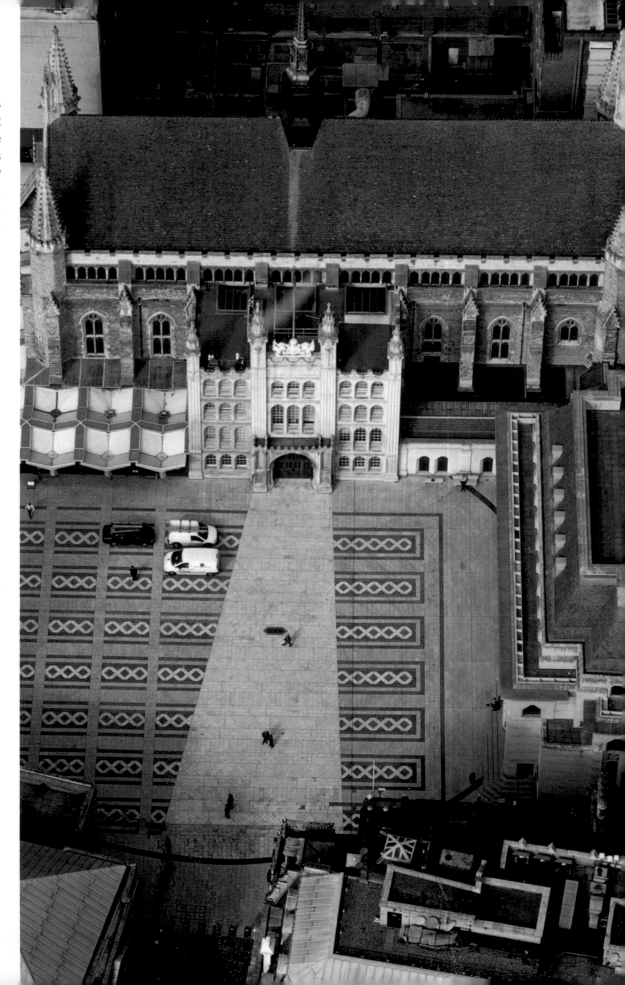

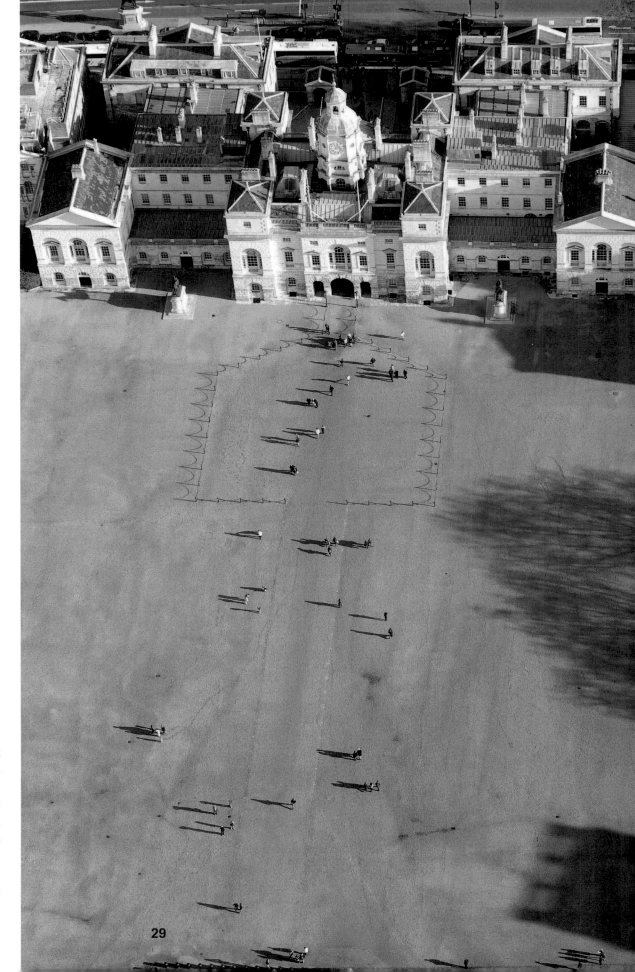

> **RIGHT**

Horse Guards Parade

Jousting tournaments were held here during Henry VIII's reign, and Horse Guards Parade is still the scene of pomp and pageantry, even in the 21st century. Every day, the Changing of the Guard ceremony takes place here, as does the annual Trooping the Colour in June to celebrate the Queen's birthday. The 18th-century buildings, designed by William Kent, have a central arch topped by a clock tower. Opposite the parade ground on the west side is St James's Park.

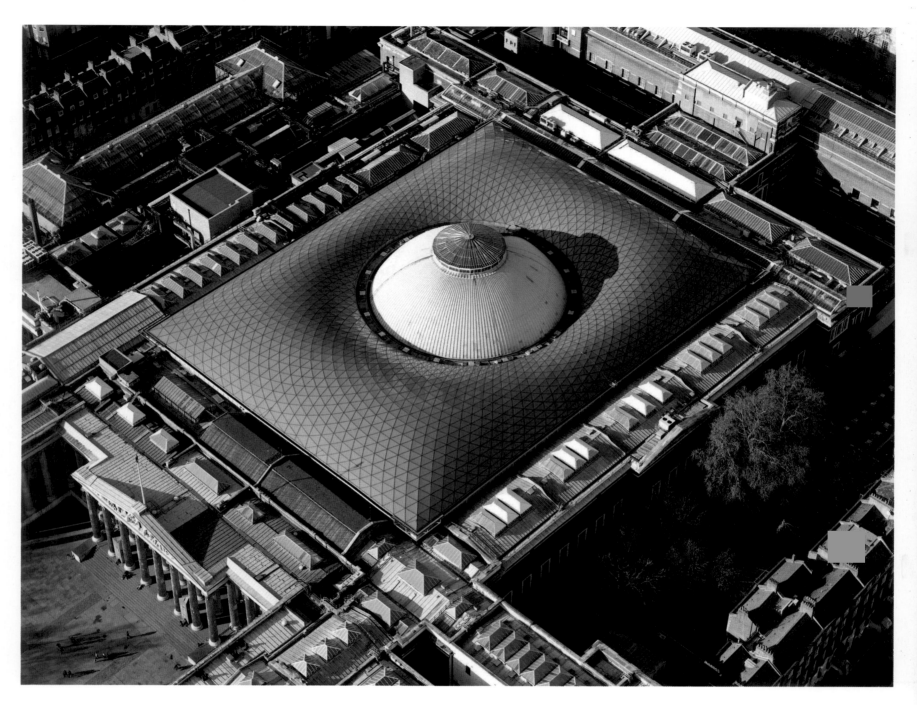

^ ABOVE
British Museum
Architect Norman Foster designed the stunning glass canopy that turned the Great Court of the British Museum into Europe's largest covered square. As well as creating a light, airy concourse for reception, shops and dining areas, Foster's renovation created more gallery space for the museum's vast collections. The venerable blue-and-gold domed Reading Room at the centre was beautifully restored and opened to the public.

> RIGHT
Paddington Station
West London's Paddington Station was one of the city's first railway terminals. The Great Western Railway began service here in 1838. Today it has 14 platforms, with trains serving the West Country and Wales, as well as Heathrow Airport. The most famous passenger to arrive here was the children's book character Paddington Bear, who was named after the station. There is a statue of him in the station concourse.

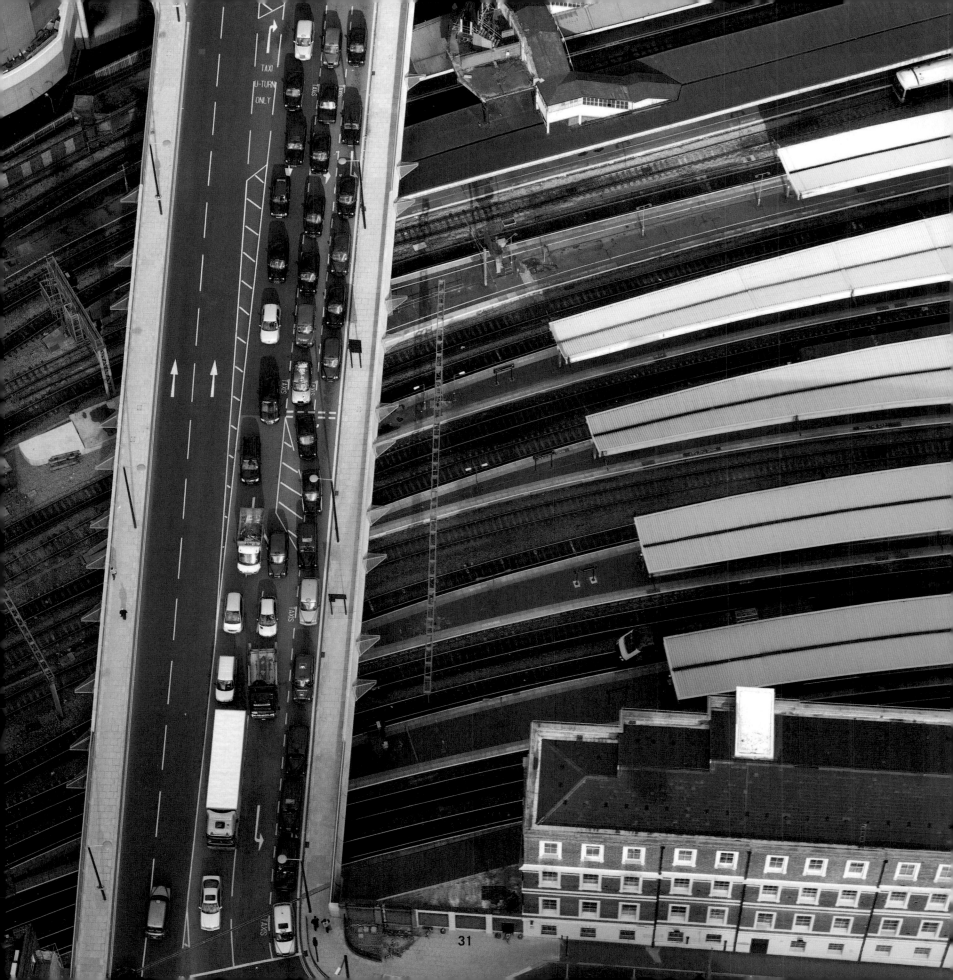

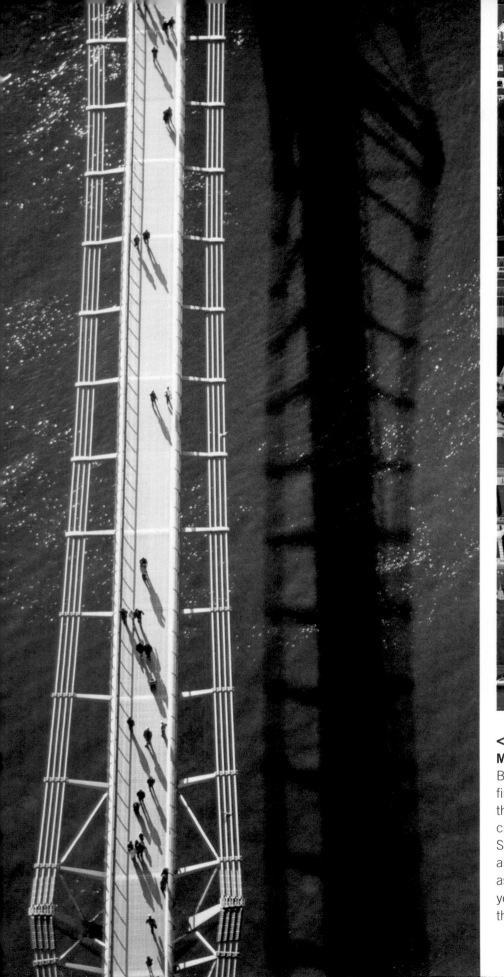

< **LEFT**

Millennium footbridge

Built to mark the Millennium in 2000, this was the first bridge constructed across the Thames in more than a century, and the city's first pedestrian-only crossing. It links two great London landmarks: St Paul's Cathedral and the Tate Modern, which also opened that year. The bridge closed almost as soon as it had opened, and it took two more years of modifications to correct a dizzying sway that earned it the nickname 'the wobbly bridge'.

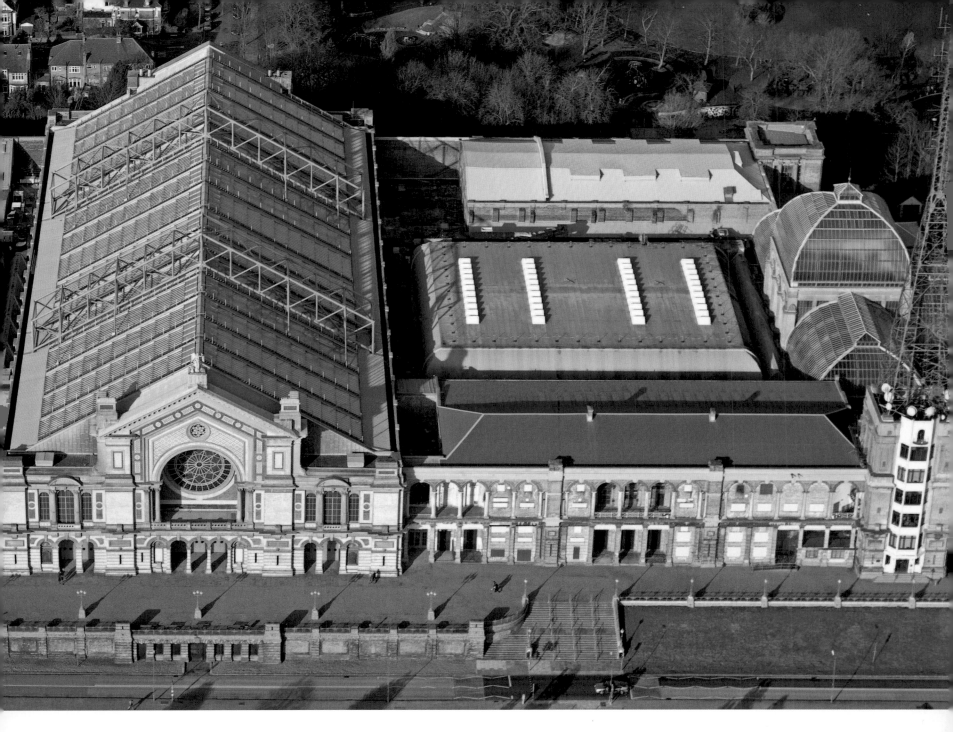

^ **ABOVE**

Alexandra Palace

Set on the heights of North London's Muswell Hill, Alexandra Palace is the city's last surviving Victorian 'People's Palace'. This was in fact its name when it opened in 1873. It burned down just 16 days later, but was rebuilt within two years. The first public television transmission took place here in 1936. Today the 'Ally Pally' is used as an entertainment, conference and exhibition centre, and has various leisure facilities.

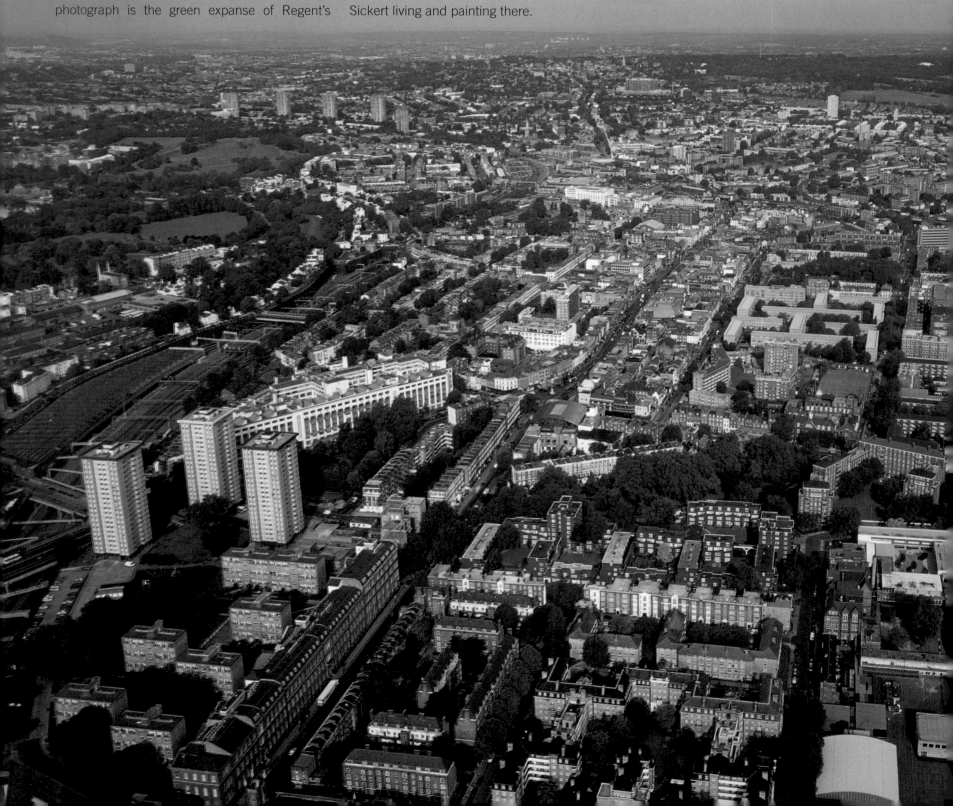

Mornington Cresent looking to Camden with Regent's Park on the left

The pocket of London known as Mornington Crescent, centred around the Tube station of the same name, lies on the southern edge of Camden Town, famous for its market. On the left of the photograph is the green expanse of Regent's Park. The crescent was named after the Duke of Wellington's brother, the Earl of Mornington, and was originally built for the gentry but later became a more bohemian area, with artists such as Walter Sickert living and painting there.

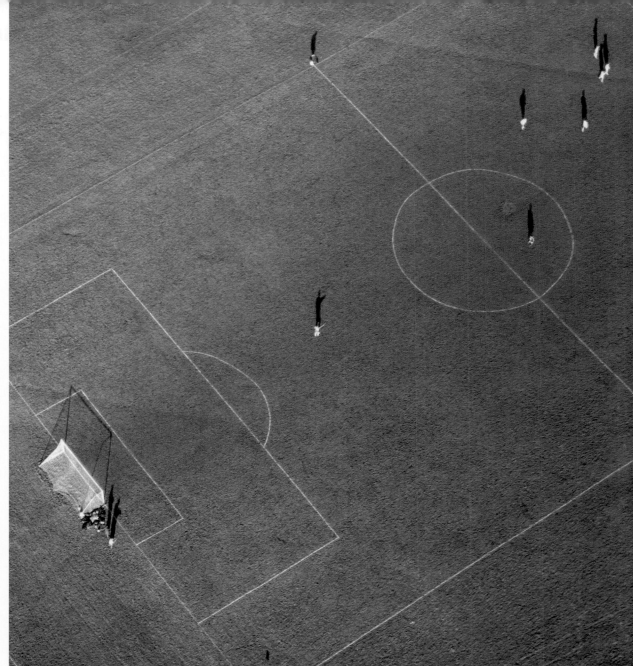

^ ABOVE

Playing fields in Dukes Meadow, Hounslow
These footballers on the extensive Dukes Meadow Playing Fields, which also include cricket pitches and a golf course, are in effect walking on water. Cradled in a loop in the Thames, this was originally made up of several lagoons, which later were planted as orchards and market gardens. Later still, for 13 years, it was heavily industrial, while gravel, sand and shingles were removed for London's booming building industry from 1924-37. The carefully-preserved topsoil was put back, and the area developed as playing fields.

HOW LONDON GREW

London is Europe's largest city, encompassing more than 610 square miles. Running through its heart is the River Thames, the most visible of all its landmarks. The Romans established the first settlement, Londinium, along its banks near London Bridge in AD43. Enclosed by a wall, it was an important outpost for over 350 years. Most of the Roman remains disappeared long ago beneath what is now London's financial district, the square mile known as the City. Few people live here today, but for centuries this was London, teeming with rich and poor alike.

Thanks to the great tidal river, which enabled trade with the Continent and beyond, the city prospered. A major step in shaping the London we know today came in the 11th century, when King Edward the Confessor moved the court upstream, building a new palace and abbey at Westminster. Since that time the centre of government and royalty and the hub of financial and commercial activity in the City have remained separate. Many major London landmarks lie along the Thames between these two anchors.

The Church once held tremendous wealth and power. By the 12th century, around 100 parish churches had been built within the city walls. More than a dozen abbeys and priories were dotted around the city limits, each with large areas of land. Then Henry VIII, angered by the Pope's refusal to grant him a divorce, broke away from the Roman Catholic Church and declared himself the head of the Church of England. In 1536, he disbanded the religious institutions and stripped them of their riches.

The scene in London was vicious. Church altars, artworks and relics were destroyed. The great palaces of the bishops were looted, given to favoured courtiers or demolished. Church lands were seized and sold off cheaply to developers. The Protestant Reformation destroyed many of London's medieval treasures, but it also paved the way for the city's expansion.

Trade grew, and new industries sprang up. With a population of barely 50,000 at the start of the 16th century, London was smaller than other European cities. But migrants poured into the city from rural areas and abroad, seeking their fortunes. London doubled in size between 1550 and 1600, to around 200,000 inhabitants.

London prospered during Tudor times. When Elizabeth I became queen in 1558, most people still lived and worked within the medieval walls. Street names such as Bread Street, Fish Street and Ironmongers Lane survive to this day and indicate the trades once plied there. But as migrants poured into the city, London doubled in size. By 1650 it was the largest city in the world. The burgeoning population began to spread beyond the walls and south of the river.

Southwark became a busy market area, catering for travellers to and from the south. Londoners also came here for its brothels, ale houses, cock-fighting and bear-baiting arenas – all the guilty pleasures they were denied in the city. When the Puritans banned theatres within the city walls, among those built across the river in Bankside was Shakespeare's Globe.

The Thames was then wider and shallower than it is today. London Bridge, first built of wood by the Romans, was now a 19-arch stone bridge lined with houses, shops and even a church. It had defensive gates that were locked at night, and the severed heads of traitors were stuck on wooden spikes. It remained London's only bridge until 1720, when a second was built much farther west at Putney.

Outbreaks of plague killed hundreds of thousands during this era. During the worst epidemics, the wealthy escaped to the country which in those days included villages like Highbury, Kingsland and Bloomsbury.

London was changed forever by the Great Fire. It broke out in a bakers shop in the wee hours of 2 September 1666, and swept through the tightly packed, thatched-roofed wooden buildings of the city. By the time it was extinguished four days later, medieval London was destroyed. Four-fifths of the city had burned, including old St Paul's Cathedral. From then on, all buildings in London were constructed of brick and stone. As the city was rebuilt, it kept its ancient street plan, and Sir Christopher Wren designed a new St Paul's.

London's westward development was spurred by the fire. The wealthy moved nearer the court at St James's. London's first square – Bloomsbury Square – set the precedent for the layout of much of the city. Famous addresses such as Soho Square and St James's Square were built in the late 17th century, while well-known streets such as Bond Street, Frith Street and Panton Street are named for the developers of the day.

By the early 18th century, London was expanding in all directions. Thousands of newcomers arrived each year, settling mostly in the industrial east and south of the city, where rents were cheaper. Londoners, who had traditionally lived near their work, now began living away from their places of business. Wealthy citizens escaped the crowded inner city and moved west and north to grand new housing developments built around leafy squares. These became the finest places to live in London. The social divide between the West End and East End still exists today.

Development in Georgian times (1714-1837) was spurred by the capitalistic schemes of aristocrats, who leased plots of land to speculative builders, who turned a profit by renting the houses they built. The square, with its tall, terraced houses and shared central garden, was a new way of using urban space profitably and had much character besides.

London's expansion occurred in fits and starts. There was no intelligent overall planning. The city was developed over a wide area by gradually adding one addition to another. People began commuting from outlying villages (now suburbs) by coach and omnibus – the first public transport system – in the early 1800s. As the city spread ever wider, the journalist William Cobbett called London 'the all-devouring Wen', an old English word for a growth on the skin.

During the Victorian era (1837-1901) Britain's empire spread worldwide. As commerce mushroomed, so did London's docklands. Many of the city's great museums and cultural institutions were founded. Urban modernization brought huge changes, particularly with the building of the railways and later the underground tube network. Many working-class areas were destroyed to make way for the new rail lines, and although it got rid of the worst slums, thousands of people were displaced.

London was radically changed again during World War II in the bombing campaign known as the Blitz, which lasted from September 1940 to May 1941. By the end of the war, much of the Docklands and East End, and 130,000 homes across the city had been destroyed. Large, unsightly housing estates were constructed on the bomb sites. The Docklands remained derelict until the 1980s, when a regeneration scheme transformed the area into the capital's second business and financial centre.

London entered the new millennium on a wave of prosperity. But as has so often been the story over its long history, it faces intense housing pressures as more and more people from within and without Britain come to the capital to seek their fortune. With plans for new housing developments, coupled with new facilities for the 2012 Olympics, London's growth in the 21st century is headed east along the Thames.

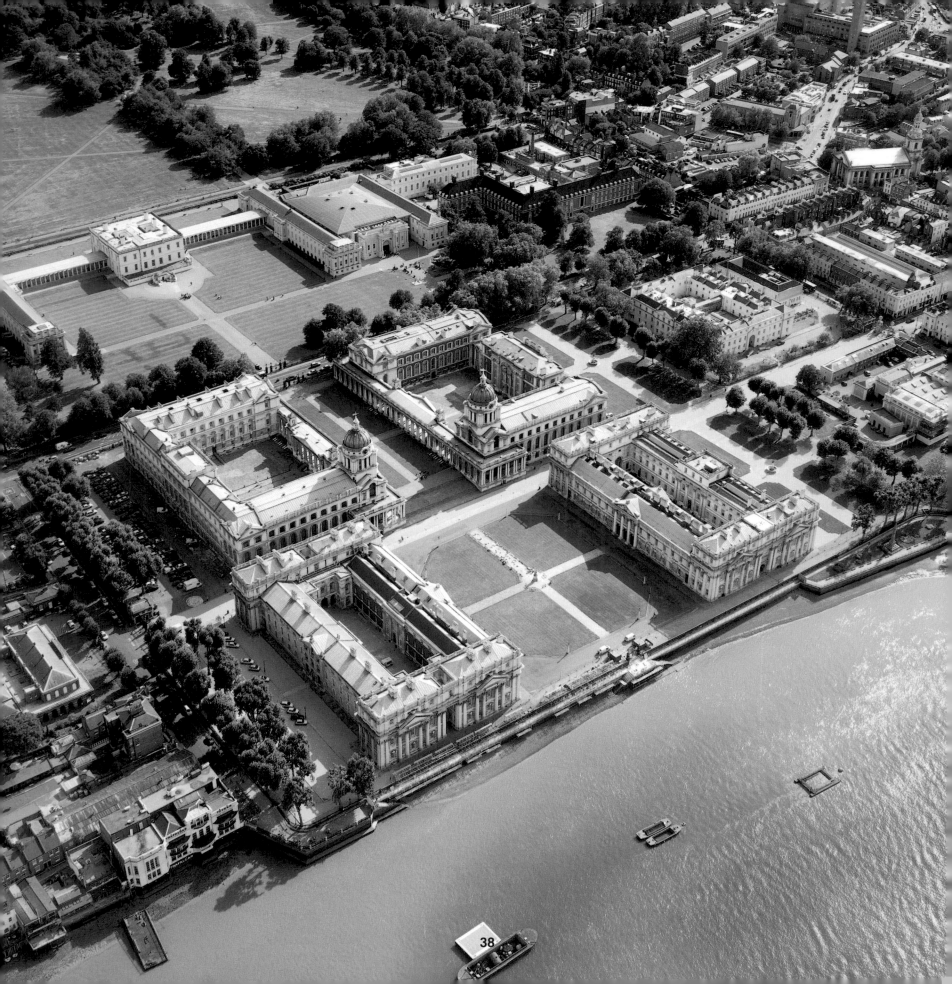

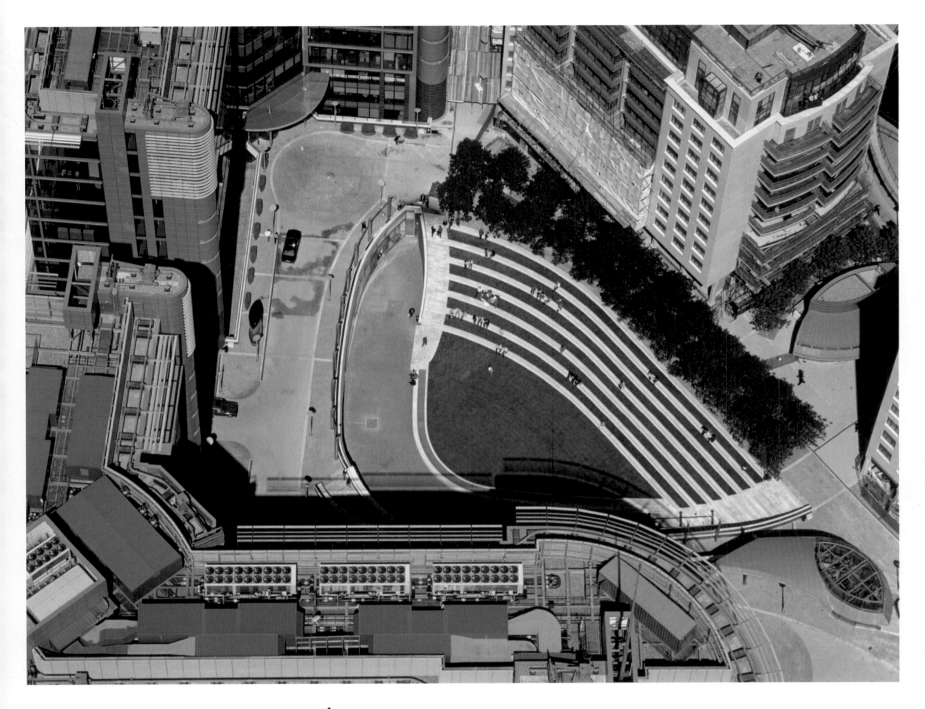

< OPPOSITE

Greenwich Royal Naval College

Initially planned as a palace for King Charles II in 1664, these symmetrical buildings were subsequently built as a hospital for sick and aged seamen during the reign of William and Mary. The monarchs made Sir Christopher Wren alter his original designs so as not to obstruct the view of the river from Queen's House. The Royal Naval College moved here in the 1870s.

^ ABOVE

Paddington Basin Development

Since the launch of the Heathrow Express, which brings visitors to London into Paddington Station in just 15 minutes, the whole area around has been undergoing much-needed major improvements. Work began in 1996, and it is one of Europe's largest programmes of its kind. It is transforming the rather seedy face of Paddington into a vibrant new part of London's scene.

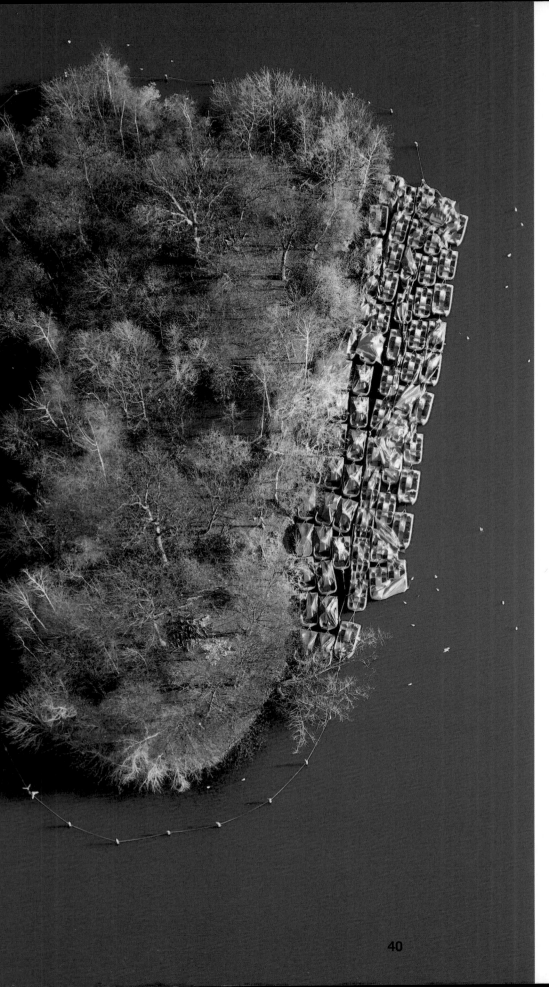

<< LEFT
Boats tied up on the Serpentine Lake
The Serpentine Lake, named for its slinky shape, was created in 1730 by Queen Caroline when she called for a dam to be built on the River Westbourne, which at that time flowed through the park. The lake divides Hyde Park from the adjacent royal park, Kensington Gardens. The lake is noted for its boating, its bird life and for swimming in the summer, although the hardy members of the Serpentine Swimming Club bathe there all year round.

> OPPOSITE
Kew Gardens
The Royal Botanic Gardens in Kew date back to 1772 when two royal estates were combined, and they quickly became one of the leading horticultural research centres in the world, which they remain to this day. Behind the peaceful paths of this UNESCO World Heritage Site is a thriving organisation employing some 700 people looking after one of the biggest plant collections in the whole of the British Isles.

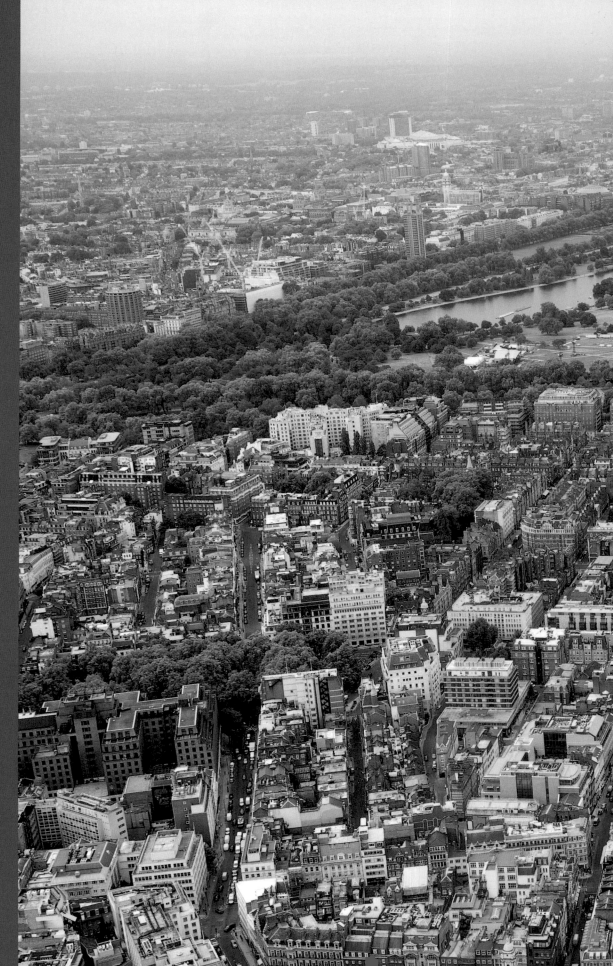

> **RIGHT**

Oxford Street, Mayfair and Hyde Park

As London spreads west, it grows more upmarket. Red buses ply the shopping route along Oxford Street, from the souvenir shops and trendy teen havens at the eastern end to the fashionable department stores along its western half. To the south is Mayfair, with its designer boutiques and expensive flats and hotels. The rectangle of treetops is Grosvenor Square, once the city's largest residential square and now home to the American Embassy. Beyond lies the great green expanse of Hyde Park.

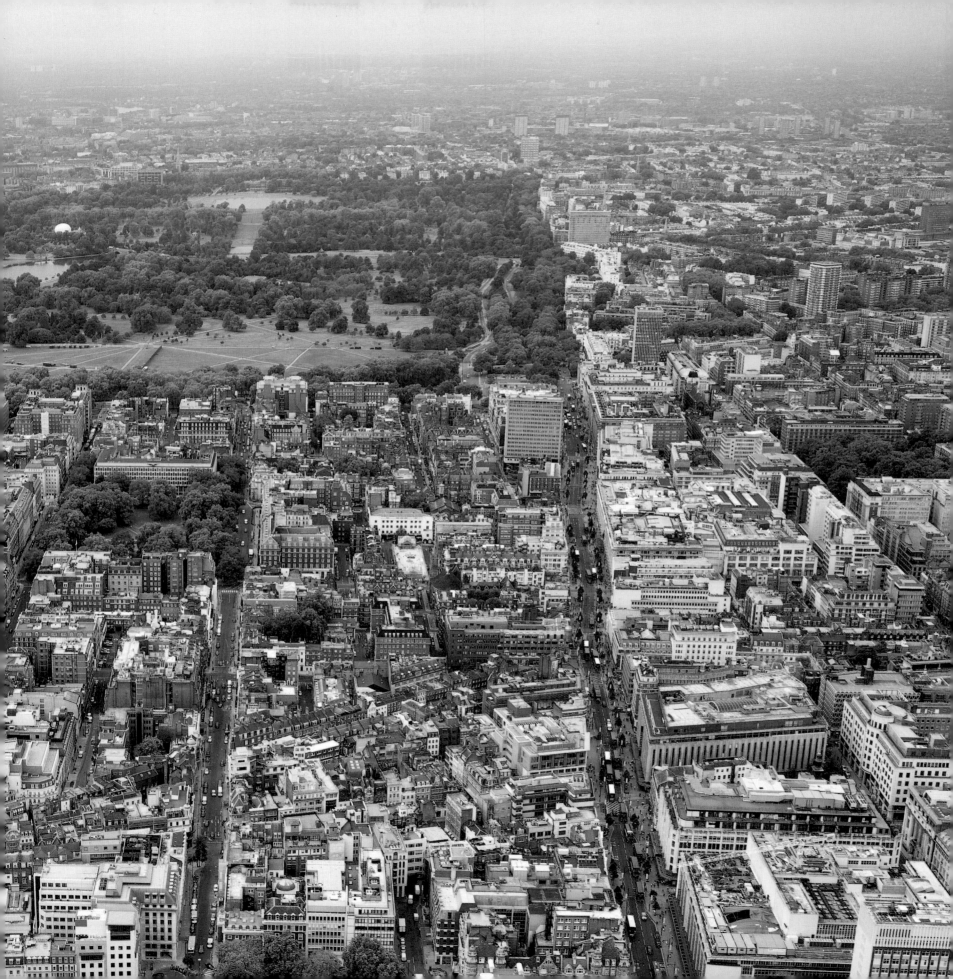

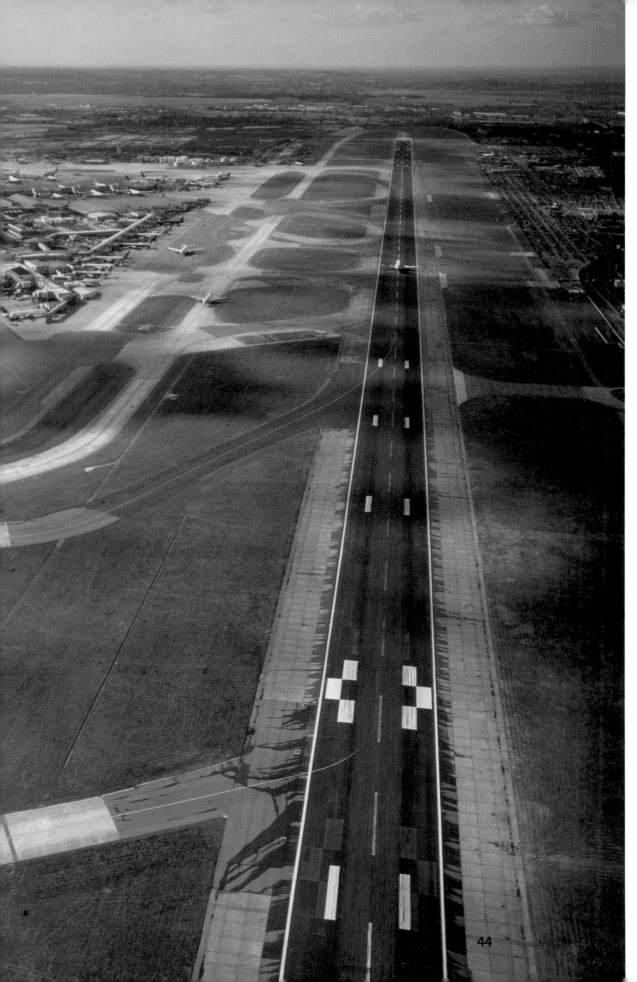

< LEFT

Runway at Heathrow

From the runways at Heathrow Airport, planes take off to land again in over 90 countries around the world. It is the world's busiest international airport by a long way, an astonishing development from its humble beginnings in 1946 when it transferred from military to civilian use. In those days passengers checked in and waited in tents, with only chemical toilets to use. Today it handles about 61 million passengers every year.

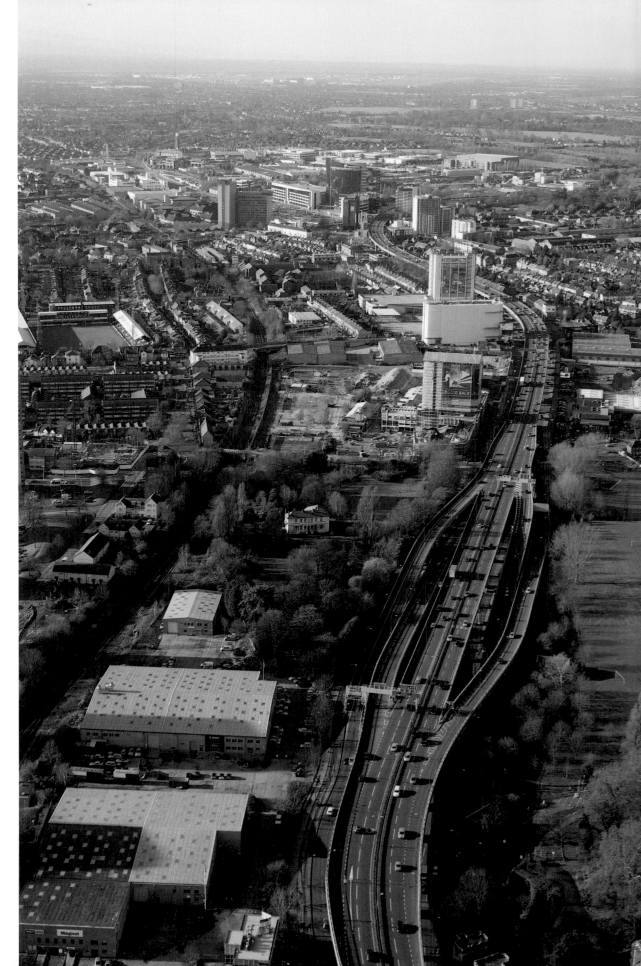

> RIGHT

M4 and A4 interchange at Brentford

It is hard to believe, looking at this busy junction of the M4 motorway with the main A4 road into central London, that Julius Caesar once fought a battle here, in 54BC. In the early 17th century the famous Native American Pocahontas lived in Brentford, and later the artist JMW Turner and the poet Shelley. It's a surprising roll-call for what many regard as a fairly dull London suburb.

Warehouses off Meridian Way

The anonymous roofs of these warehouses off Meridian Way in Edmonton in northeast London may look dull, but they are a reminder that London has always been an important trading centre. When Britain's explorers and adventurers set sail they brought back goods from all over the world, and that trade helped to create the powerful British Empire. The resulting trading Guilds that were formed then controlled the city, the Guild members electing the Lord Mayor of London.

Tower 42

Tower 42 in Bishopsgate is the tallest building in the City of London, on a site whose history can be traced back to at least the 2nd century AD. The Tower itself was opened in 1981 by HM Queen Elizabeth II, indicating its importance to the city, close as it is to the Bank of England, the Stock Exchange, the former Baltic Exchange (now the Gherkin) and the Lloyds building. On its 24th floor it also houses one of London's top restaurants, Rhodes 24, owned by TV star chef Gary Rhodes.

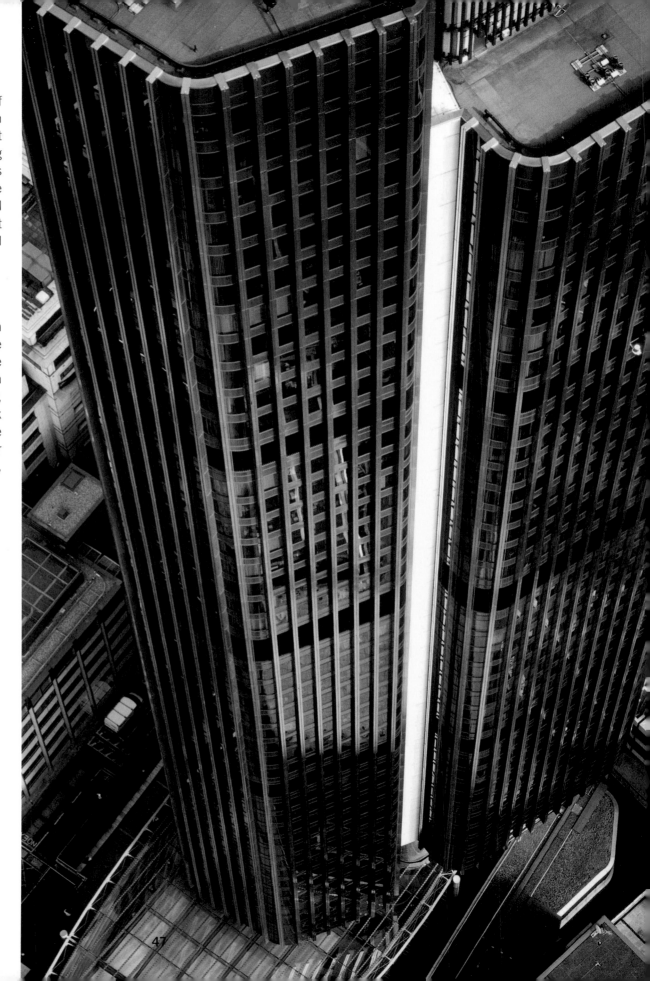

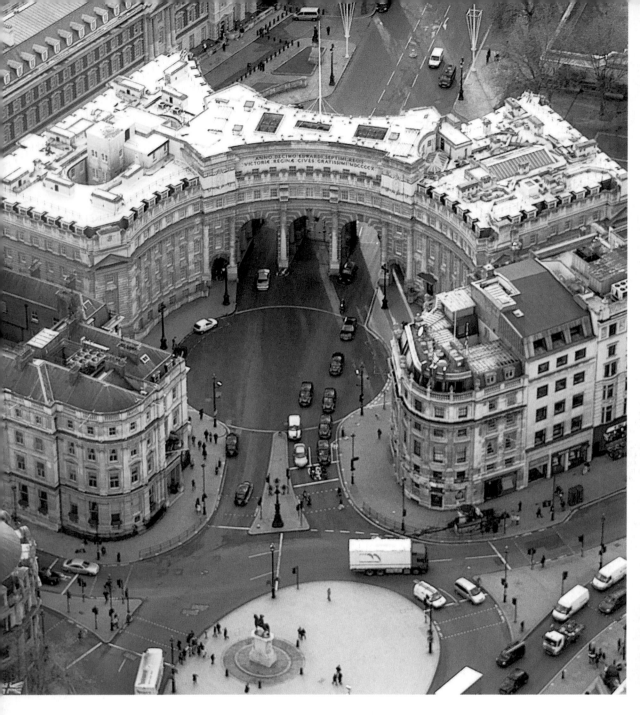

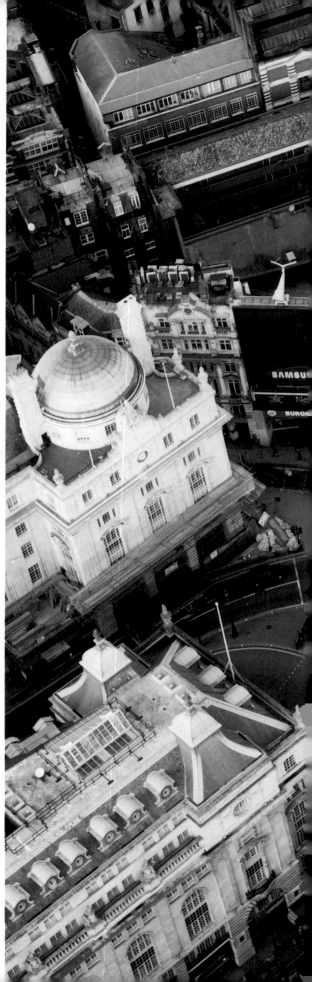

^ ABOVE
Just off Trafalgar Square

Admiralty Arch, at the top of this picture and just off Trafalgar Square, is a comparatively recent addition to London's architecture. It was designed in 1910 by Sir Aston Webb, who had also worked on Buckingham Palace, to provide a suitably regal gateway from the busy Trafalgar Square down the Mall to Buckingham Palace. The main central arch is only opened for ceremonial occasions, and regular traffic has to pass either side of it.

> RIGHT
Piccadilly Circus, Lillywhites and Eros

The statue of Eros in Piccadilly Circus is tiny, barely visible in this wide panorama, yet it has come to be one of London's most familiar symbols. For such an icon, it hasn't been treated very kindly, having been moved and repositioned over the years. The poor naked fellow isn't even Eros. The statue was erected in 1893 to honour the Victorian politician and philanthropist Lord Shaftesbury, and is actually of Eros's twin, Anteros.

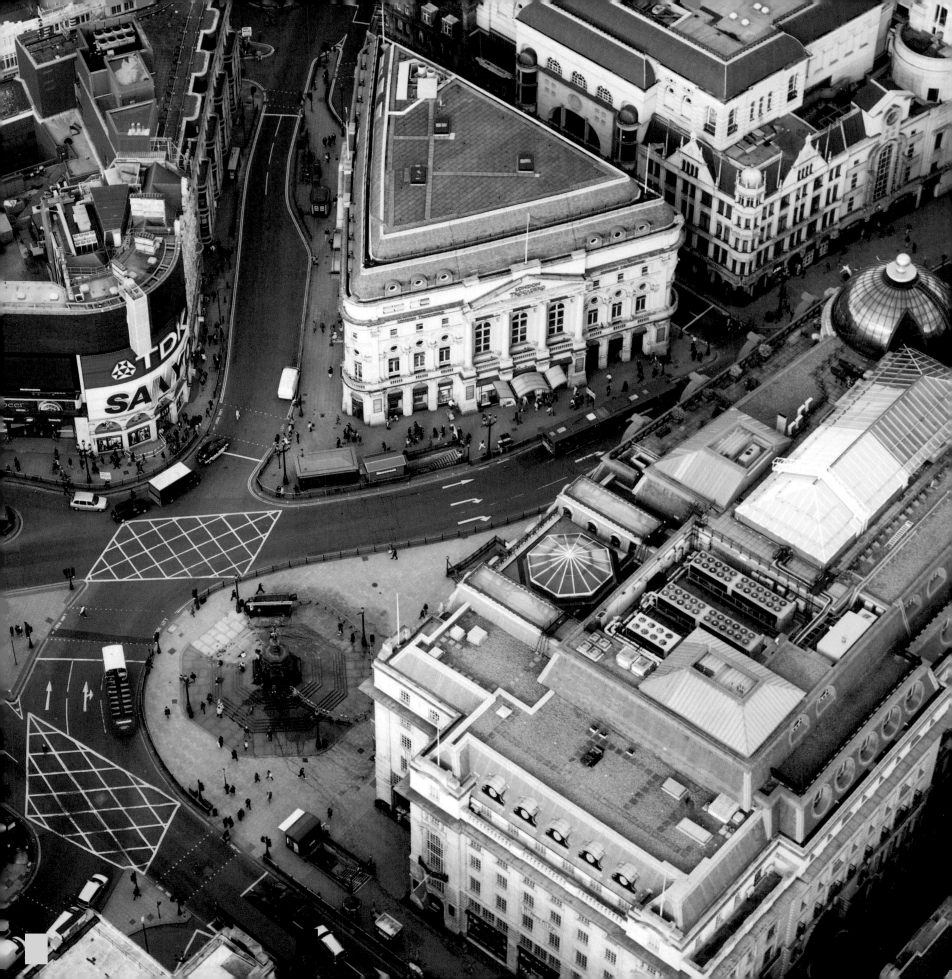

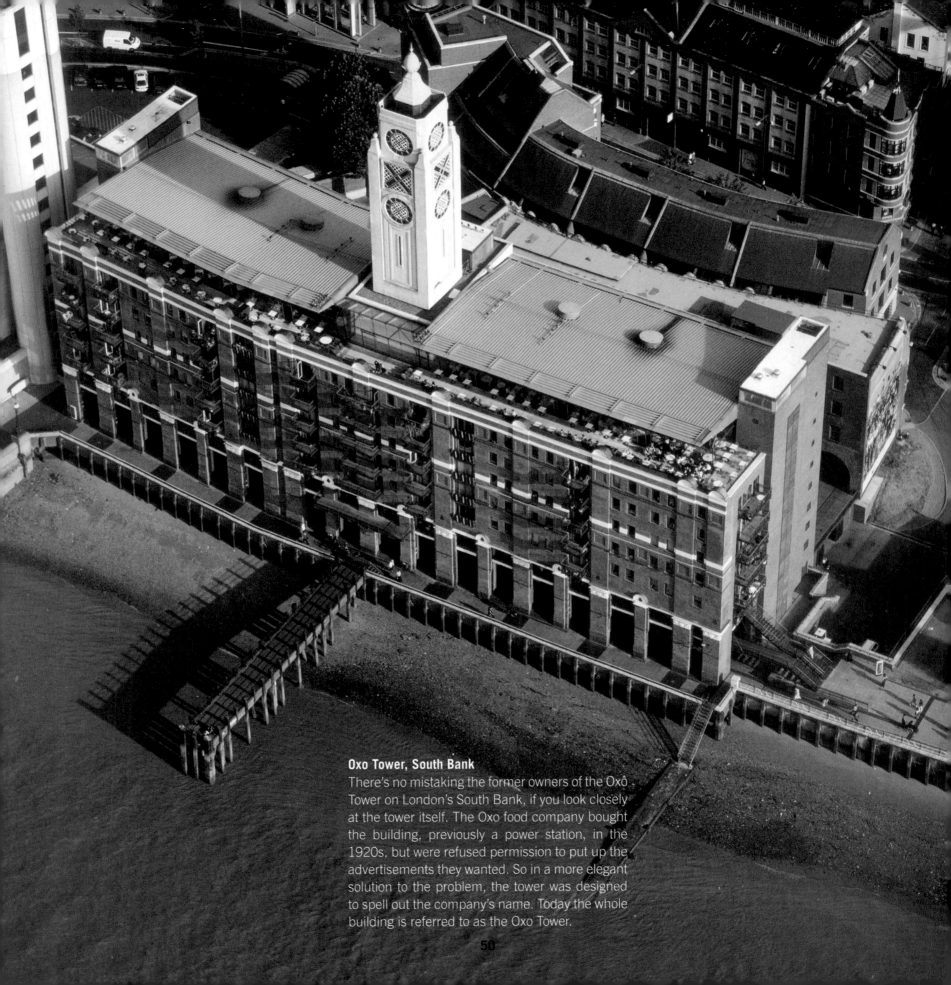

Oxo Tower, South Bank

There's no mistaking the former owners of the Oxo Tower on London's South Bank, if you look closely at the tower itself. The Oxo food company bought the building, previously a power station, in the 1920s, but were refused permission to put up the advertisements they wanted. So in a more elegant solution to the problem, the tower was designed to spell out the company's name. Today the whole building is referred to as the Oxo Tower.

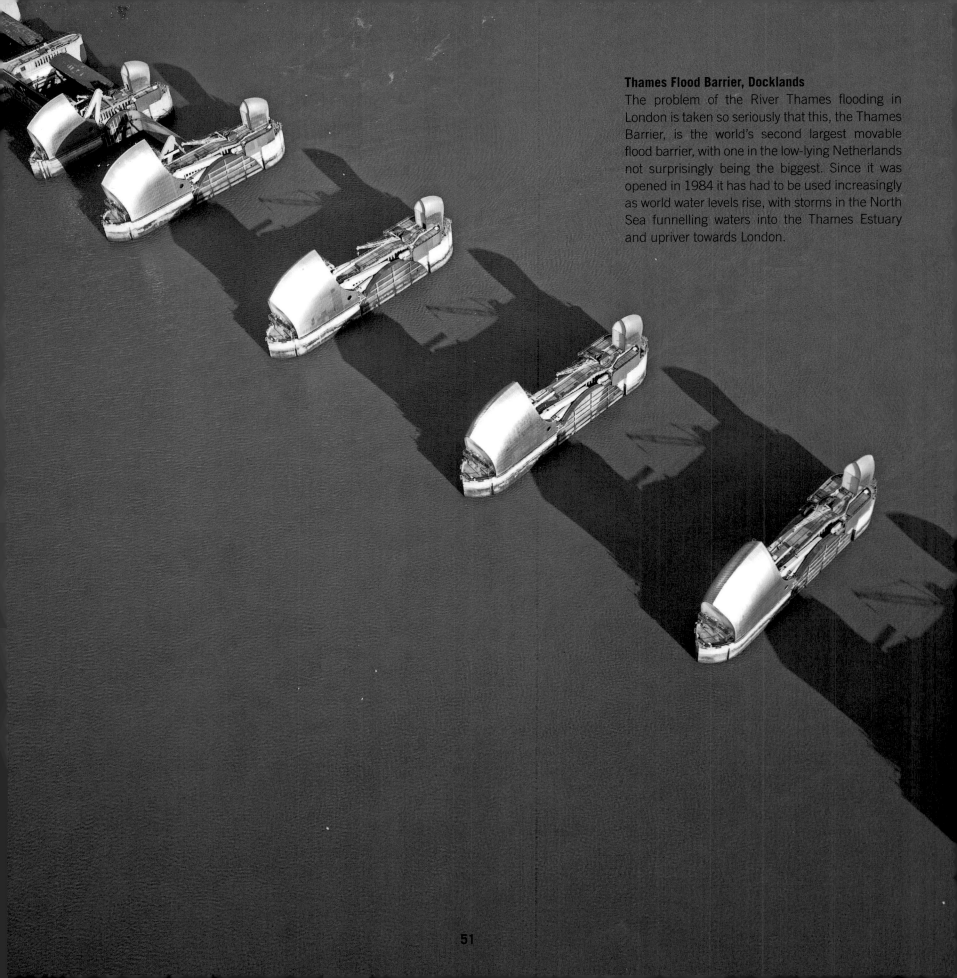

Thames Flood Barrier, Docklands
The problem of the River Thames flooding in London is taken so seriously that this, the Thames Barrier, is the world's second largest movable flood barrier, with one in the low-lying Netherlands not surprisingly being the biggest. Since it was opened in 1984 it has had to be used increasingly as world water levels rise, with storms in the North Sea funnelling waters into the Thames Estuary and upriver towards London.

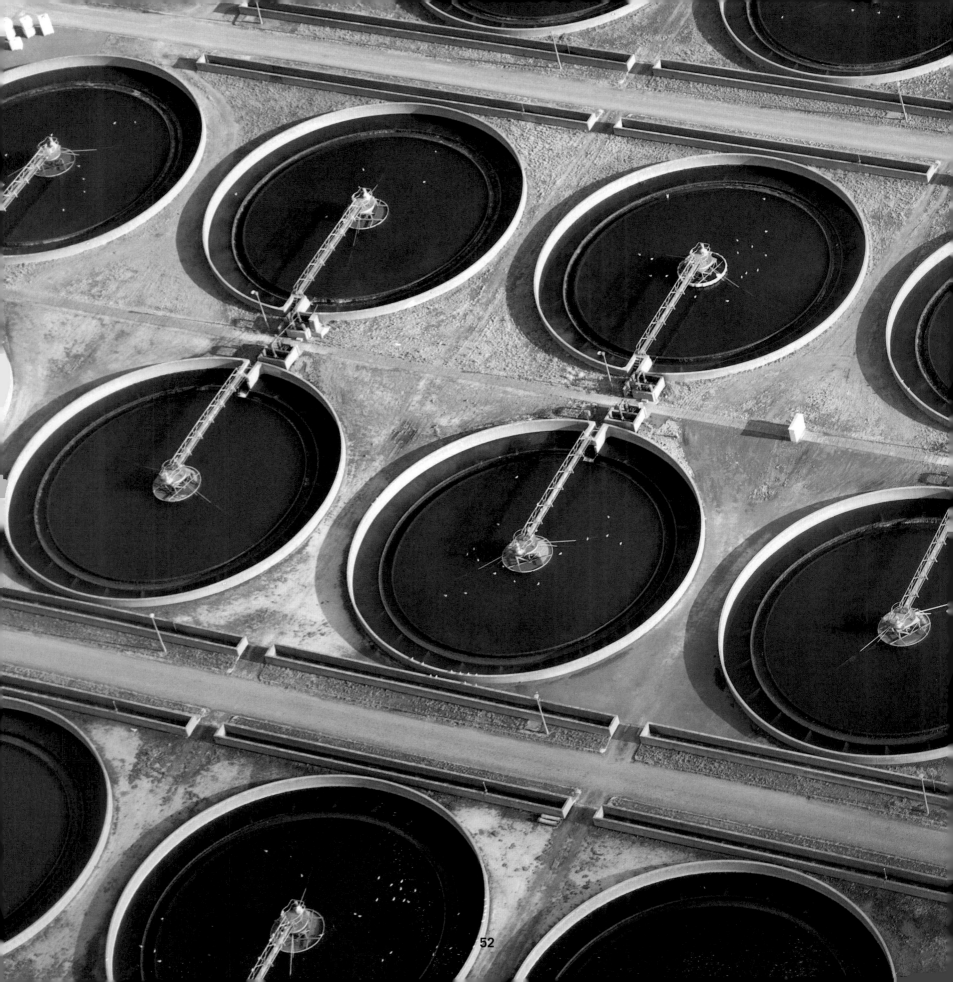

52

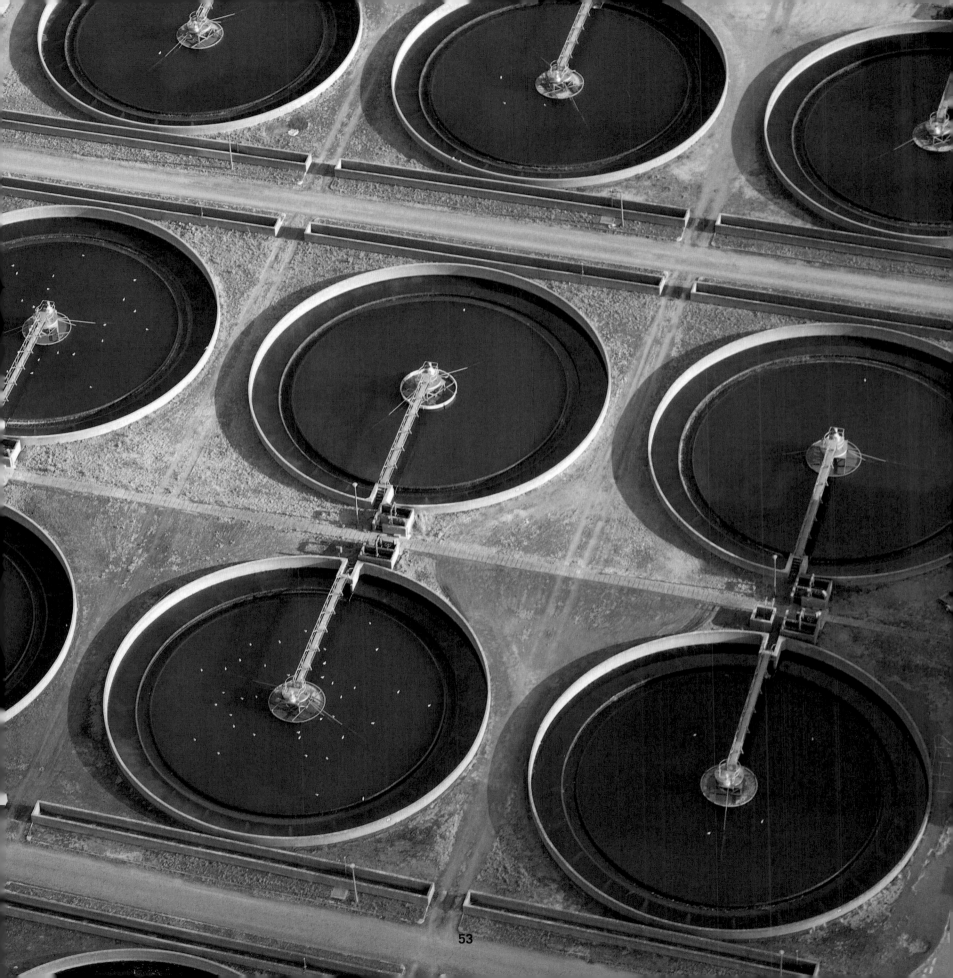

« PREVIOUS
Sewage Works/Water Treatment Plants, Newham

Even the most industrial of urban landscapes can look visually appealing from the air. This Warhol-like view is in fact the water treatment plants for the largest sewage works in the country. They are situated on the north side of the Thames at Beckton, in the borough of Newham, and serve over half of London's population.

> RIGHT
National Gallery on Trafalgar Square

This unusual and interesting bird's eye view of London's National Gallery shows that while the front which looks out over Trafalgar Square is aesthetic and harmonious, the roofs of the buildings are anything but. The founding of the Gallery goes back to 1824 when a determined effort was made to start a national collection to rival the best of those in Europe, and the present building was opened to house the growing collection in 1838.

> OPPOSITE
Marble Arch

Marble Arch, which now looks a little odd and lonely at the Oxford Street end of Hyde Park, was originally the grand gateway to Buckingham Palace in 1827. It only survived there for 24 years before it was moved here in order to make way for extensions to the Palace. The possibility of moving it back, or to another more attractive location, has been mentioned several times in recent years, but for the moment it stays resolutely where it is.

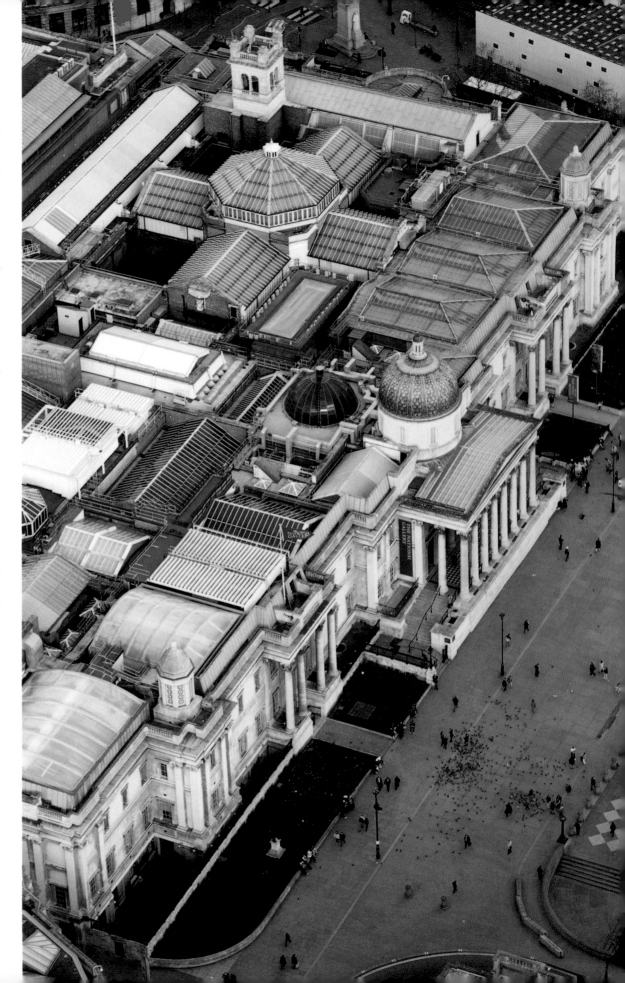

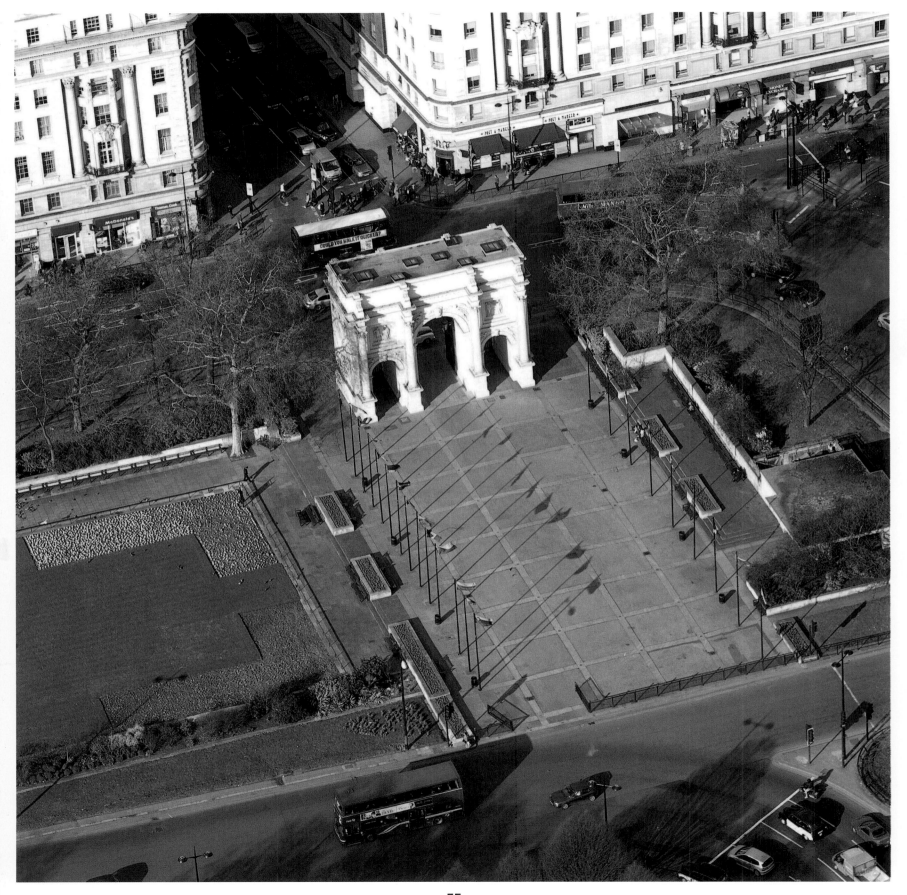

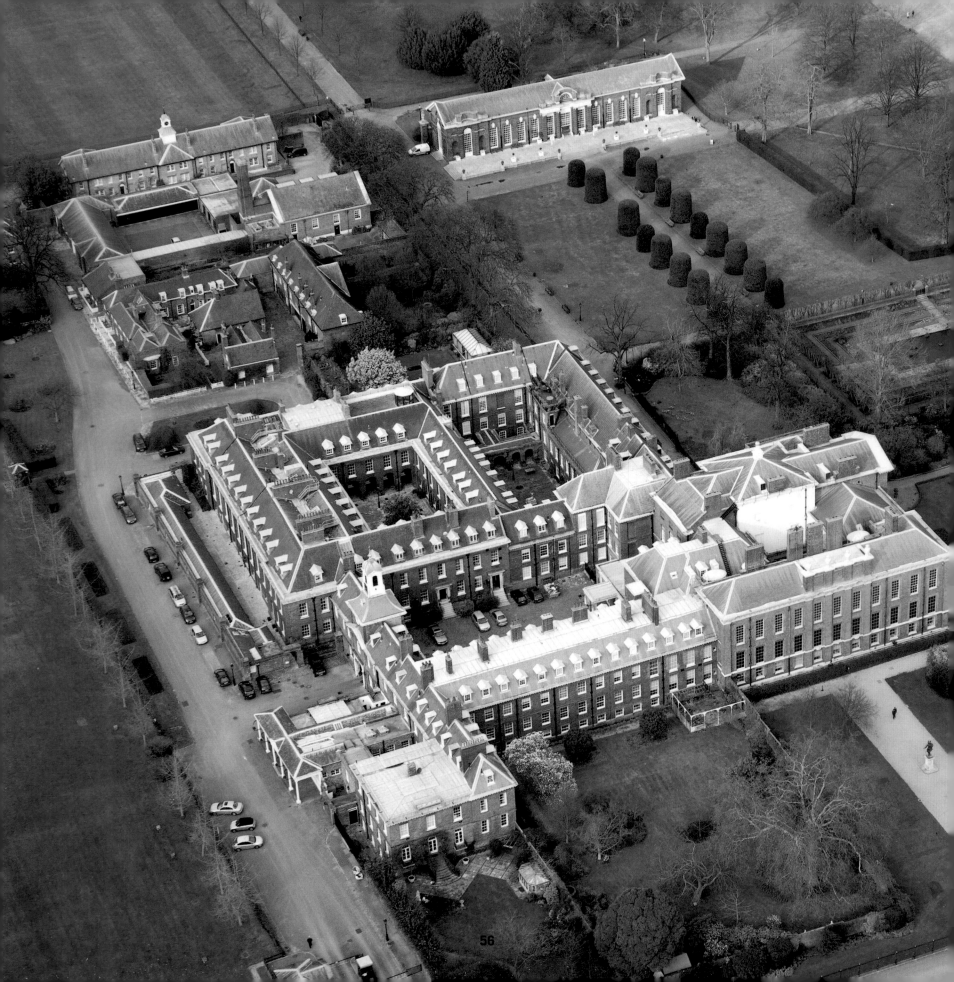

56

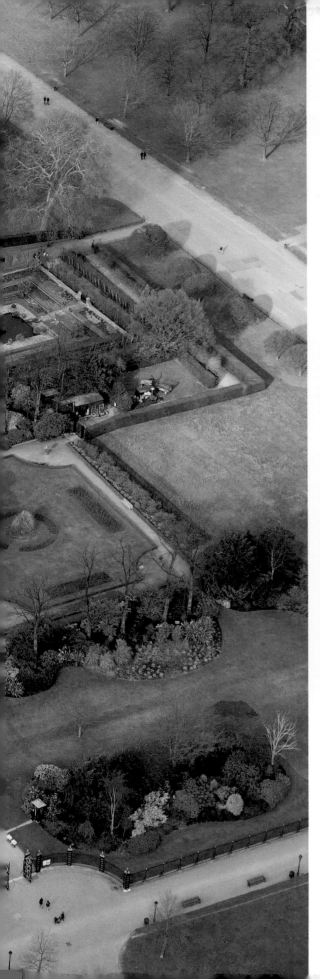

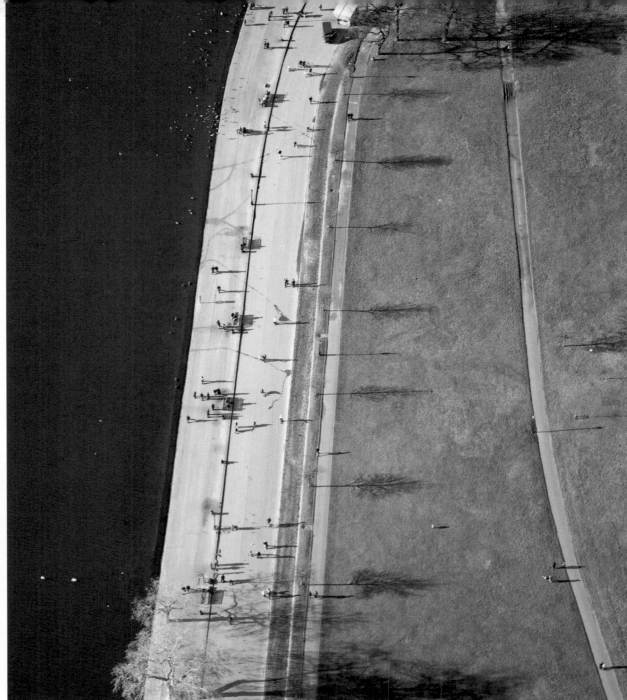

< **LEFT**
Kensington Palace

Most famous recently as the home of the late Diana, Princess of Wales, Kensington Palace goes back to the late 17th century when Kensington was a village well away from the centre of London life. King William III had the Palace built as he suffered from asthma and wanted a fresh-air retreat from a London which, even back then, was a smoky and unhealthy place to live.

^ **ABOVE**
Footpaths along the Serpentine, Hyde Park

The sinuous Serpentine Lake in Hyde Park is a popular spot for Londoners and visitors to enjoy the sunshine. As well as swimming and boating, there are two restaurants by the lake, the Serpentine Gallery and, since 2004, the Diana, Princess of Wales Memorial Fountain – not far from the Princess's former home in Kensington Palace (opposite).

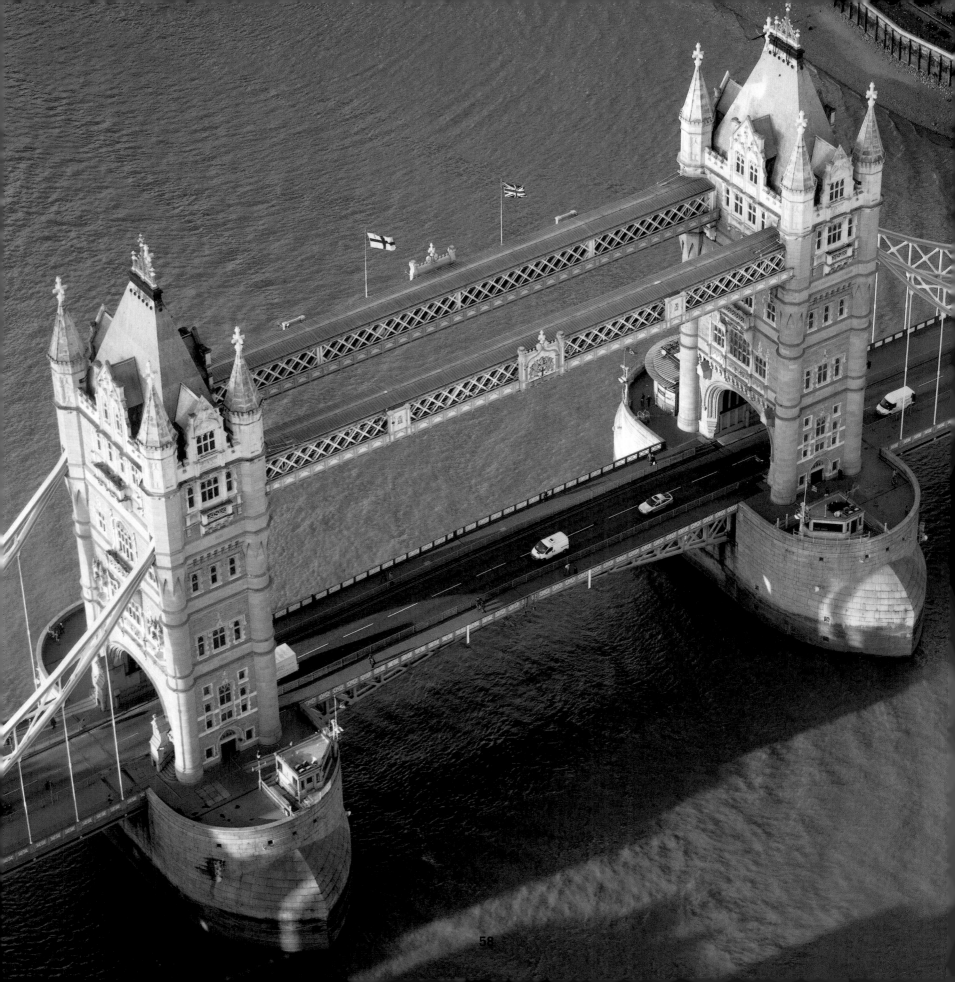

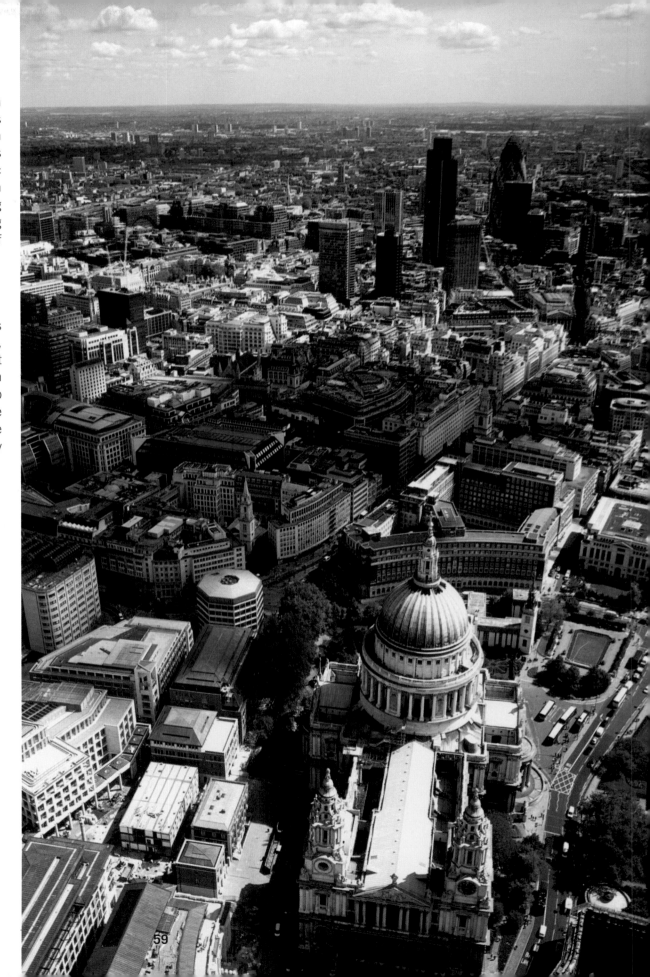

< **OPPOSITE**

Tower Bridge

London's Tower Bridge has become, like Big Ben and the London bus, one of the city's symbols. Its Neo-Gothic design is the result of a competition held to find a new bridge to connect the two banks of the Thames, without impeding river traffic getting to the port at the Pool of London, which was just upstream from the required crossing point near the Tower of London. The striking solution was opened in 1894 after eight years of construction work.

> **RIGHT**

St Paul's Cathedral and City of London

St Paul's Cathedral seems to look warily towards the towers of office blocks in the City of London, as if knowing that the modern world worships not God, but wealth. When it was built in the 17th century, probably the fifth St Paul's Cathedral to go up on the same site, the building would have dominated the skyline, as well as the lives of the people of London. It celebrates its 300th birthday on 20 October 2008.

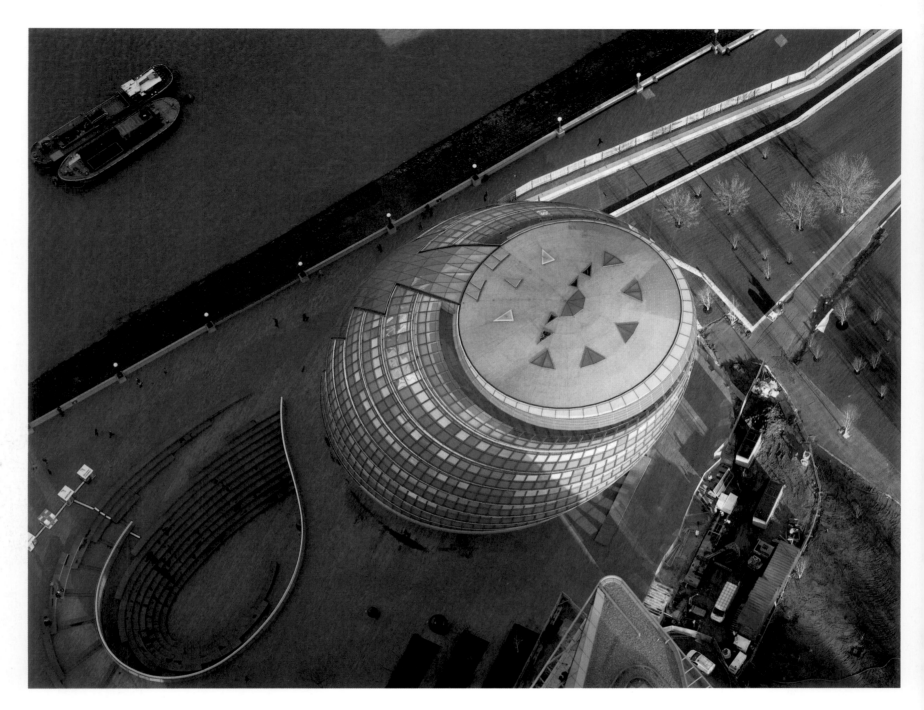

^ ABOVE
GLA building on the South Bank

London's City Hall, home to the Mayor of London, the London Assembly and the Greater London Authority, is perhaps even more striking from the air than from the ground. It looks like a stack of coins about to slide over, and has been more unkindly dubbed the Leaning Tower of Pizzas. In fact its clever design reduces its overall surface area and enables it to run on a quarter of the energy of a comparable square office building.

> OPPOSITE
Tate Modern

London's latest major art museum to open, Tate Modern is housed in the former Bankside Power Station. Its imposing scale has been used to great effect, with some equally imposing modern art installations. It stands on the south bank of the River Thames, connected to the north side by the Millennium Bridge, the city's most recent river crossing. This footbridge famously wobbled when first opened, but it has since been stabilised.

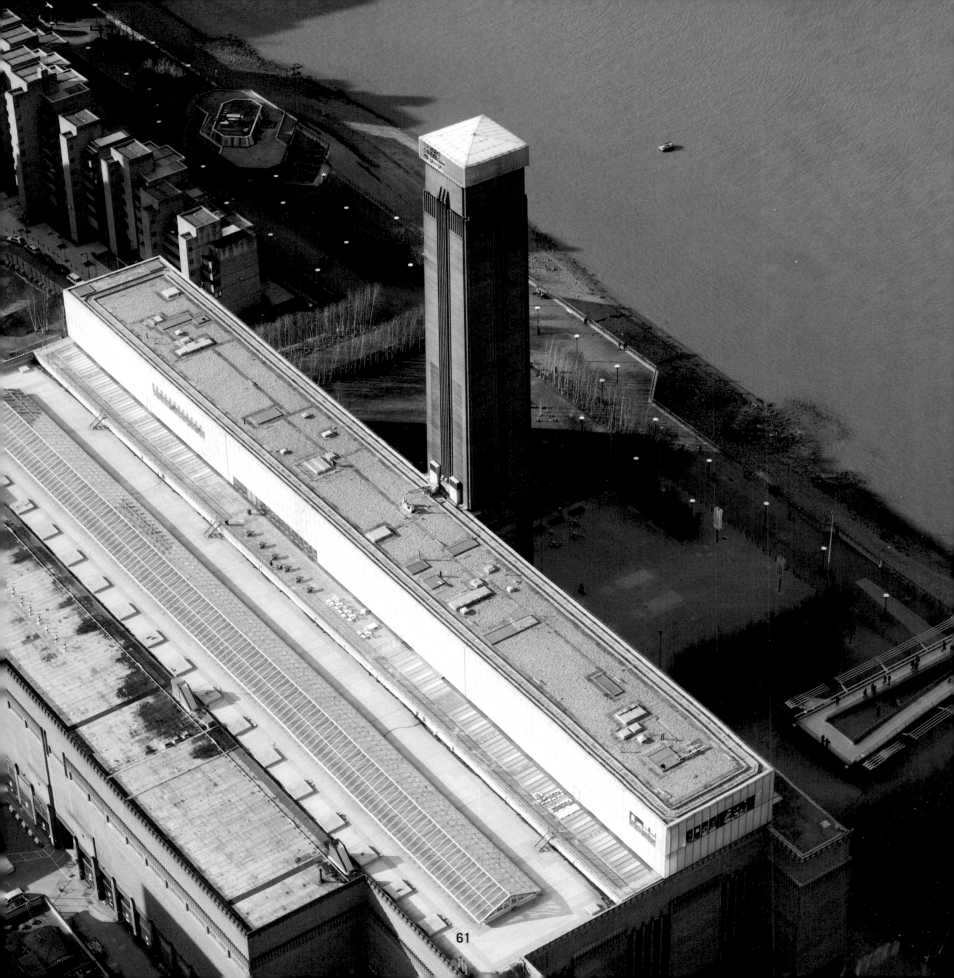

Houses of Parliament, Westminster Abbey and the Cabinet War Rooms

The Palace of Westminster, home to the two Houses of British Government, the Commons and the Lords, has not been a royal palace since the 16th century. Most of the buildings date from the 19th century, when it was rebuilt after a disastrous fire, but the oldest part, Westminster Hall, goes back to 1097. The adjacent Westminster Abbey is even older, and is where the coronation of every British monarch has taken place since 1066.

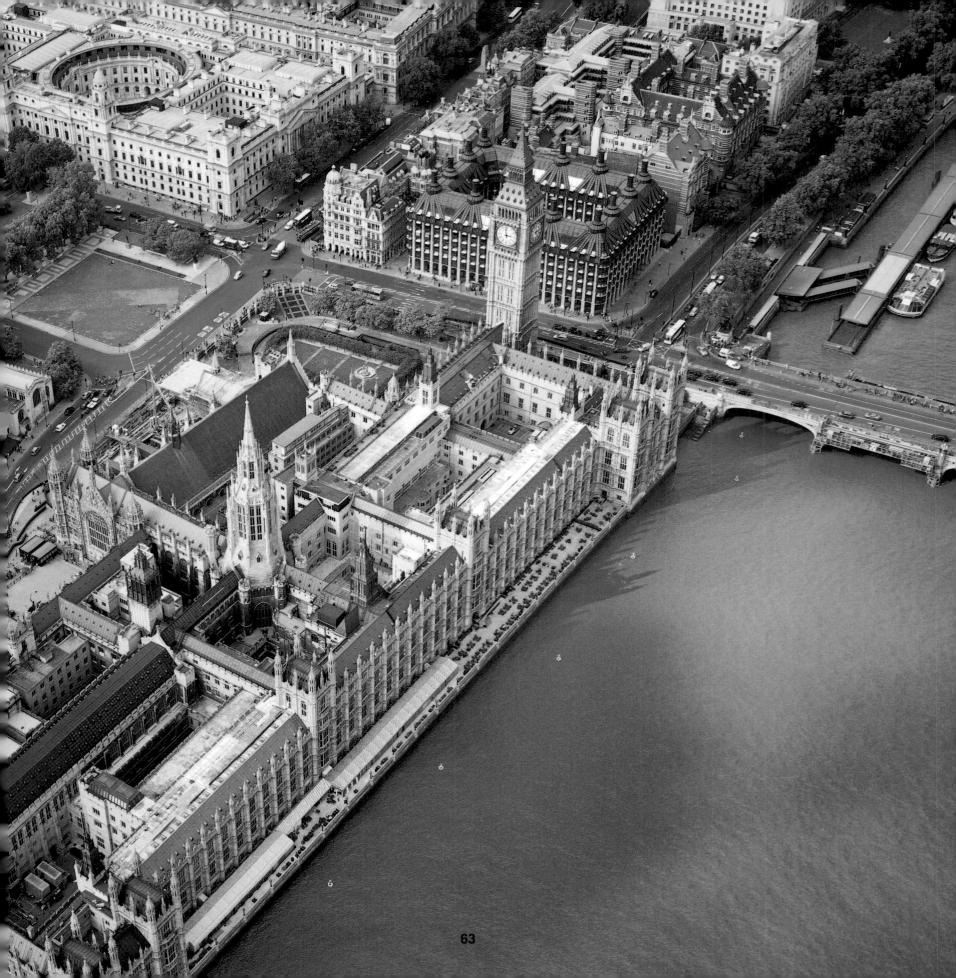

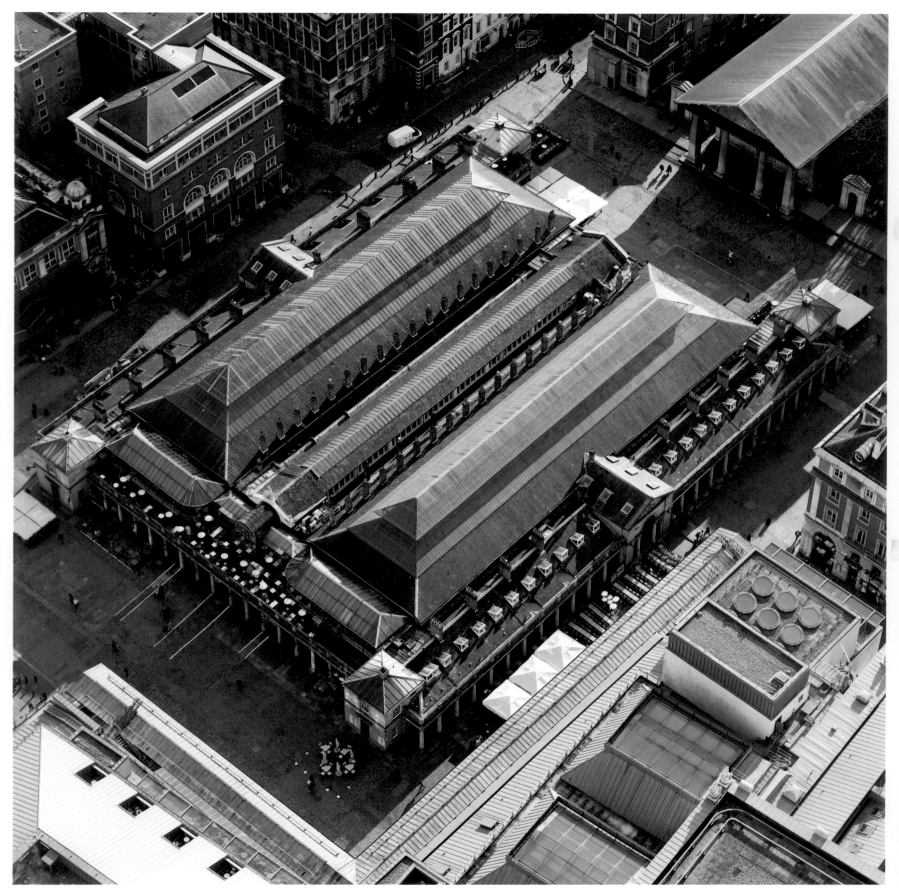

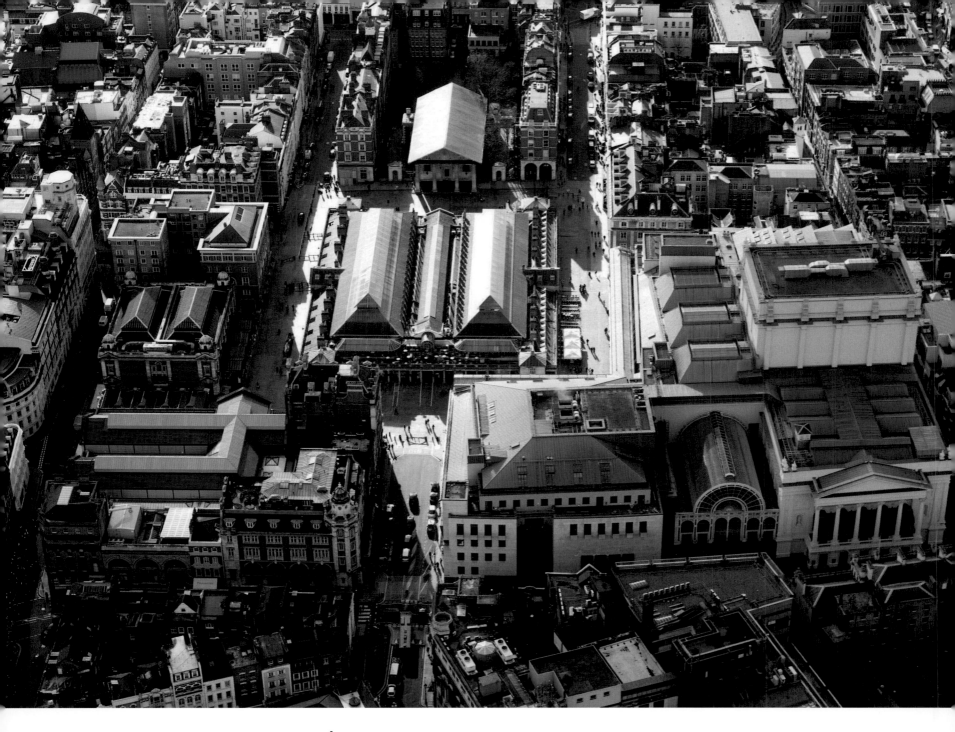

< OPPOSITE

Covent Garden Market

Many visitors who come to see the shops, buskers and eating places around Covent Garden know that this area was once the home of the bustling central fruit and vegetable market for London, until it was moved out to Nine Elms in 1974. Fewer know that its original name was actually Convent Garden, as since the 13th century it had been the site of a huge 40-acre kitchen garden for the Convent of St Peter, in Westminster.

^ ABOVE

The Royal Opera House and Covent Garden Market

London's Royal Opera House is often called simply Covent Garden, from its location, and perhaps from the long belief of opera-goers that there could be no other good reason for going to Covent Garden than to go to the opera. Its history goes back to 1660 when King Charles II granted permission for a royal theatre to be built here, and the present opera house is the third building to occupy the site.

VILLAGE LONDON

From the air, London looks like one great, sprawling metropolis. But go underground and you'll find a different story. As you ride the tube, many of the stations you pass through are named for separate villages that stood there before they were swallowed up into the expanding city.

In some parts of London, village origins are still evident in both appearance and atmosphere. The best-known is Hampstead, famous for its literary and artistic connections. This north London suburb grew from a quiet village into a fashionable spa when healing waters were discovered in the springs here around 1700. Flask Walk and Well Walk were named during that heyday in the 18th century.

Many writers, artists and intellectuals lived in Hampstead over the decades, including John Keats, John Constable, Karl Marx, George Orwell and Sigmund Freud. They established a bohemian community here in the late 19th century. Today the well-kept Georgian houses, sloping streets and winding lanes preserve the village ambience, which is enhanced by the natural landscape of Hampstead Heath on its doorstep. These days, though, village living comes at a high price and current residents include many wealthy actors and rock stars.

Several southwest London suburbs also have village-like atmospheres, at least in part. Richmond, with its historic buildings set around Richmond Green, leafy streets, riverside walks and vast parkland, is one of the most appealing parts of the capital. Other attractive pockets can be found around Ferry Lane at Kew, along Chiswick Mall and in Twickenham.

The strongest sense of London as a collection of villages comes not from its architecture but from its people. Countless immigrants have settled in the city over the years. According to the 2001 census, 30 percent of London residents – some 2.2 million people – were born abroad. There are more than 50 separate ethnic groups numbering 10,000 or more. More than 300 languages are spoken, and it's likely that every race on earth is represented in the capital. Ethnic minorities make up 40 percent of the city's population. Although dispersed throughout the city, there are distinct communities with strong cultural roots. These are some of London's most vibrant areas. From food to fashion to music and the arts, these global villages have added much to the rich tapestry of life in the city.

A prime example is Brick Lane, which runs through the heart of Spitalfields in East London. The area blossomed in the late 17th century when Huguenot refugees fled here to escape religious persecution in France and established their traditional crafts of silk weaving and furniture making. Irish immigrants, then Jewish refugees from Russia and Poland, followed in the 19th century, bringing their skills as tailors, furriers and leather workers. Today the area is a centre for London's Pakistani and Bengali residents, as well as the largest community of Bangladeshis outside Bangladesh. Their culture is so predominant that a few years ago the neighbourhood around Brick Lane was officially re-christened Bangla Town, and even the street signs are bi-lingual. On the corner of Brick Lane and Fournier Street is a building that sums up Spitalfields' changing character. Built as a Huguenot chapel in 1743, it later served as a Methodist church, a synogogue, and is now the Jamme Masjid mosque.

Shop windows sport brightly coloured bolts of fabric for the wholesale trade, and there are bustling street markets. Brick Lane is famous for its curry houses, with more than 40 Bangladeshi, Pakistani and regional Indian restaurants concentrated here and on the side streets. With specialist ingredients flown in every day, you can try exotic dishes that you won't find anywhere else in Britain.

Thanks to London's diverse population, you can eat your way around the world without ever leaving the city. You can have *pide* (Turkish pizza) in Green Lanes, *arepas* (Colombian corn bread) at Elephant and Castle, and find anything from huge snails and calves' feet to *cassava* and *dasheens* at Hackney's wonderful Ridley Road market.

Another great concentration of Indian restaurants and shops lies along the Uxbridge Road in Southall, where most of the residents come from the sub-continent. Stockwell claims the largest Portuguese community outside Portugal. There are Congolese neighbourhoods in Tottenham, Somalis in Wembley and a Little Vietnam area of Hackney.

Every Londoner has their favourite Chinese restaurant from among the dozens of tiny establishments packed in and around Gerrard Street in Soho. Though pagoda-style gateways and exotic grocers mark this colourful street as London's Chinatown, in fact the city's 60,000 Chinese residents are widely dispersed and few live here now. The city's first Chinese community came on trading ships from the Far East in the late 1700s and settled in the Docklands around Limehouse. Declines in the shipping industry and the bombing of World War II spurred the move to the West End.

Soho is another area that has sheltered refugees, from the 18th-century Huguenots and Jews to Italians and Greeks fleeing poverty and persecution in 19th- and 20th-century Europe. This legacy survives in place names such as Greek Street. Here you'll find authentic Italian delis, Spanish wine shops, French patisseries and an Algerian coffee store.

Italian immigrants made a big impact on London. Their first village was Clerkenwell, which by the early 20th century had a population of 10,000. Remnants of it remain in traditional food shops, cafes and churches around Exmouth Market. But it was the second wave of southern Italians, who settled in Soho in the 1950s and 60s, which brought a stylish, European air to the city with espresso bars and pasta houses.

The Jewish community also put down early roots in Clerkenwell and founded London's diamond trade district in Hatton Garden. Many Jews fled to London in the 1930s and 40s to escape the Nazi threat in Europe. Golders Green in north London has been a prominent and prosperous Jewish area since the early 1900s, though it is now home to other nationalities. Meanwhile East London's Stamford Hill has the largest community of Hasidic (Orthodox) Jews in Europe.

True London Cockneys are said to be born within the sound of the bells of St-Mary-le-Bow church in Cheapside. But the tight-knit, working-class communities of the East End were devastated by the Blitz and after the war large areas went into decline. Today many traditional Eastenders have moved out into the eastern suburbs.

From 1948, when the first boatload of West Indian workers arrived, immigrants have come to London from Commonwealth countries in the Caribbean and Africa. Communities have grown up in Clapham and Brixton in south London, Hackney in the east and Notting Hill in the west. But London is always changing. Notting Hill, once run-down and edgy, is now home to celebrities. One great legacy of its Afro-Caribbean community remains: the Notting Hill Carnival, held each year in August, with spectacular costumes, parades, steel bands, food stalls and music. It is the second-largest street carnival in the world, after Rio de Janeiro.

From the Notting Hill Carnival to Chinese New Year and other annual events, all London turns out to celebrate its great, global village.

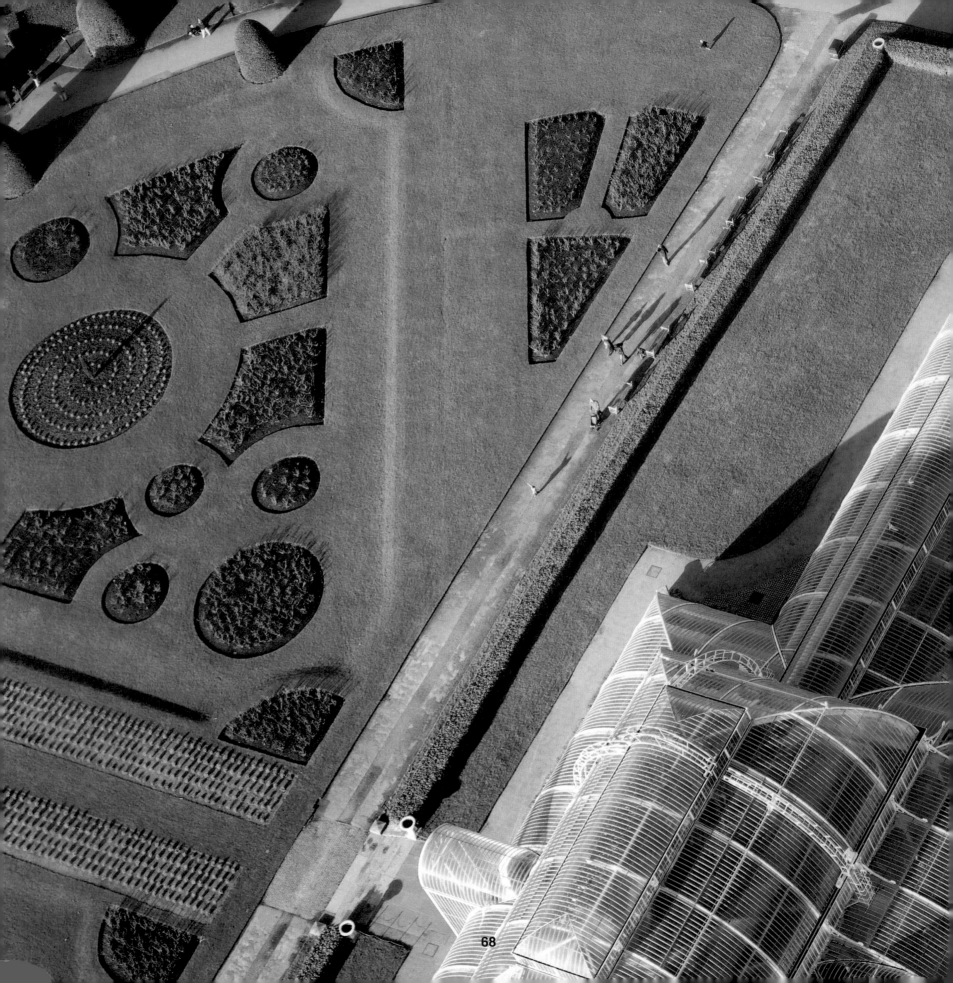

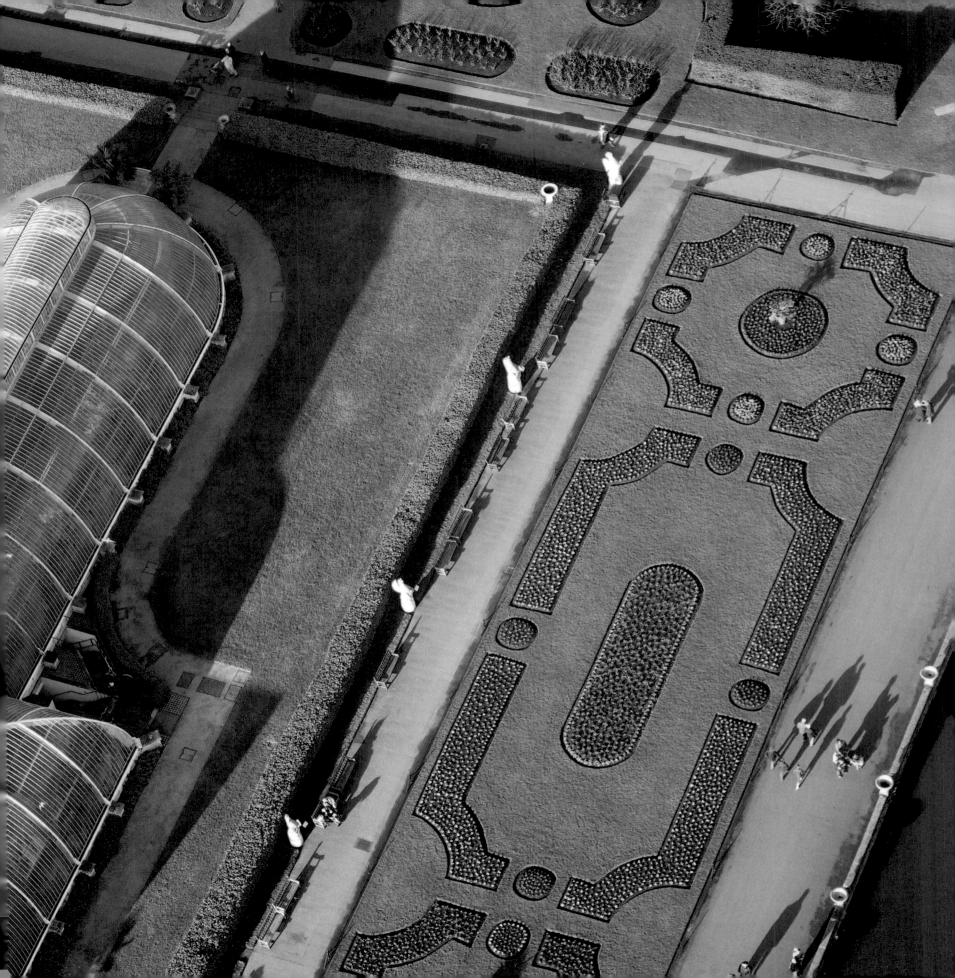

« PREVIOUS
Kew Gardens

One of the glories of the Royal Botanic Gardens at Kew is the magnificent Palm House, built 1844-48. It was designed to be at the very centre of Kew, an eye-catching building created to house the huge exotic palms that were being brought to Britain from all over the world in Victorian times. The Palm House remains the most important Victorian glass and iron building in the world.

^ ABOVE
Brixton Road, Coldharbour Lane, looking south to Brockwell Park

The sun never really sets on Brixton, in south London, as its pubs and clubs (official and unofficial) buzz on into the night. The late-night party people overlap with the early arrivals at Brixton Market, one of London's liveliest street markets, made all the more vibrant because it is in the heart of London's Caribbean and African communities. The reality of Brixton life for many is shown by the vast housing estate in the foreground, just one of many in the area.

> OPPOSITE
Central Markets, Smithfields

The reason there's a meat market right in the middle of London at Smithfields is because it has been here for over 800 years, when it was outside the city and its name was Smooth Fields. Meat has been traded here since then, and it is one of the oldest recorded markets in London and the largest meat market in the British Isles. The market has a stylish roof, but what cannot be seen is the network of tunnels below ground through which the cattle and other animals were originally brought into the market hall.

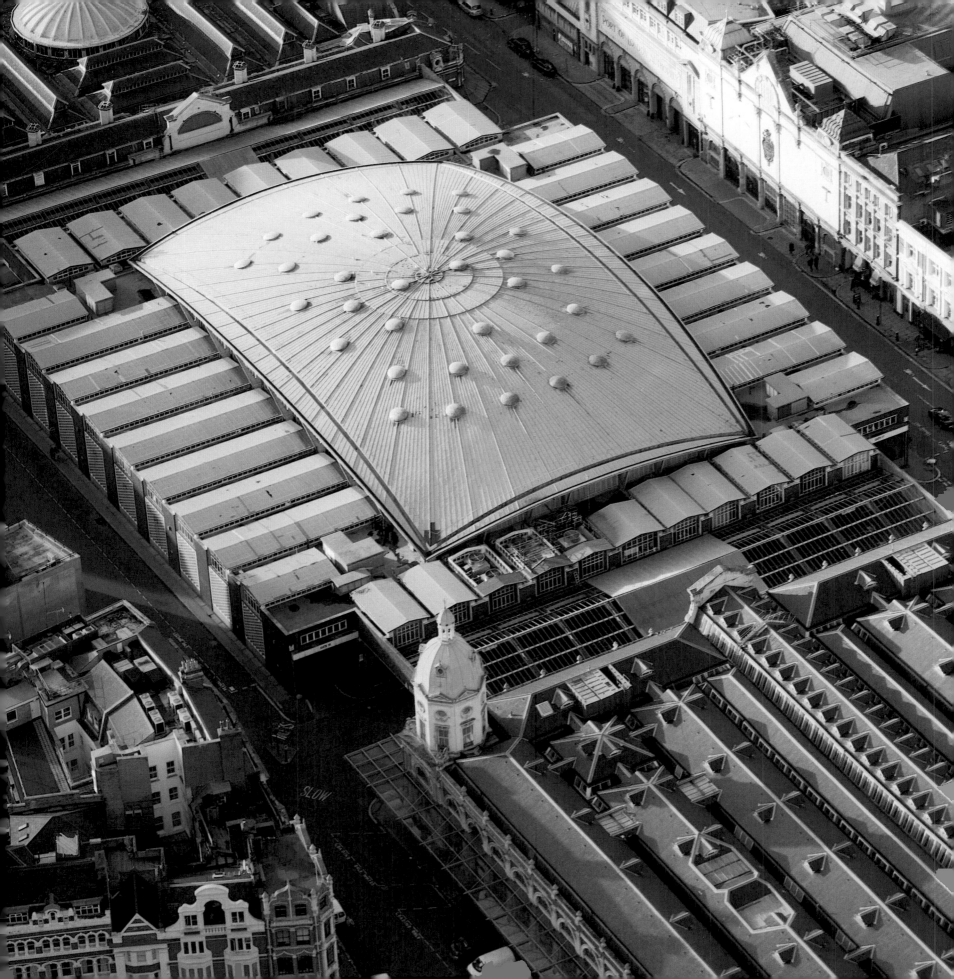

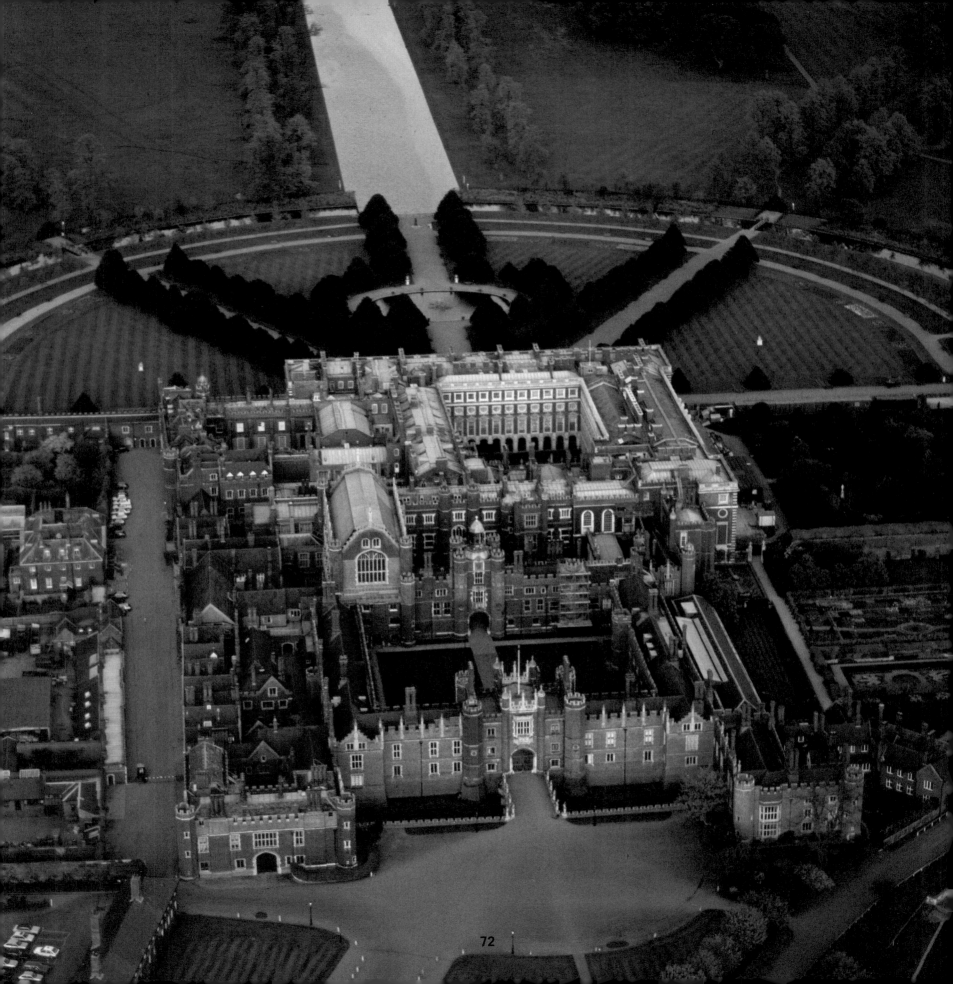

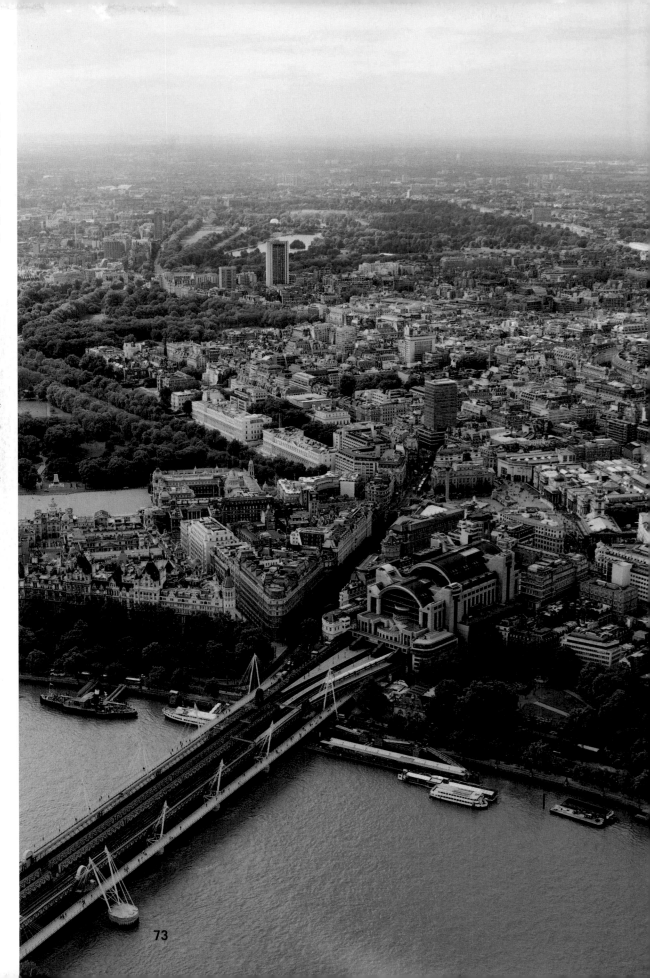

< OPPOSITE
Hampton Court, Surrey
Begun in 1516 by Henry VIII's Lord Chancellor, Cardinal Wolsey, Hampton Court Palace eventually became the finest royal palace in the country. It remains staggeringly impressive, as this atmospheric sunset shot makes clear, but it was originally even more so. The Great Gatehouse, visible in the lower centre of the photograph, was twice as high when Wolsey first built it. Nor does this photo reveal the 669 acres of the Palace Gardens, with its famous maze.

> RIGHT
Charing Cross Station and Embankment
Charing Cross Station covers the site of the old Hungerford Market which stood here in Victorian times. Then, the embankment was lined with run-down factories and rat-infested workshops. One of these, Warren's Blacking Factory, was where Charles Dickens was sent to work at the age of 12, labelling jars of boot polish to earn money to support the family while his father was in prison. He re-created it as a scene in *David Copperfield*. Now the pleasant Embankment Gardens have replaced the site of Dickens' childhood misery.

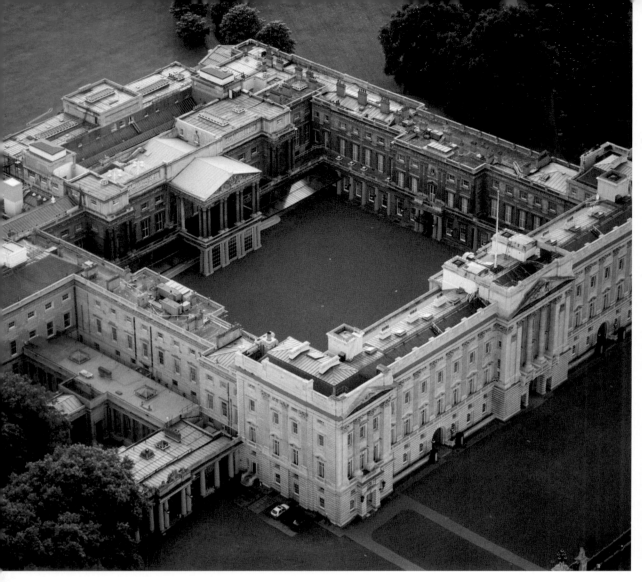

^ **ABOVE**
Buckingham Palace
It isn't very often mentioned that Buckingham Palace was once a brothel – or at least was built on the site of one of London's most notorious houses of ill-repute, to be precise about it. The Palace dates back to 1702 and gets its name from the fact that it was first the city home of the Duke of Buckingham. It was bought by King George III in 1761 as a home for his wife, Queen Charlotte, but only became the official residence of the British royal family in 1837 when Victoria came to the throne, and decided she wanted a new home.

> **OPPOSITE**
Victoria, Buckingham Palace and St James's Park
From the air it can be seen that London is still very much a green city in places, with Hyde Park to the left, Green Park in the centre behind Buckingham Palace, and the barely visible beginnings of St James's Park in the bottom right of the picture. London's eight royal parks cover, in total, an area of about 5,500 acres.

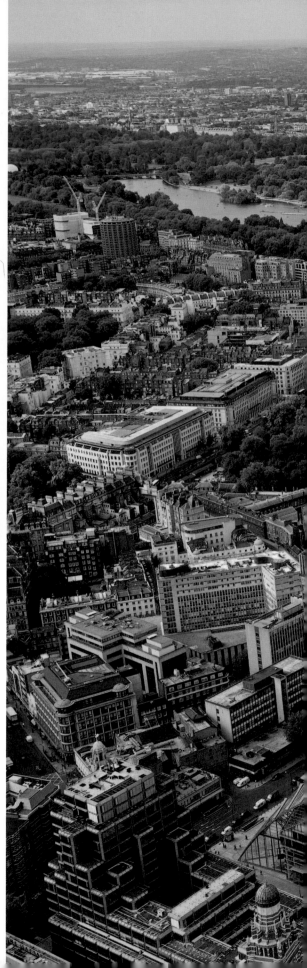

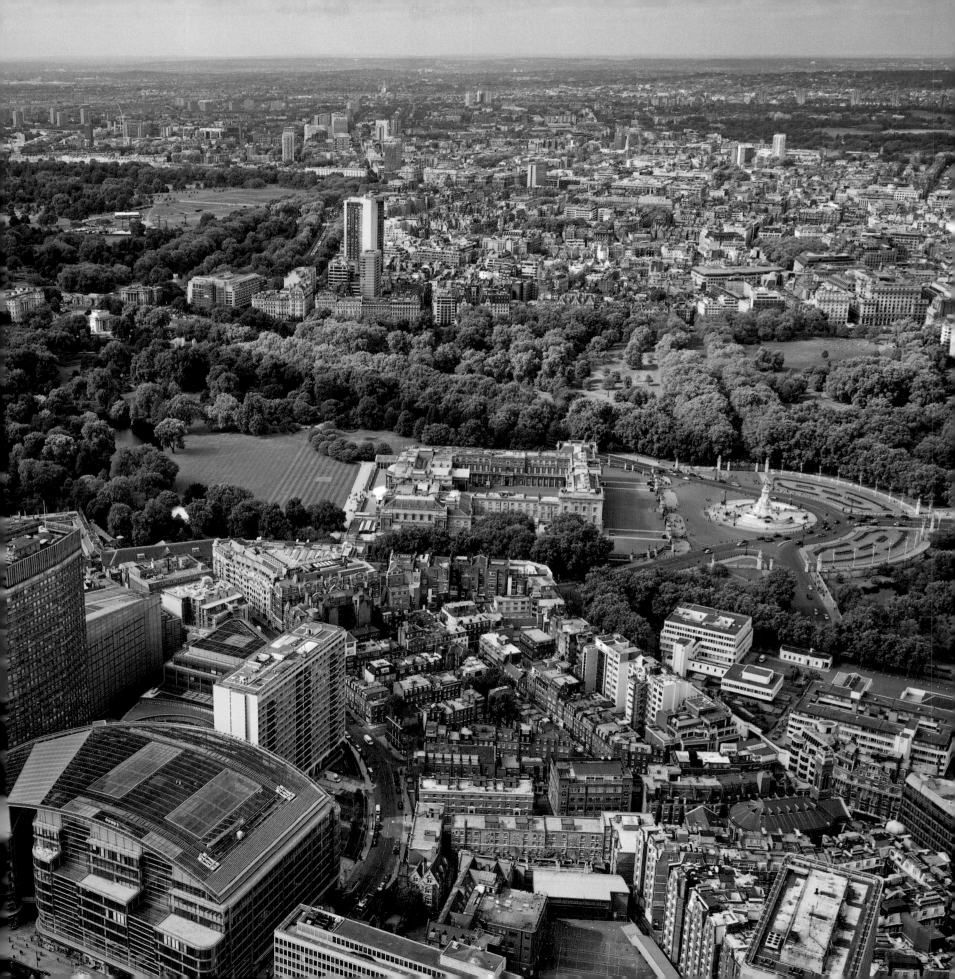

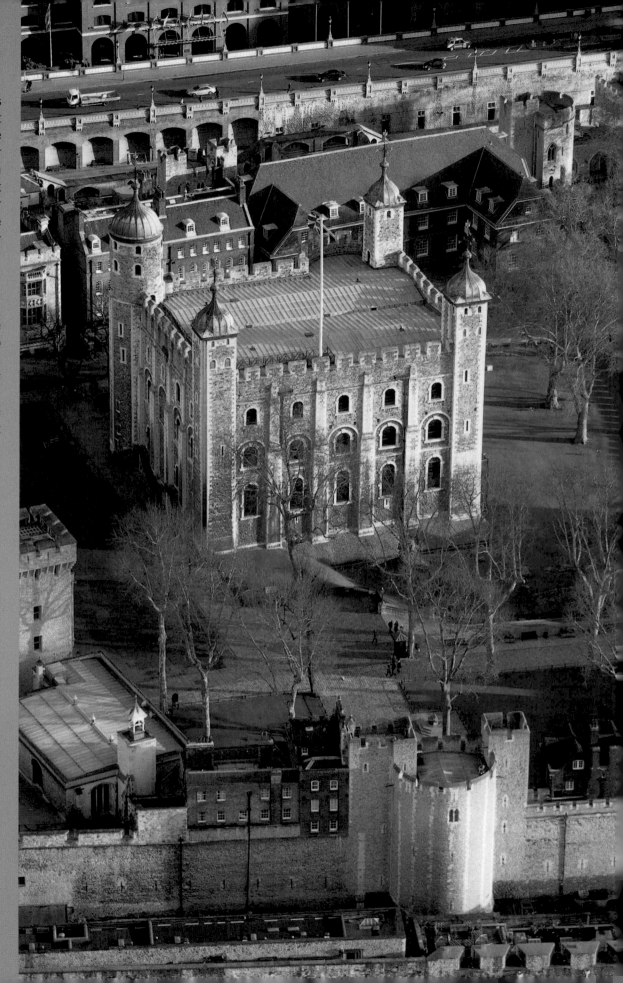

> RIGHT

Tower of London

The White Tower, which dominates this image, is only a part of the Tower of London complex, but probably its most familiar building. It is also the kind of historical building which goes back so far that it makes visitors gasp. It was begun by William the Conqueror and finished by his sons in about 1087, and used as a watch tower to look out over what was happening in the City of London. The building as you see it today has looked more or less the same for the last 700 years.

> OPPOSITE

National Theatre on the South Bank

In contrast to the ancient Tower of London, the city's National Theatre goes back all the way to 1976, when the first of its several theatres and concert halls was opened. Its hard and angular urban style has been much criticised, though behind those roofs and walls is a much more welcoming place where some of London's finest plays are produced.

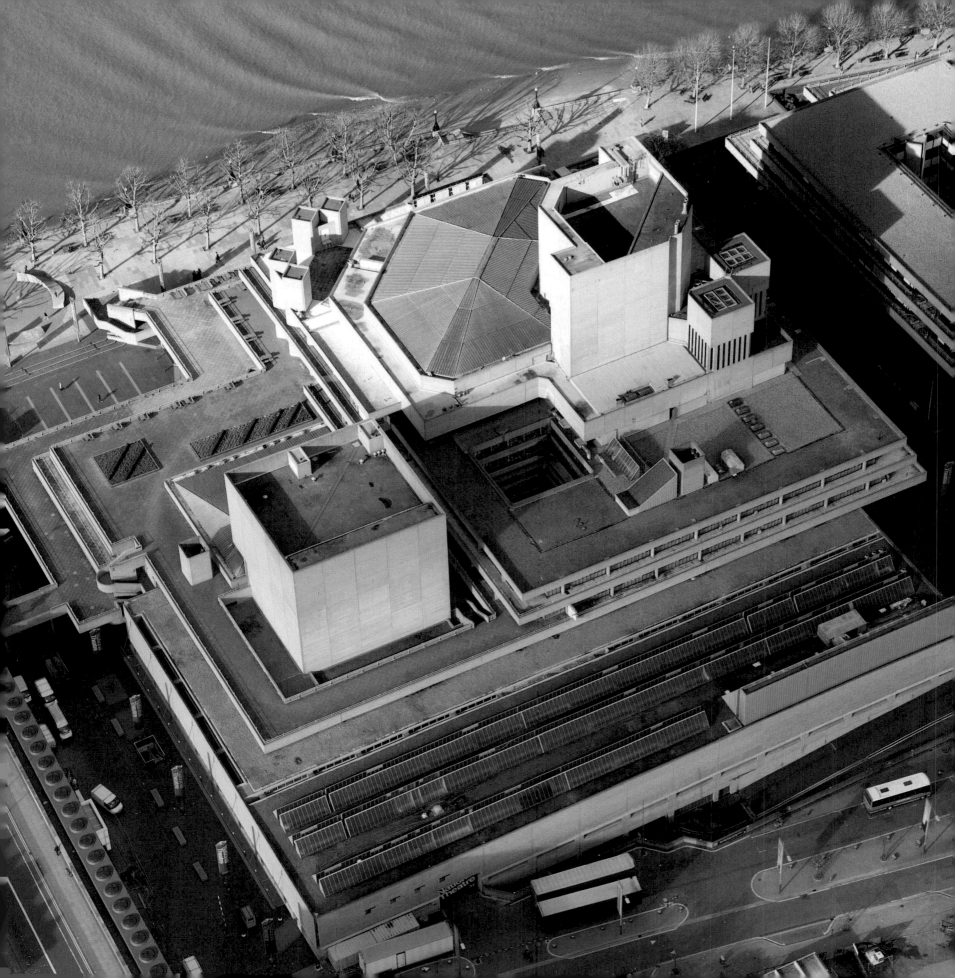

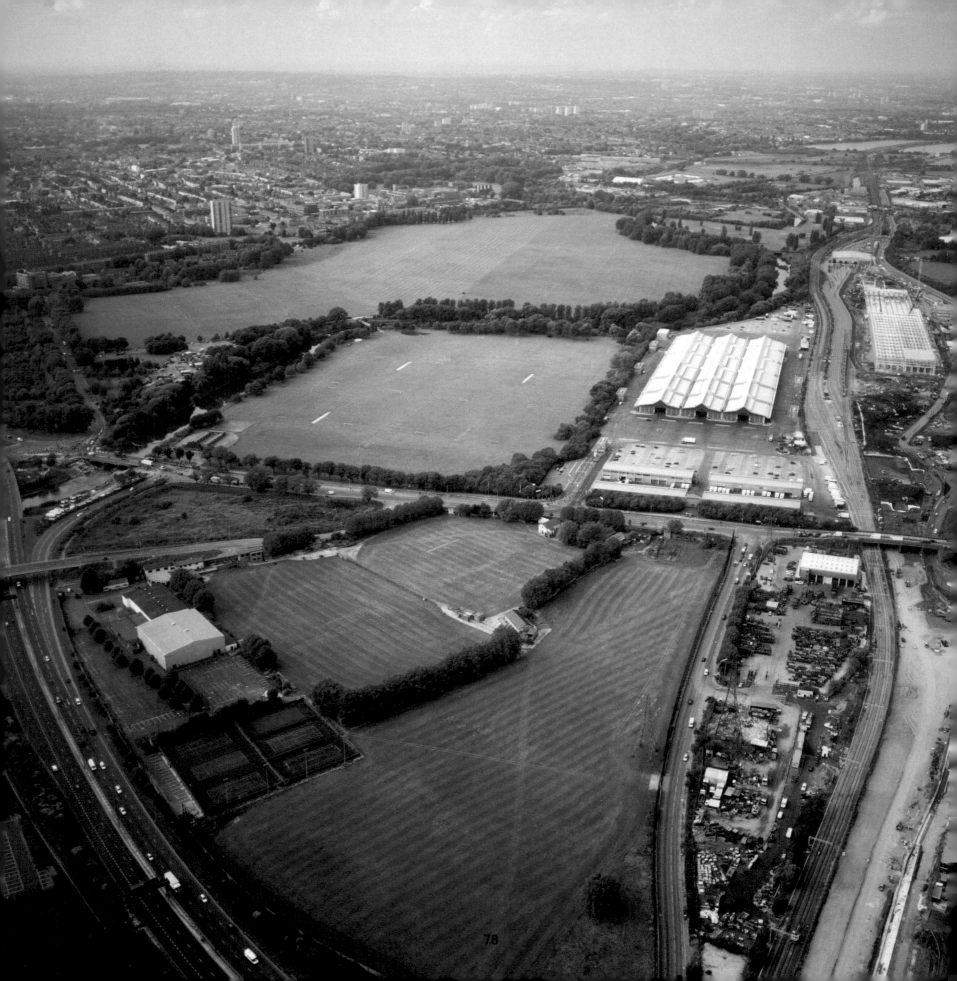

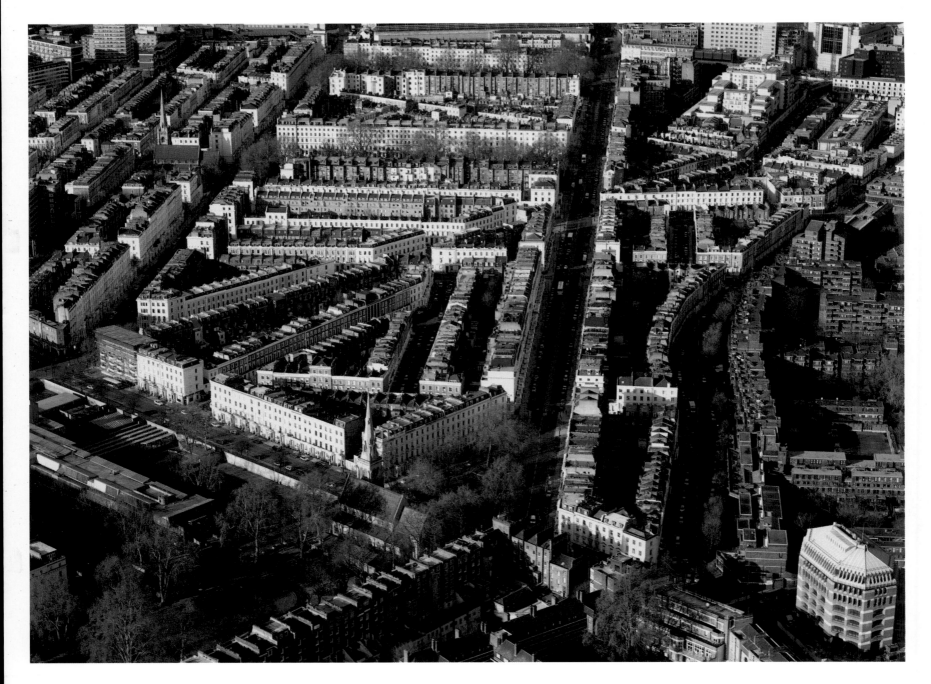

< OPPOSITE
Temple Mills and the area for re-development for 2012 Olympic Games

This landscape at Temple Mills, in Stratford, East London, is about to undergo a fabulous and very expensive transformation as work continues on building the Olympic Park for the 2012 Summer Olympics to be held in London. The finished product is bound to seem a very long way from the old water mills that were owned by the Knights Templar, which gave this part of rural England its name in medieval times.

^ ABOVE
Pimlico

Pimlico, which lies between Buckingham Palace and the River Thames, remains a rather secretive corner of London. Few guidebooks to the city even mention it, as there are no major sights to see, and no-one even knows for sure where its name comes from. It's full of fine houses and the homes of ordinary Londoners, though some extraordinary people including Sir Winston Churchill, Sir Laurence Olivier and novelist Joseph Conrad have lived in these streets.

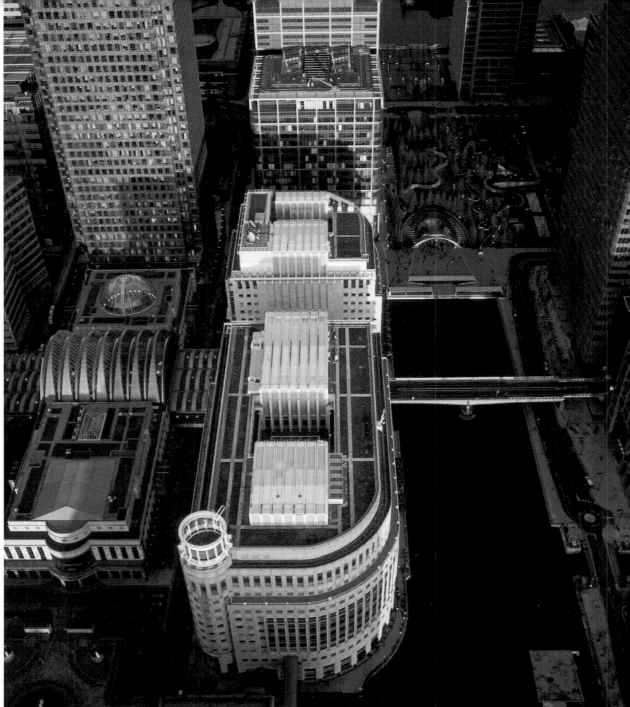

< LEFT
Millennium Dome
Although it is now officially known as The O2, to Londoners this will forever be known as the Millennium Dome. Built to house a spectacular and costly exhibition to celebrate the Millennium, the Dome became a cause of controversy as it lay empty and in debt. It has at last found new life as a sports arena and concert hall, and hub of a new nightlife and entertainment area of London.

^ ABOVE
Canary Wharf
The drama of the Canary Wharf development is captured here by the camera, showcasing the modern architecture which transformed this part of East London. Where once boats came and went to places like the West Indies and the Canary Islands, now the three tallest buildings in Britain mark an area that has become an alternative business centre to the City of London.

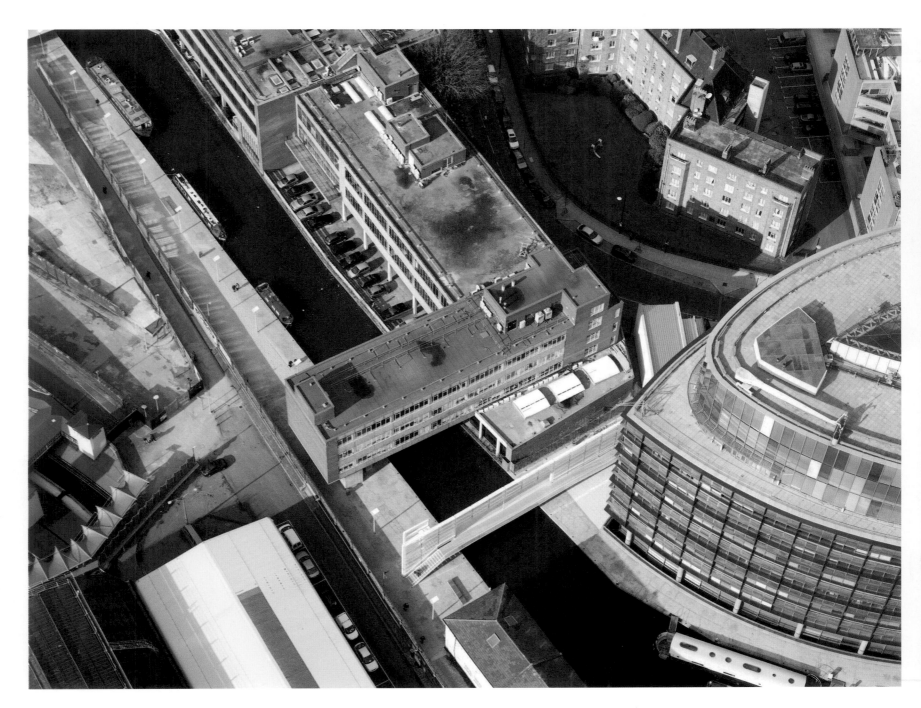

^ ABOVE
Paddington Basin
Not many London residents know much about the
waterways of the city, the rivers and canals that
weave behind buildings and have their own world.
The Paddington Basin here is one end of the Grand
Junction Canal, a major engineering project in the
late 18th and early 19th centuries which linked
several parts of London with England's second
city, Birmingham, over 100 miles away.

> OPPOSITE
Boats at the ExCel Exhibition Centre
The Royal Victoria Dock in East London's
Docklands once welcomed the world's biggest
steamships, but after closing in 1981 it was later
redeveloped into the ExCel Exhibition Centre.
Leisure craft can still tie up right alongside the
Centre, making it an ideal venue for the annual
London Boat Show and other major exhibitions.
The waterways remain alive, but changing.

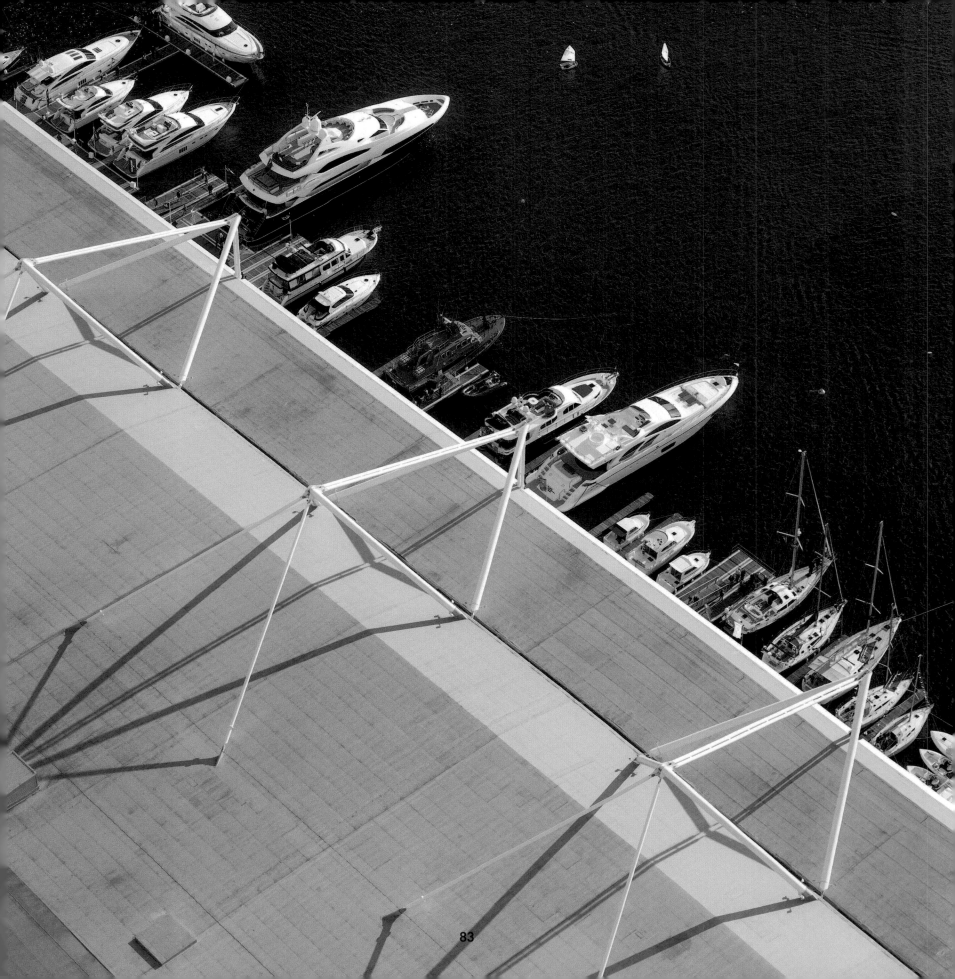

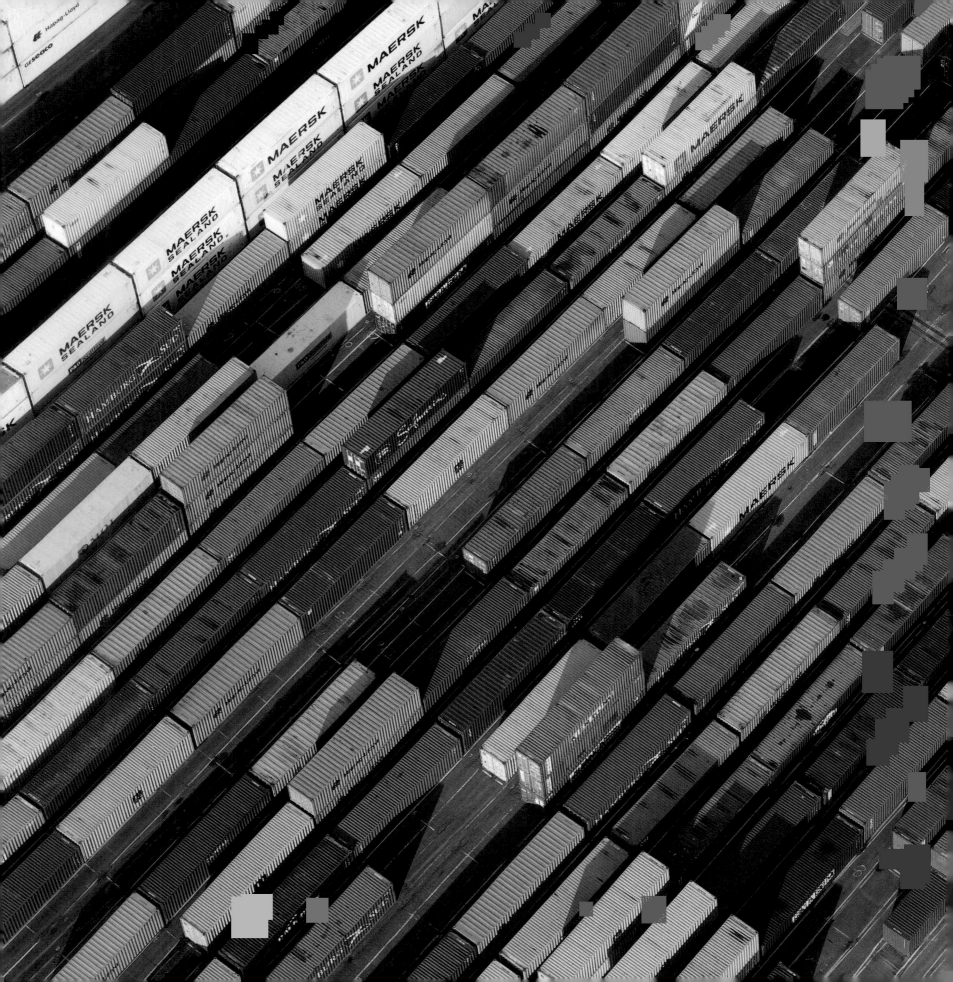

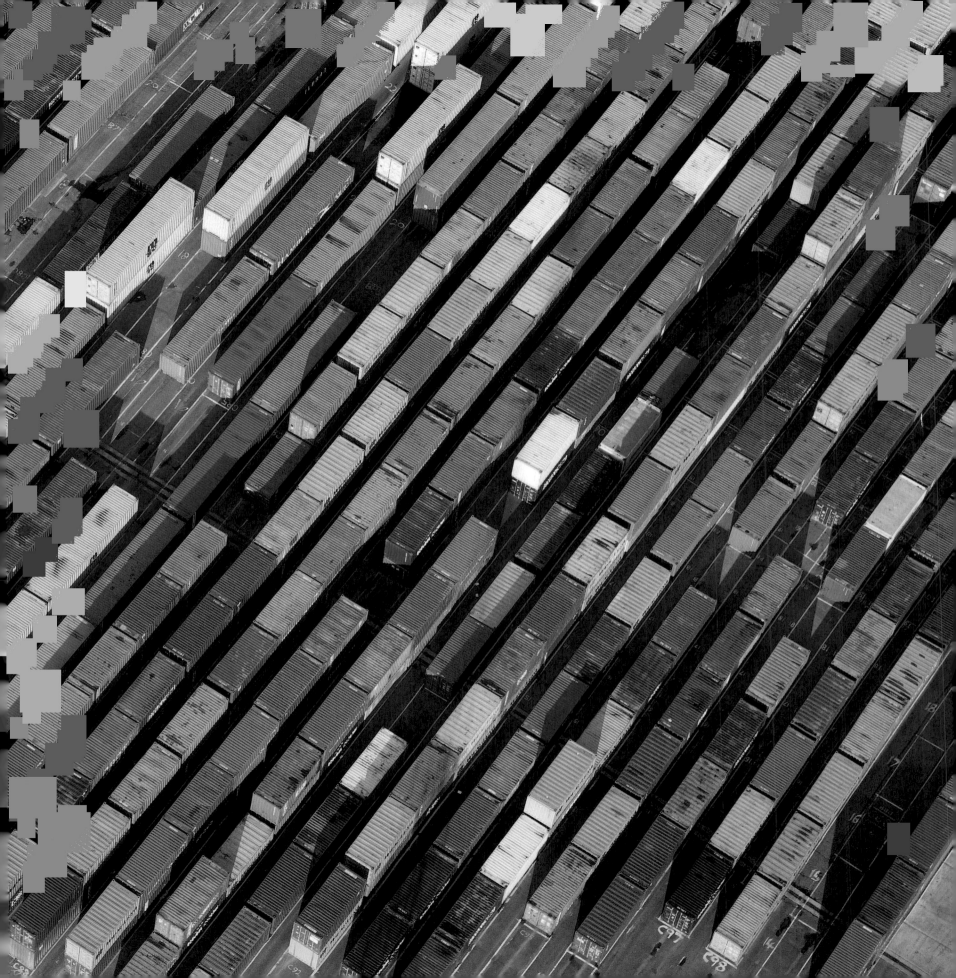

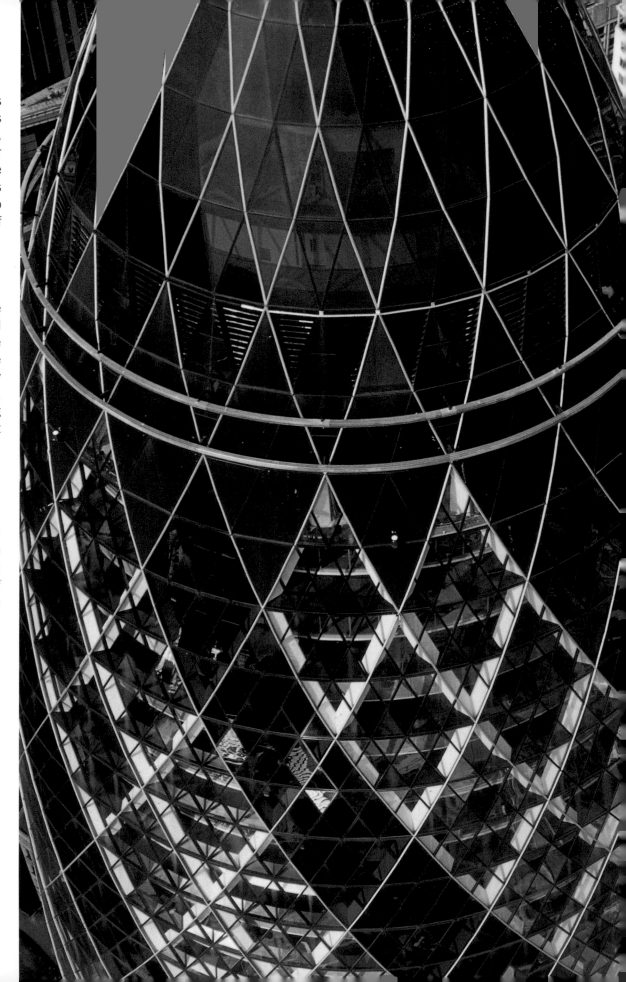

« PREVIOUS
Container port, Tilbury Docks

By the 1930s Tilbury Docks had become famous for the grain trade, with ships of 50,000 tons regularly unloading here. A new grain terminal, added in 1969, could discharge 2000 tons per hour – one of the fastest such operations in the world. Further improvements created deep berths for large container ships, whose bright cargo sprawls across the docks, creating a work of abstract art when seen from above.

> RIGHT
Swiss Re Tower (the Gherkin)

Ask most Londoners (taxi drivers aside) where 30 St Mary Axe is and they probably couldn't tell you. The building's former name as the Swiss Re Tower is perhaps slightly better known. Call it the Gherkin and they will know it instantly. Originally nicknamed 'the erotic gherkin' by a newspaper, before it was even built, Lord Foster's astonishing futuristic design instantly became London's latest icon when it opened in 2004.

> OPPOSITE
Tower 42, Swiss Re Tower, Bank, Mansion House, Bank, City of London and Tower Bridge

The modern skyline of the City of London, with buildings like Tower 42 and the Gherkin, are painted pink by the setting sun. Yet old London will never be totally lost, as the graceful shape of Tower Bridge still spans the River Thames, while just upstream HMS *Belfast* is now a museum, after taking part in the battles of World War II.

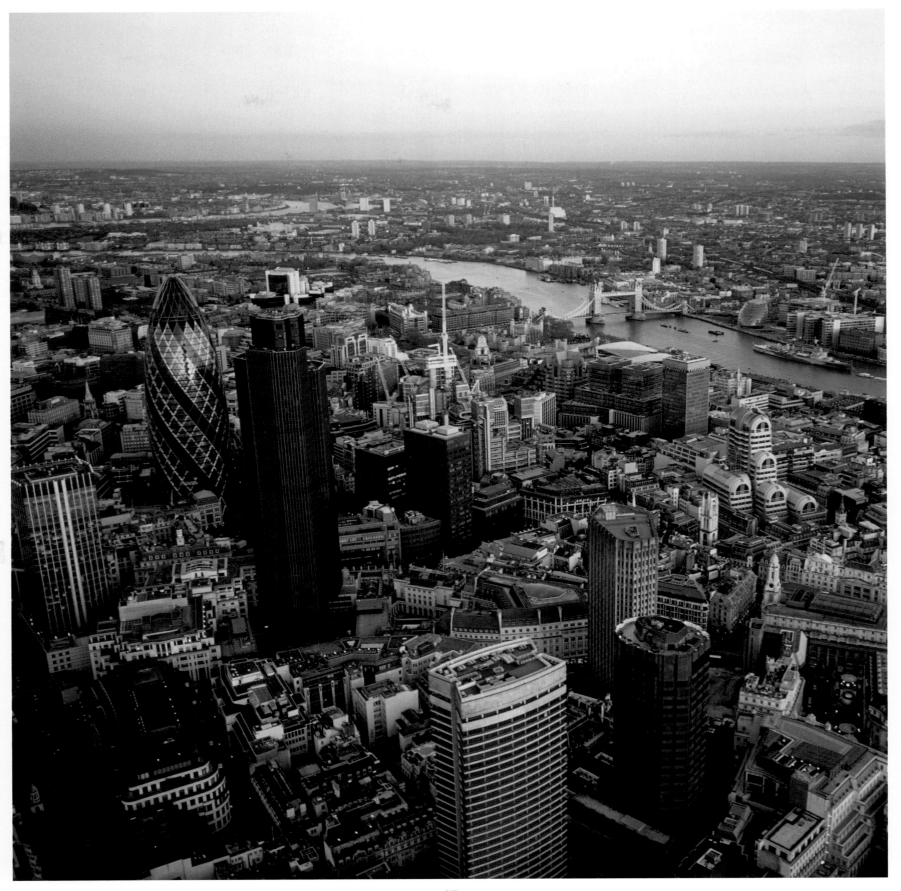

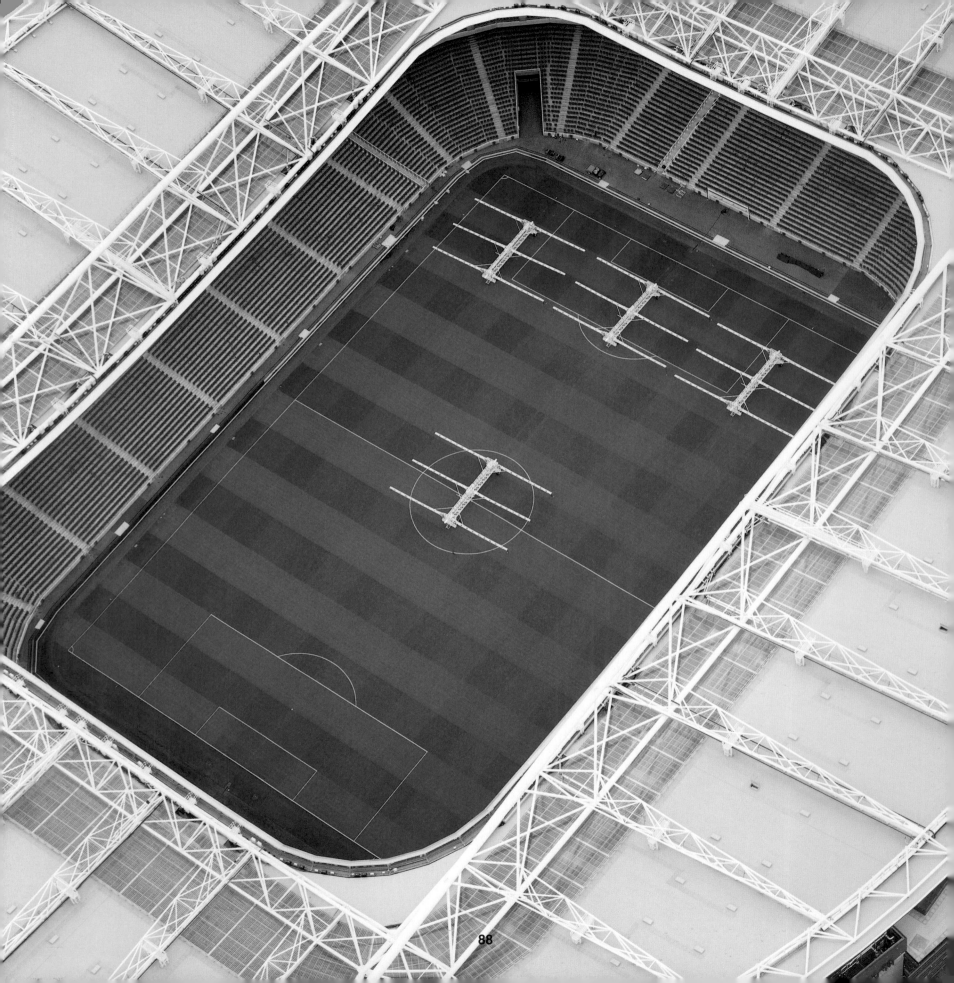

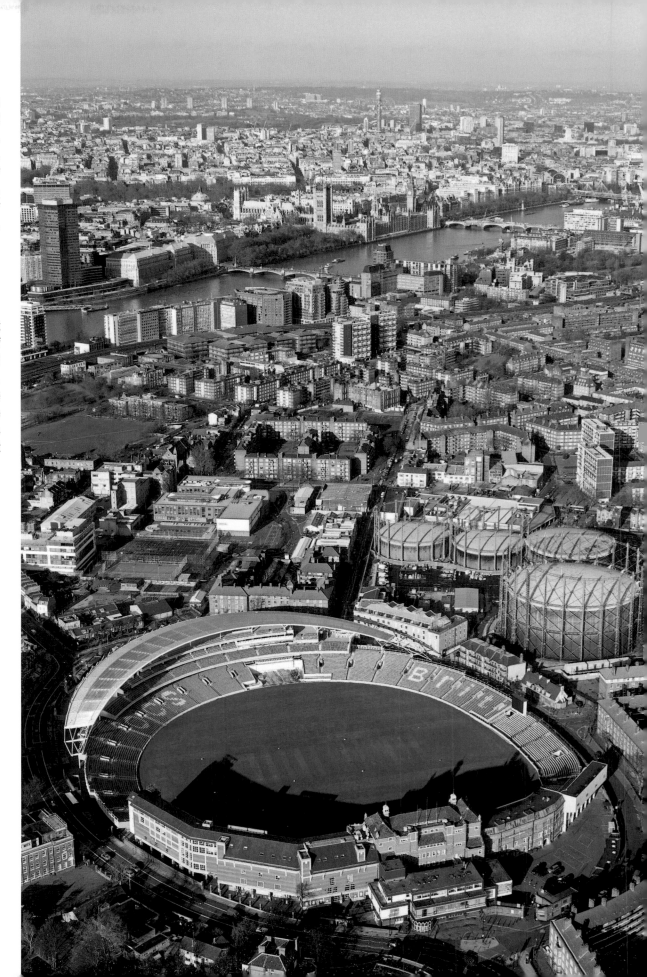

< **OPPOSITE**

Arsenal FC's Emirates Stadium

Sport is big business in London. Not only are the Olympic Games coming to the city in 2012, and a new Wembley Stadium has recently been built, but the new home of the Arsenal Football Club, the Emirates Stadium, was officially opened by Her Majesty Queen Elizabeth II in October 2006. It is the third biggest stadium in London, after Wembley and the rugby stadium in Twickenham, and cost £390 million.

> **RIGHT**

The Oval cricket ground and Lambeth with Westminster in the background

The older face of British sport is shown here at the British Oval, or 'Grand Old Lady', the home of Surrey County Cricket Club and the first ground in Britain to host an international cricket match. It is actually owned by Prince Charles, the Prince of Wales, through the Duchy of Cornwall, and the Houses of Parliament visible by the River Thames only reinforce the feeling that the game of cricket is at the very heart of England.

WORLD CAPITAL

London is in every sense a world capital. In the early 1800s, it became the first city in the world whose population reached one million, and it was the first to reach five million too, in that same century. At the height of the British Empire it was the world's leading trading centre, and it can claim with some justification to be the world's first modern city.

In population terms London now lags way behind expanding urban centres such as Delhi, Mumbai, Sao Paulo, Mexico City and Istanbul. Paris might claim these days to be both the fashion and food capital, and New York and Tokyo vie for the title of the world's financial centre, but London can still claim to be the one city which leads the world when everything is taken together.

In business terms, every leading world bank and financial institution has a major presence in London. Over 300,000 people work in London's financial industries, which often act as a gateway to the main cities of Europe. Over half of the banking activity in Europe takes place in London. Financial services contribute over £15 billion per year to Britain's balance of payments, and most of this comes through London.

London has been the main centre for the insurance industries for 300 years, and its hold on this business sector shows no signs of diminishing. Over a quarter of the world's shipping and aviation insurance is done in London, with Lloyd's of London being the oldest insurance company in the world, a tradition which helps the world's markets to see London as a relatively safe and stable business capital.

In fact London now has two financial centres. The historic Square Mile of the old City of London, where the Bank of England has acted as the British Government's bank since it was founded in 1694, has been joined by the dazzling new Canary Wharf centre, located three miles to the east in the once crumbling but now rejuvenated Docklands.

Construction work here only began in 1988, and yet it now contains the UK's three tallest buildings. One of these, the HSBC Tower, is the international headquarters for HSBC, the world's third largest banking group, which employs 8,000 people in this one building alone. Nearby is the Citigroup Centre, the UK headquarters for the American financial company Citigroup, rated in the Forbes Global 2000 as the world's largest company. It is this combination of the centuries of tradition with steady growth and always keeping one eye on the future which keeps London ahead of the game as the world financial capital.

With its successful bid for the 2012 Olympic Games, London is set to become a sports capital, too. In the run-up to the Games, the entire city will benefit from investment in new and improved public transport systems, hotels and sports and training facilities. The plan calls for the ambitious re-development of some of the poorer parts of the city, notably Stratford in east London, which will be the site for the Olympic Park and a new 80,000-seat stadium. The eyes of the world will be focused on London in 2012, boosting tourism and business as well as its sports status.

Ever since William Shakespeare arrived in the city some time between 1585 and 1592, London has been a world leader on the theatrical stage. By the turn of the century he was living on the south side of the river in Bankside, close to the original Globe Theatre where his works were first performed, and where the reconstructed Globe Theatre now stands.

London has never been content to rest on its theatrical laurels, however, despite the fact that *The Mousetrap* by Agatha Christie has been showing

in the West End since November 1952, making it the world's longest-running play. London still has more theatres than any other city in the world, with a dazzling breadth of productions. These range from the safe musicals that can be seen anywhere round the globe to risk-taking drama and outrageous comedies that push the boundaries.

London's theatreland has great class and cachet. Even America's finest and most famous actors, who normally command fees of millions of dollars per movie, can't wait to work for basic wage on the London stage. Nicole Kidman had one reviewer describing her 1998 performance in *The Blue Room* as 'pure theatrical Viagra', and Kathleen Turner had a similar sizzling effect when she came to London to play Mrs Robinson in the stage version of *The Graduate*.

Other stars who have shown that they still regard the London theatre as a challenge, and the supreme showcase for their talents, include *Friends* star David Schwimmer, Val Kilmer, Christian Slater, Rob Lowe, Brooke Shields and, perhaps most of all, Kevin Spacey. Spacey had such love for the London stage that he accepted the role of Artistic Director of the much-loved Old Vic Theatre in 2003. Since then he has not only been the creative guide of the theatre, but usually stars in two productions a year, and directs another one.

If there's another art where London inarguably rules the world, then it's popular music. America may have led the way through the 1950s, but there was a seismic shift in the Swinging Sixties when London was the only place to be. The driving force behind this, the Beatles, may have come from Liverpool, but the group quickly moved to live in London, the centre of the British music business. It became the Sixties' style capital too, with Carnaby Street and the King's Road being to cutting-edge

fashion what Abbey Road was to the music industry. Since then London has hardly ever slipped from the Number One spot in the popular music charts. The Sixties phenomenon was shown to be no flash in the pan as it happened all over again in the 1990s, when Cool Britannia ruled the airwaves, and much else besides. The arrival of the young Prime Minister Tony Blair played its part, alongside a creative boom in fashion, food and music, which once again made London the place to be. Star chefs like Gordon Ramsay, Jamie Oliver, Angela Hartnett and Marcus Wareing have helped transform the London restaurant scene, at the same time igniting a passion for good food, organic ingredients and healthy eating that has spread around the globe.

There has also been a renaissance in the fashion business, where once London lagged behind cities like New York, Milan and, inevitably, Paris. The chic French might not like to be reminded of it, but recently some of their top fashion houses have been led not by home-grown French designers but by Brits like John Galliano, Alexander McQueen and Stella McCartney. For while Paris is known for couture, London is and always has been admired for its style. Londoners have a flare for offbeat street fashion and edgy club cred that has inspired worldwide trends, and the young designers of tomorrow can often be spotted in the market stalls of Spitalfields, Portobello Road and Camden Lock.

As a style capital, London is always evolving, leading rather than following, and creating rather than copying the lifestyle trends that go on to capture the imagination of the world. While other cities might occasionally take the lead in certain areas, and stride proudly down the catwalk in the spotlight for a short while, there is surely no other city in the world that can match London when it comes to being at the forefront of so much, in so many different fields, and over so many centuries.

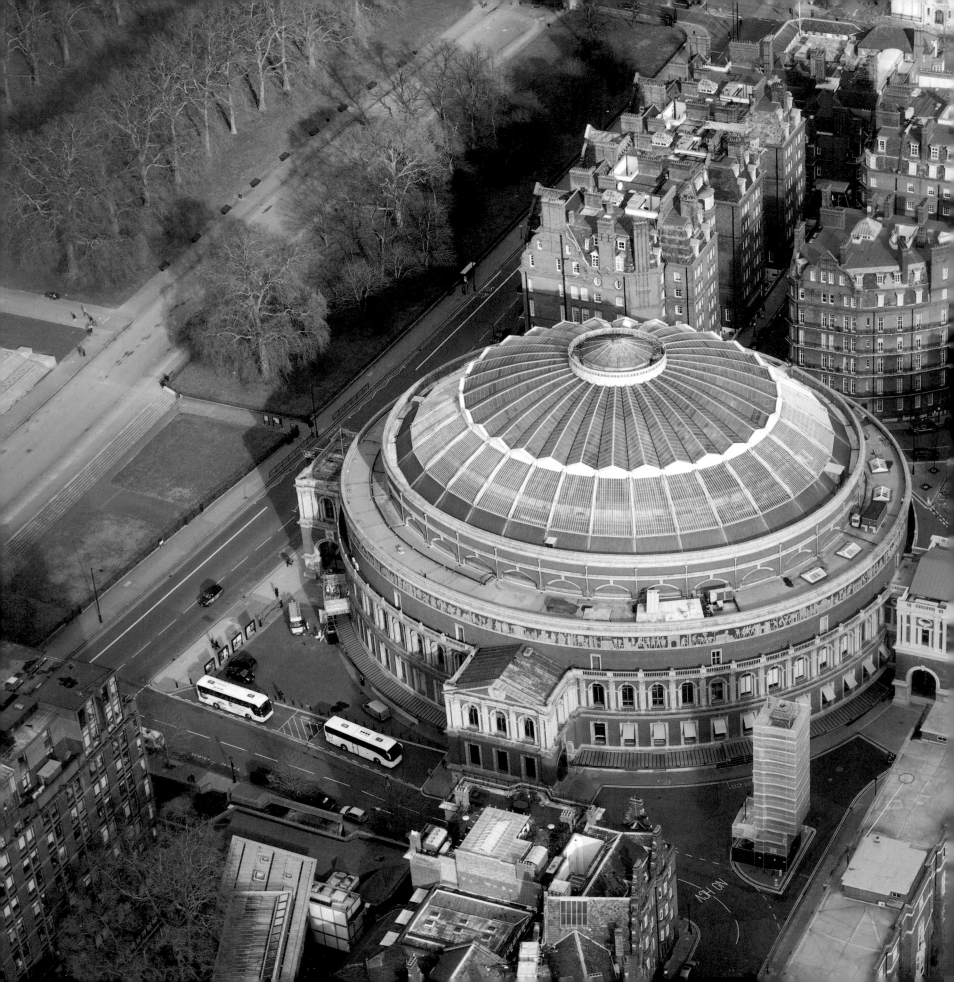

Royal Albert Hall

Since its opening concert in 1871, over 150,000 performances have taken place inside the Royal Albert Hall, from rock stars like Bob Dylan and Eric Clapton through to the annual feast of Britishness known as the Promenade Concerts. It was opened by Queen Victoria, who at the opening ceremony changed the name of the building from the planned Central Hall of Arts and Sciences to the Royal Albert Hall, in loving memory of her husband Prince Albert who had died ten years earlier from typhoid at the young age of 42.

Hyde Park in the summer

A crossroad of paths in Hyde Park, a park close to the hearts of Londoners. Not only does it offer escape from the streets, and a place to sunbathe or stroll, it also has lots of emotional ties for the city's citizens. It is the home of Speaker's Corner, where the right to free speech is displayed every Sunday morning, and has been the venue for memorable events like the Rolling Stones' free concert in 1969 which epitomised the 1960s, and the later Live Aid concerts which relayed scenes from the park around the world.

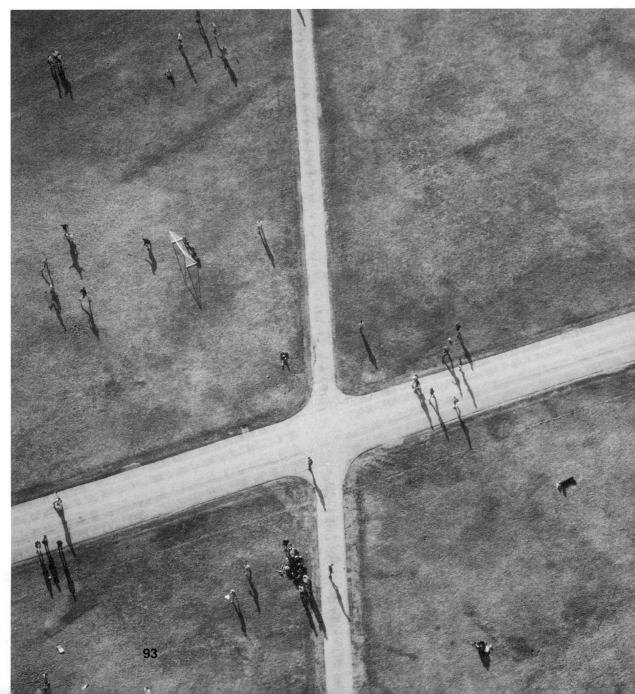

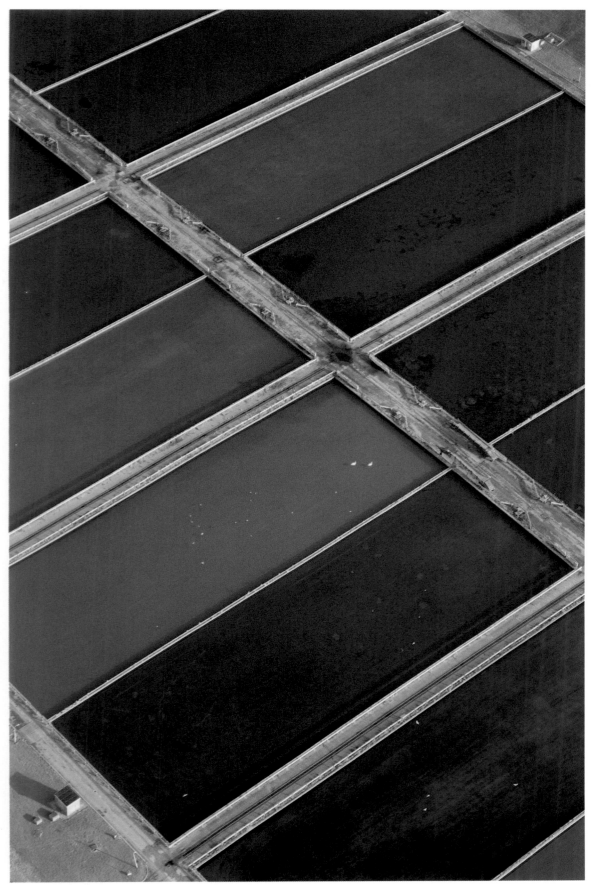

<LEFT
Water treatment plants, Beckton
These vast reservoirs are part of the water treatment plants at Beckton in east London, which are operated by Thames Water. Every day, sewage from 3.4 million city residents is processed at this facility. With the volume of water treated here, you could fill 34 Olympic-sized swimming pools every hour. (But you'd think twice about diving in!)

> OPPOSITE
Millbank and Tate Britain looking over Vauxhall Bridge to the MI5 building
The Vauxhall Bridge links Westminster and Tate Britain on the north bank of the Thames with the Vauxhall area on the south bank, where the headquarters of Britain's Secret Service can be found, in the building to the left of the bridge. The building of several towers to the right of the bridge is St George Wharf, one of London's most exclusive addresses.

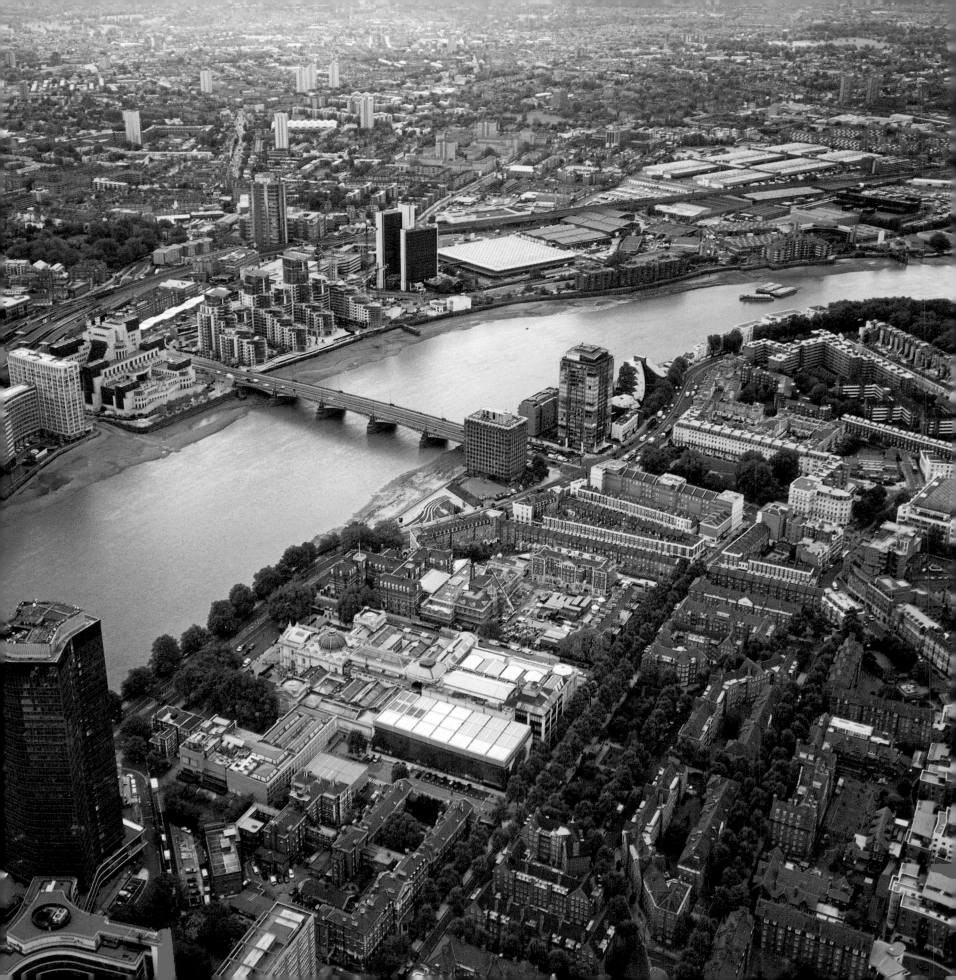

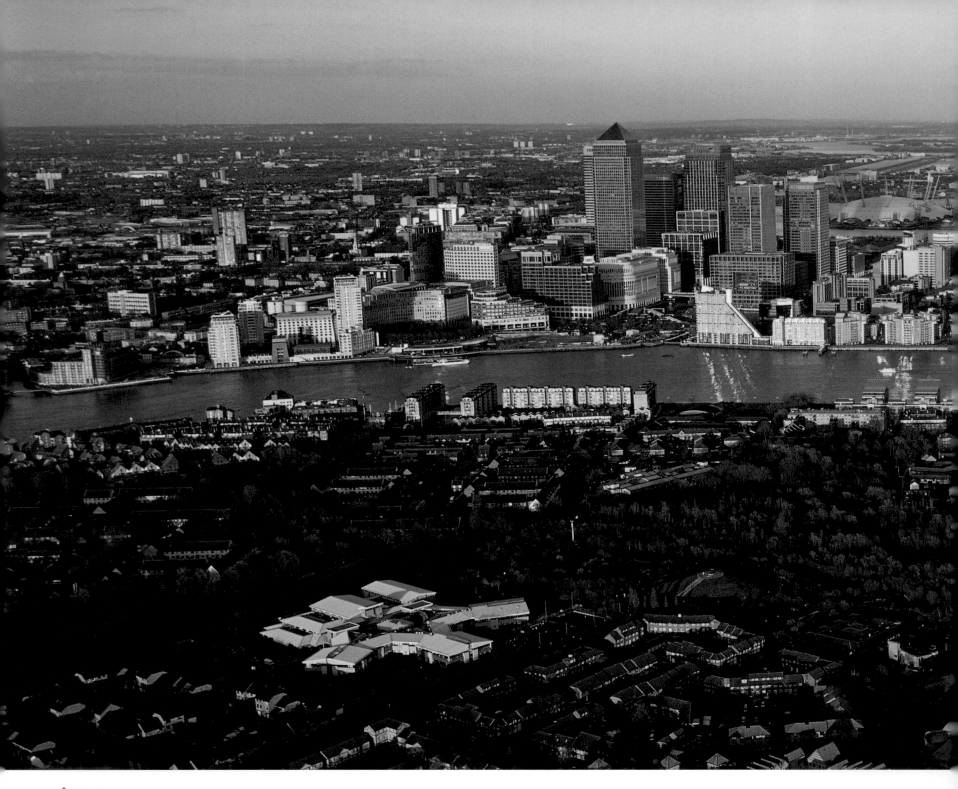

^ ABOVE

**Rotherhithe, Southwark and Greenland Dock
looking to the Isle of Dogs**

This fascinating panorama is of a part of London which was effectively dead in the 1960s, when the docks had closed and unemployment was high. Today it has had an exciting regeneration, with the towers of Canary Wharf clearly seen on the peninsula created by a huge loop in the River Thames at this point. Beyond the towers is the area known as the Isle of Dogs, so old that no-one knows for sure where its name comes from. Could it have been place where there was once a royal kennels? Or was it originally called the Isle of Ducks because of the wildfowl in the marshes here? In fact it was probably the Isle of Dykes, from the Dutch engineers who built dykes to keep back the flood waters.

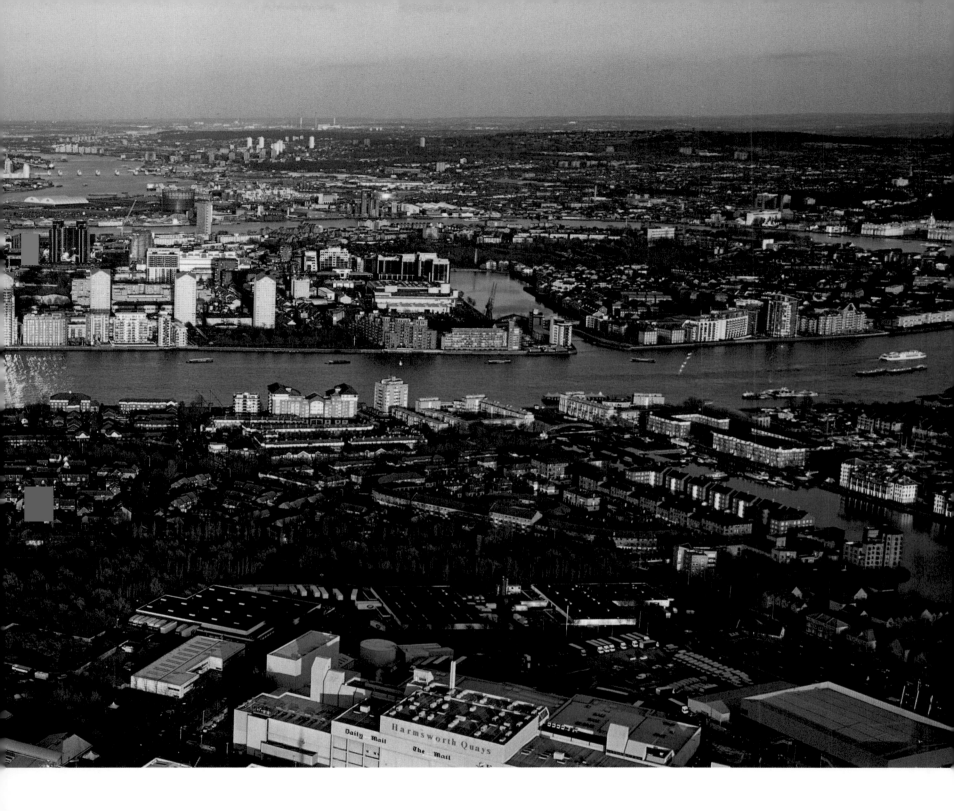

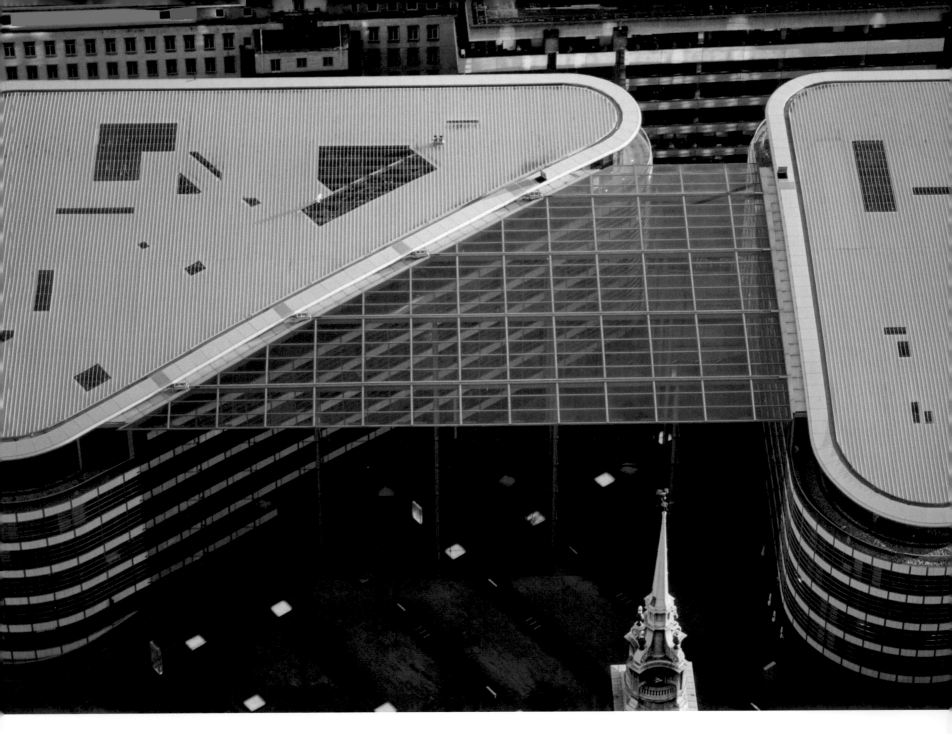

^ ABOVE

All-Hallows-by-the-Tower and Tower Place

London old and London new stand side-by-side here, where the tower of All-Hallows-by-the-Tower church, which survived the Fire of London, seems to be almost touching the modern glazed atrium (one of the largest in Europe) which links the two halves of the Tower building. The church goes back to at least 675AD, with Roman remains found inside its crypt, while Tower Place was constructed in 2003.

> OPPOSITE

London Eye and Hungerford Bridge

The London Eye, or Millennium Wheel, is the world's largest observation wheel and gives passengers a bird's-eye view over London. It's one of the most modern additions to the London skyline, and yet down below it is the Hungerford Bridge, equally striking when it was opened in 1845 as a suspension footbridge across the Thames, having been designed by the renowned engineer Isambard Kingdom Brunel.

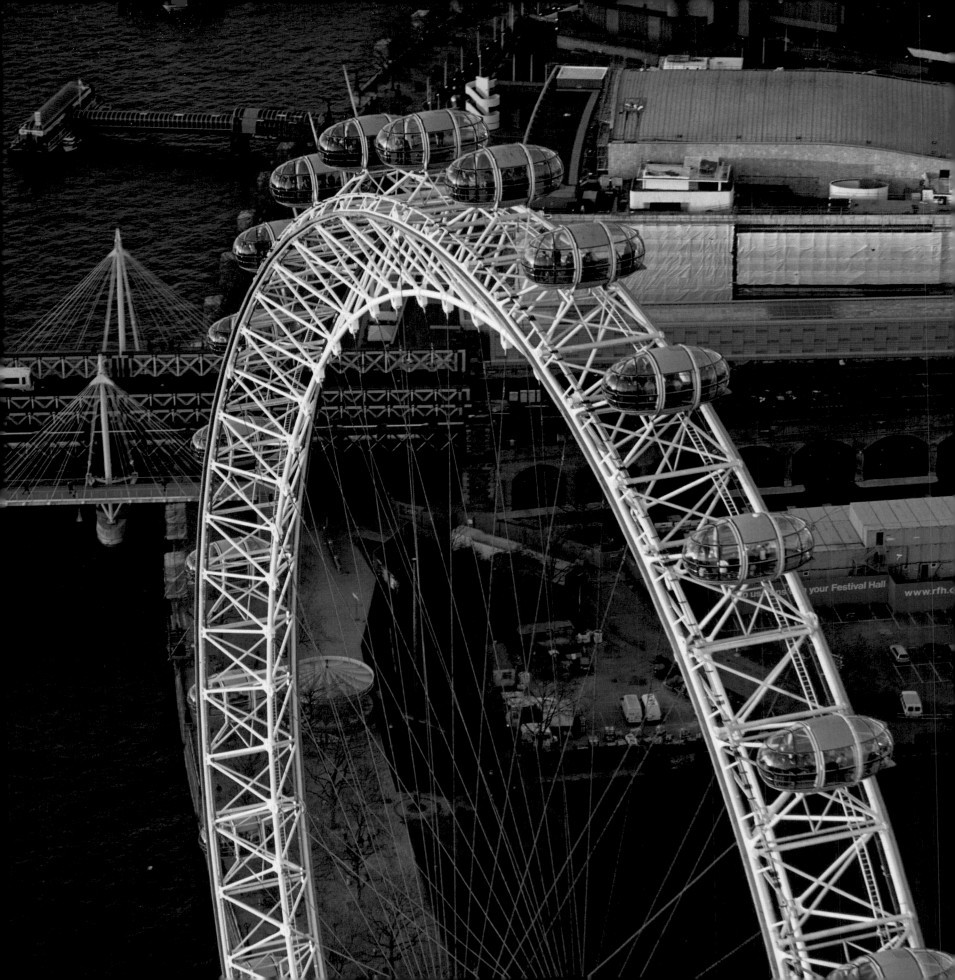

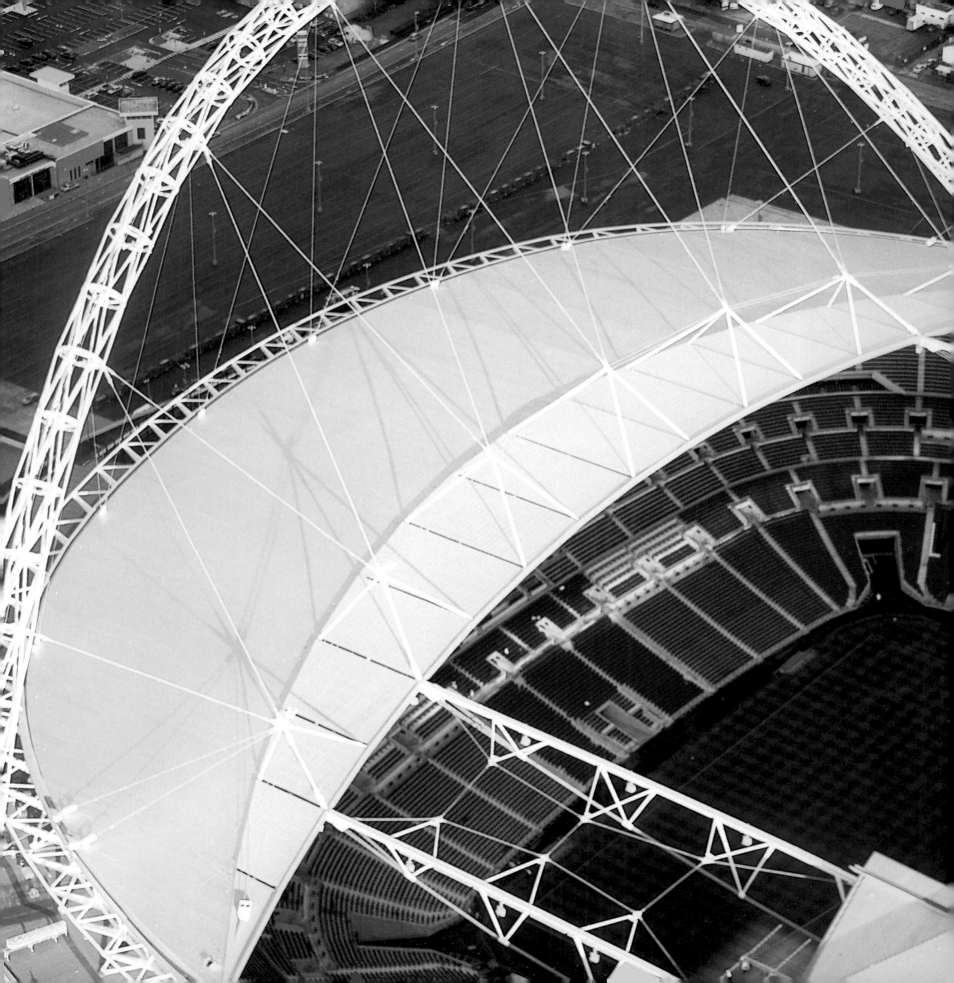

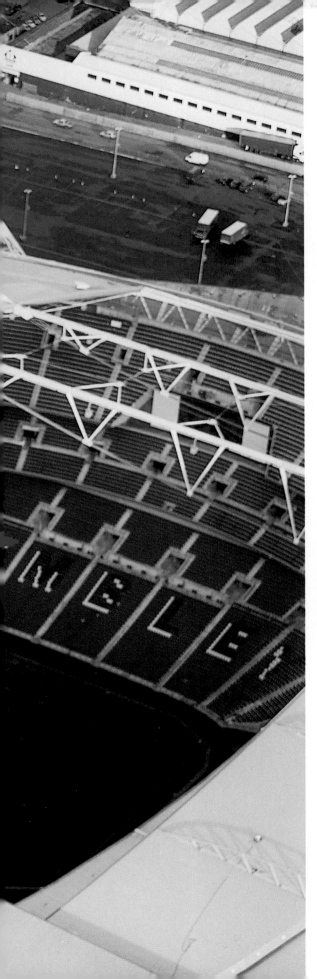

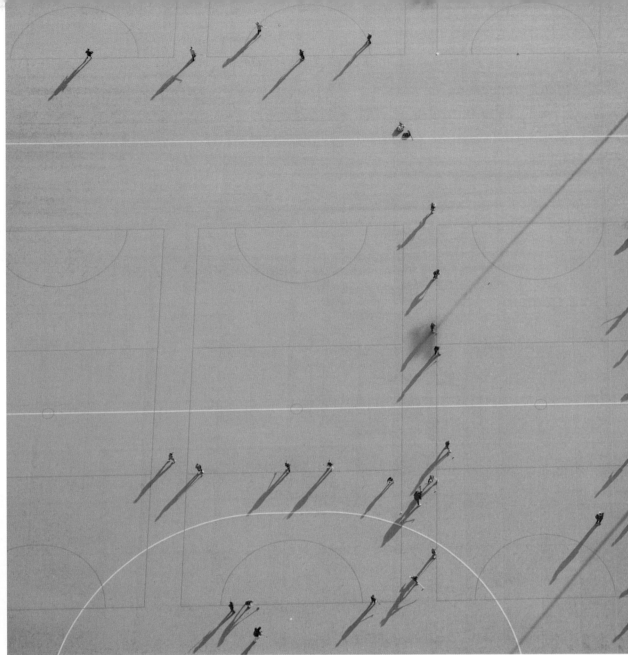

< **LEFT**

Wembley Stadium

For over five years England was deprived of a national football arena, when the old Wembley Stadium was demolished to make way for a new one. This was opened in March 2007, and its eye-catching arch is one of its most striking features. Tall enough for the London Eye (see previous page) to pass underneath it, it also supports the 5000-tonne roof and eliminates the need for pillars, making for unrestricted views for all 90,000 fans. It is the largest football stadium in the world to have every seat under cover.

^ **ABOVE**

University of Westminster sportsground

Londoners enjoy football and other sports at grounds all over the capital. These sports grounds for the University of Westminster are near the River Thames in Chiswick, in southwest London. The southwest of the city is blessed with green spaces, including Kew Gardens, Richmond Park, Syon Park, Gunnersbury Park and Barnes Common. With the River Thames meandering its way past several of these parks, it makes the southwest a popular – and expensive – part of London to live in.

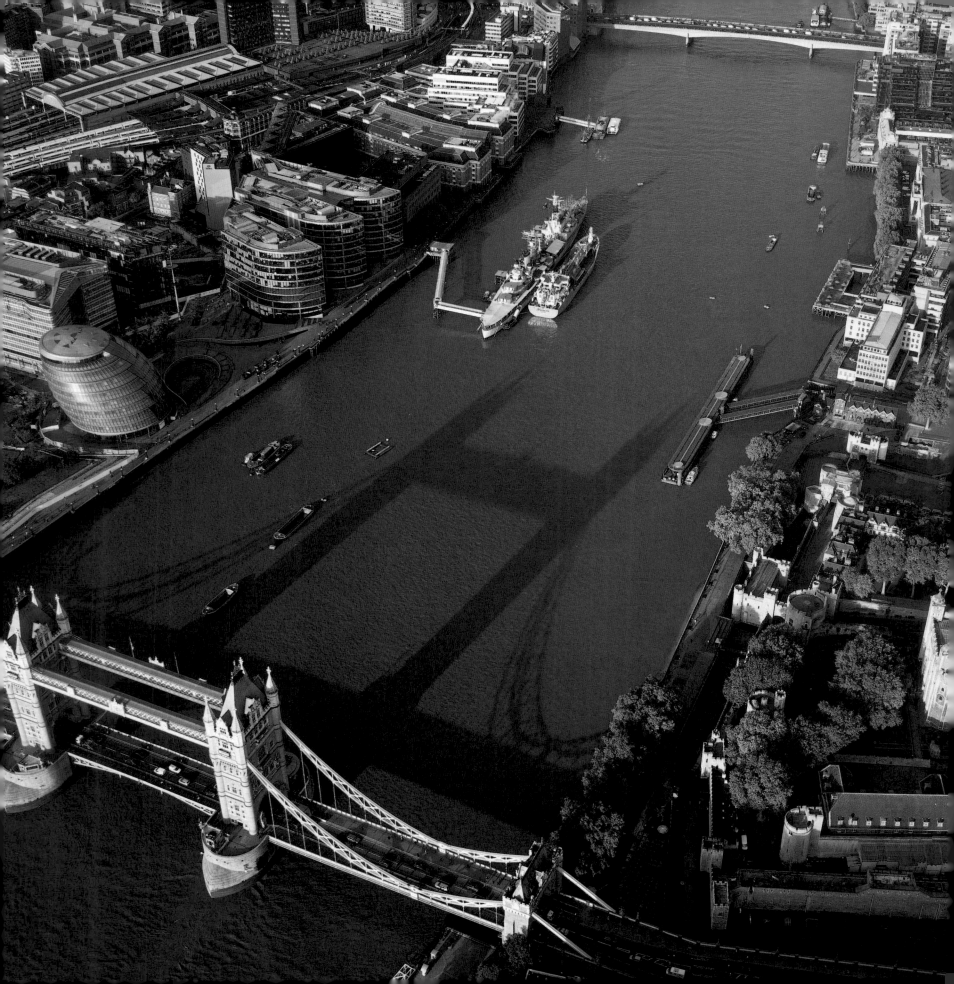

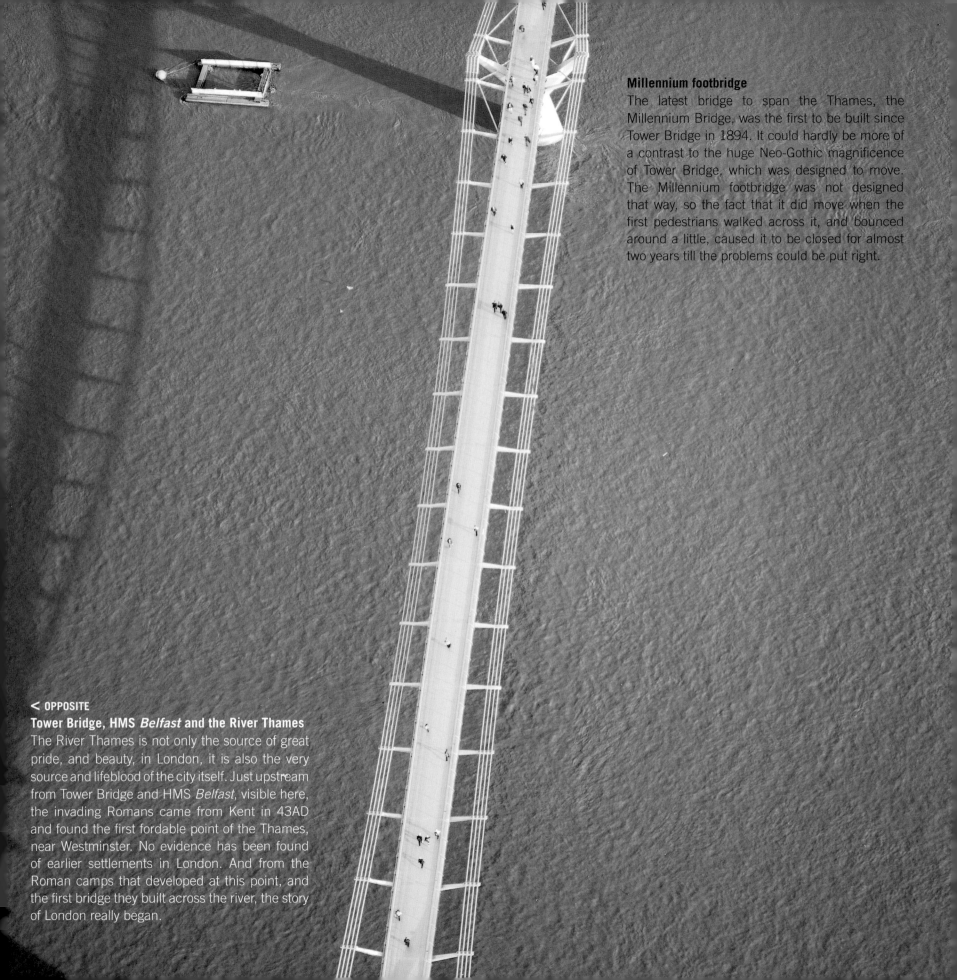

Millennium footbridge
The latest bridge to span the Thames, the Millennium Bridge, was the first to be built since Tower Bridge in 1894. It could hardly be more of a contrast to the huge Neo-Gothic magnificence of Tower Bridge, which was designed to move. The Millennium footbridge was not designed that way, so the fact that it did move when the first pedestrians walked across it, and bounced around a little, caused it to be closed for almost two years till the problems could be put right.

< OPPOSITE
Tower Bridge, HMS *Belfast* and the River Thames
The River Thames is not only the source of great pride, and beauty, in London, it is also the very source and lifeblood of the city itself. Just upstream from Tower Bridge and HMS *Belfast*, visible here, the invading Romans came from Kent in 43AD and found the first fordable point of the Thames, near Westminster. No evidence has been found of earlier settlements in London. And from the Roman camps that developed at this point, and the first bridge they built across the river, the story of London really began.

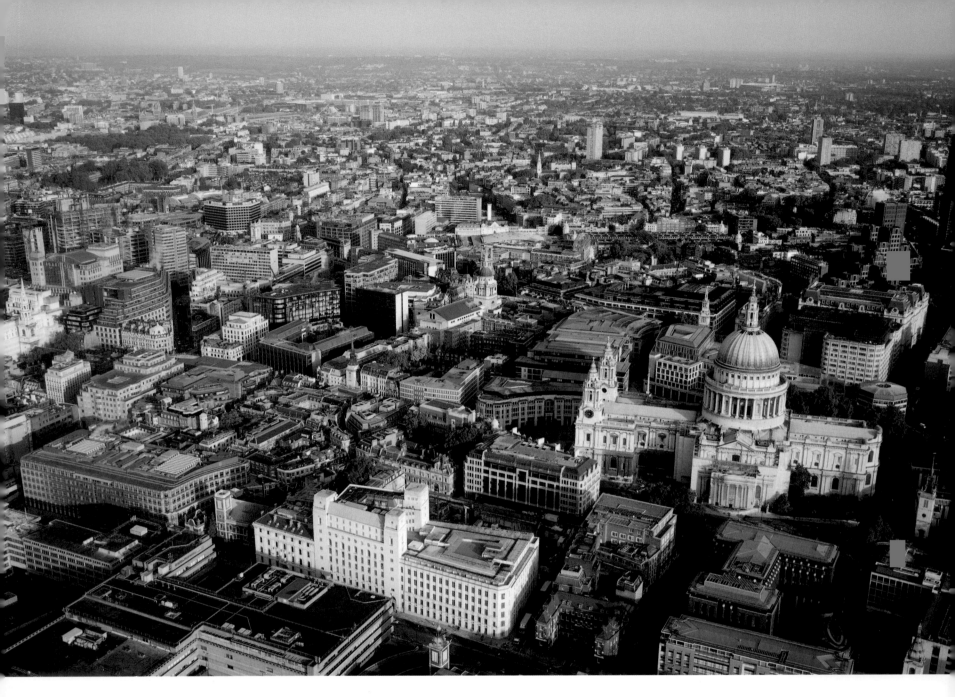

^ ABOVE
St Paul's Cathedral and Bank
It is perhaps a comfort to anyone who attempts a difficult task that not even Sir Christopher Wren, the greatest architect of his day, got it right the first time. His initial design for St Paul's Cathedral, which attempted to replicate the building which had been destroyed in the Great Fire of London in 1666, was rejected. So was his second, in the shape of a Greek cross. So was his third. Perhaps it's understandable that when he was allowed to proceed with his fourth design, he veered from the plans and produced the building we have today.

> OPPOSITE
Bank, Cornhill and Mansion House, City of London
One of the busiest traffic junctions in London is here at Bank, in the financial heart of the city. As the name suggests, the Bank of England is nearby, and so too the Lord Mayor's Mansion House (visible here to the left of the junction, with the flagpole). The Mansion House was built in the mid-18th century, and is one of the most splendid Palladian houses in London.

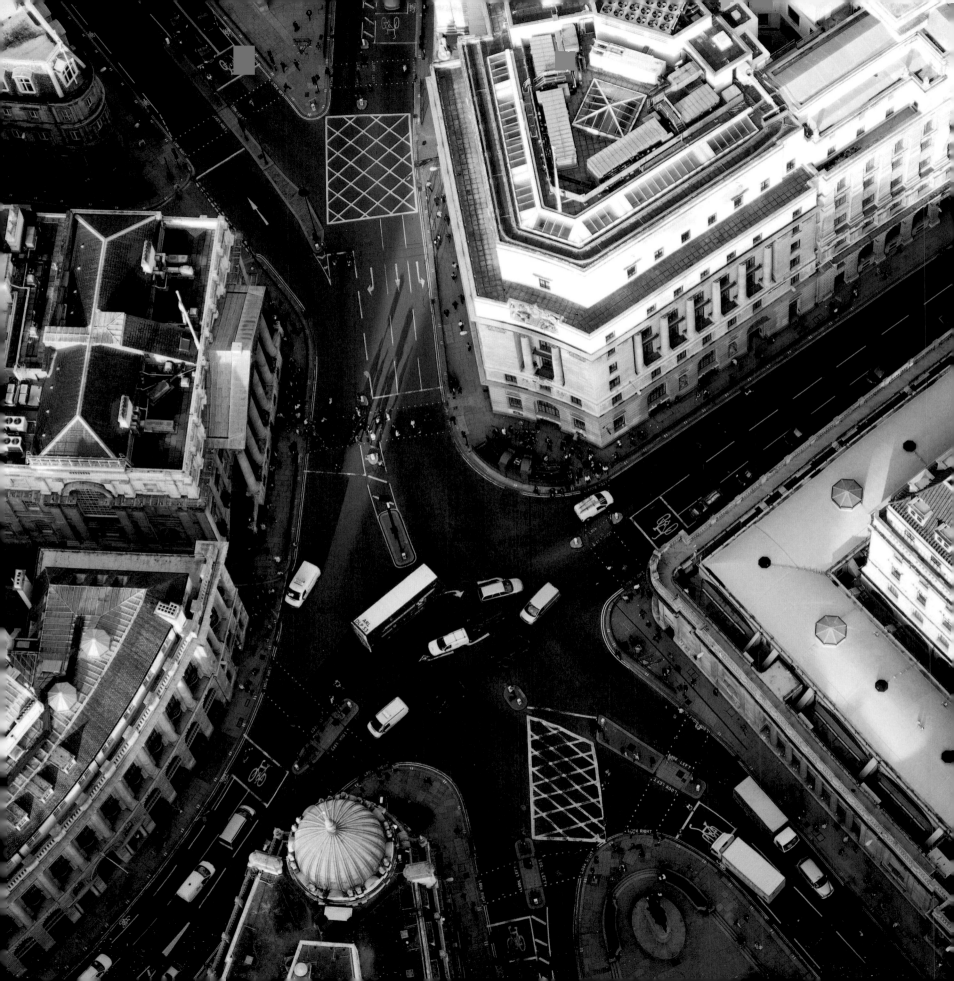

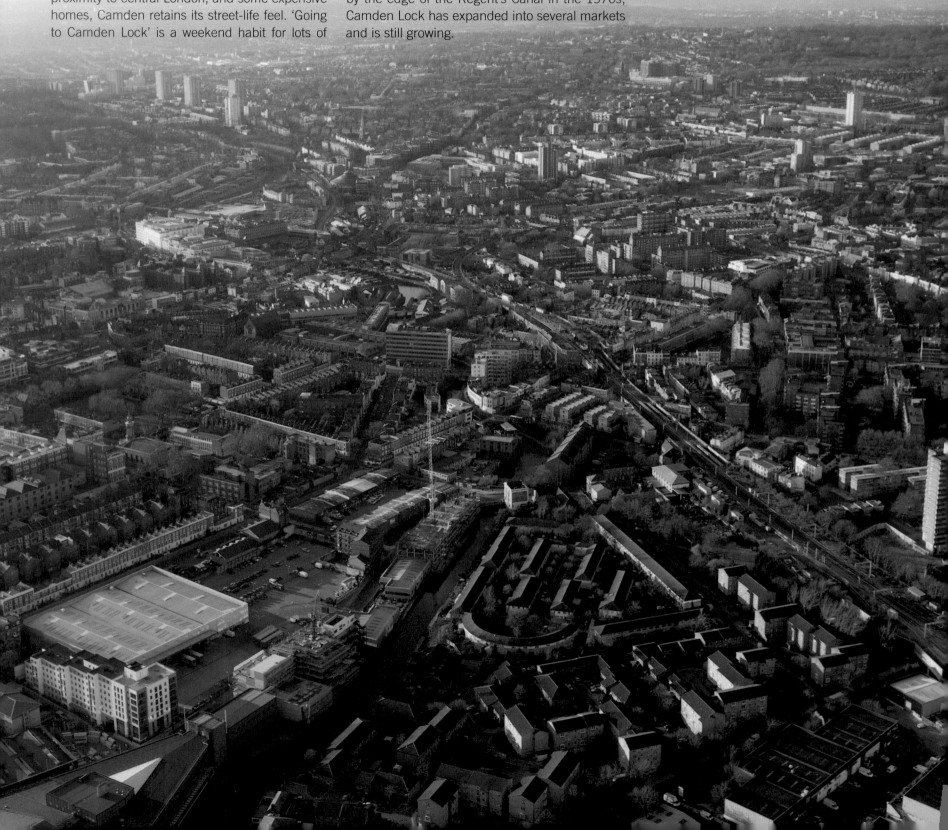

Camden looking from Royal College Street to Camden High Street and tube

Writers, artists, anarchists, students, punks – Camden Town in north London is home to all of these, and plenty more. Despite its close proximity to central London, and some expensive homes, Camden retains its street-life feel. 'Going to Camden Lock' is a weekend habit for lots of Londoners with alternative lifestyles, as the market there caters to every taste with all kinds of arts, crafts and fashions for sale. Since it opened by the edge of the Regent's Canal in the 1970s, Camden Lock has expanded into several markets and is still growing.

The Globe
Shakespeare's Globe shows the first thatched roof in London since the Great Fire of London in 1666 raged through such rooftops. It is an almost exact replica of the original theatre which was built in 1599, and where many of Shakespeare's greatest plays had their first performances. In those days this area south of the river was well away from the City of London, and a hotbed for vice and disreputable activities, like theatre-going.

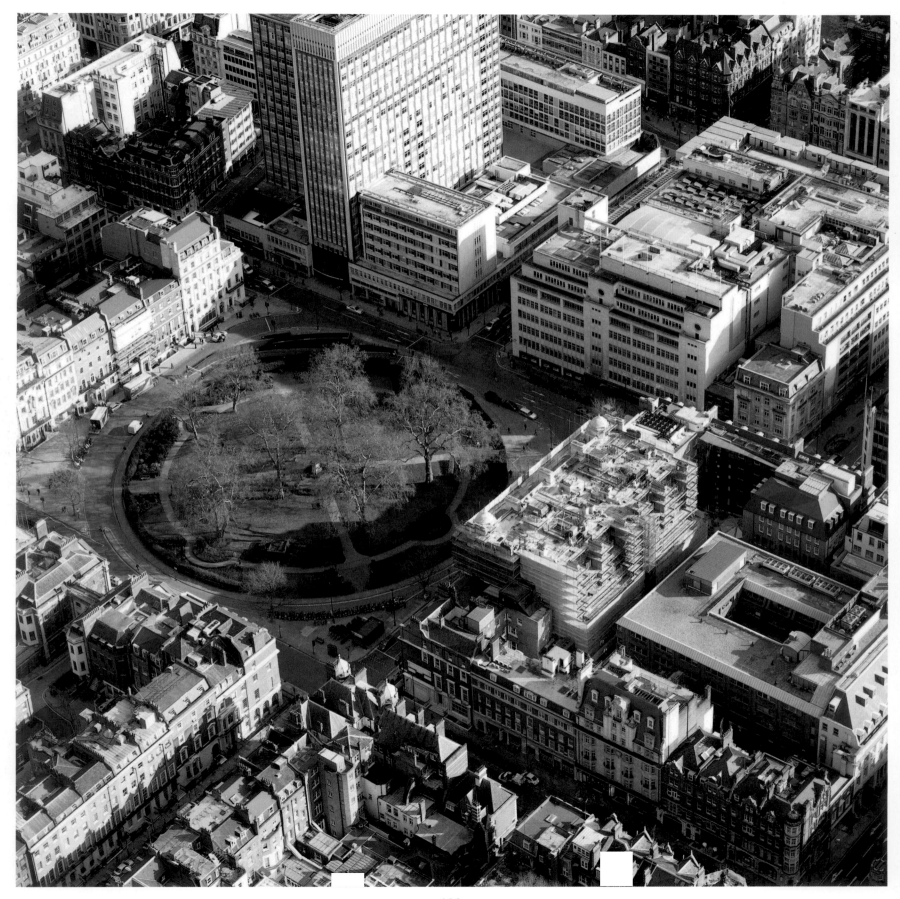

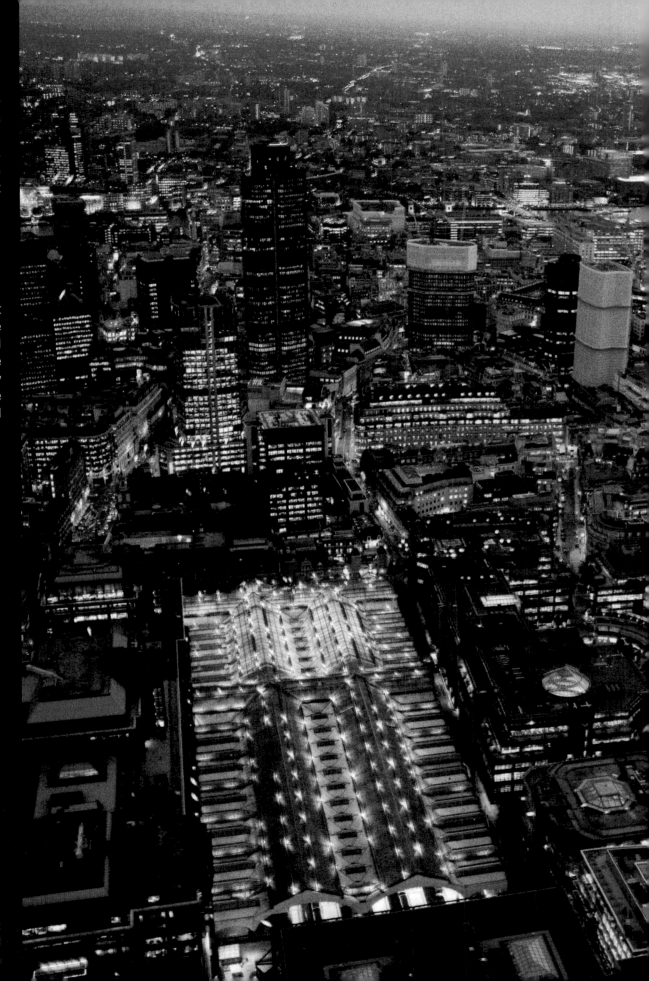

< LEFT
Cavendish Square

The north side of Cavendish Square (facing into the square at bottom left) has the finest houses on this graceful London square not far from busy Oxford Street. That side of the square was originally planned to be part of a mansion for the immensely wealthy Duke of Chandos, though it was never completed. Later, Lord Nelson would live at 5 Cavendish Square, on the east side and just visible at the edge of the photograph.

> RIGHT
Liverpool Street, City of London and Broadgate

For many visitors to the city, Liverpool Street remains a stop on the underground or the mainline station from where trains to Stansted Airport depart. Step outside, though, and you are in a vibrant part of the City of London, busy by day with city workers and shoppers. At night, the station gives off a neon glow in a scene that could almost be part of New York.

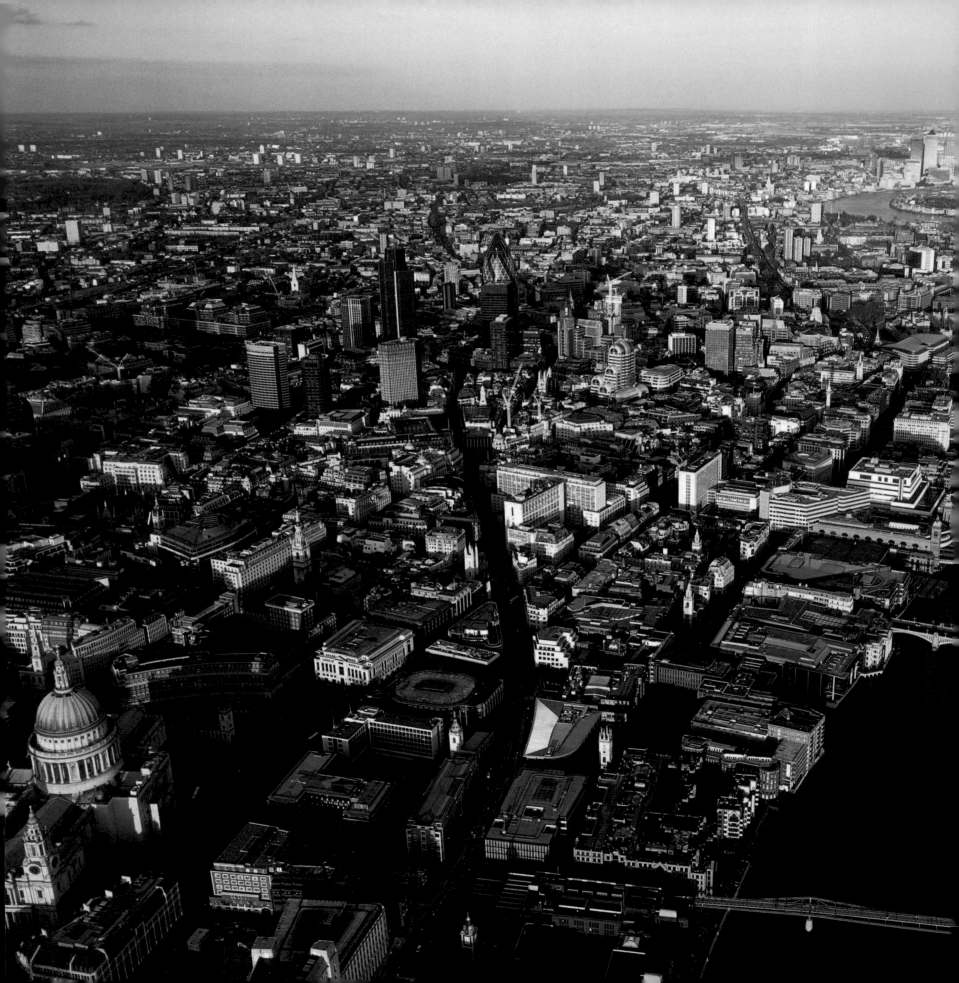

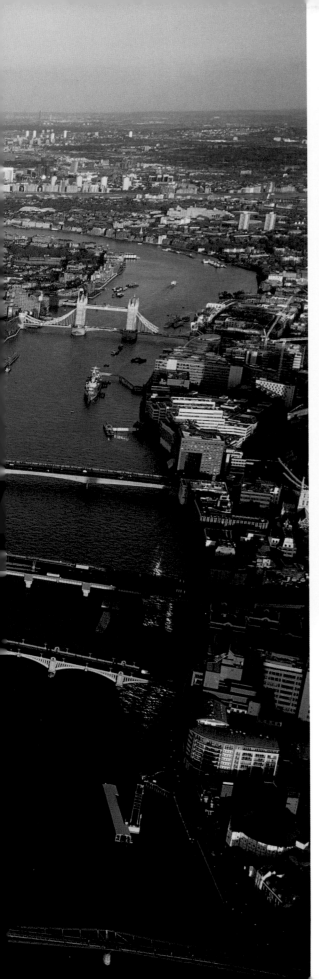

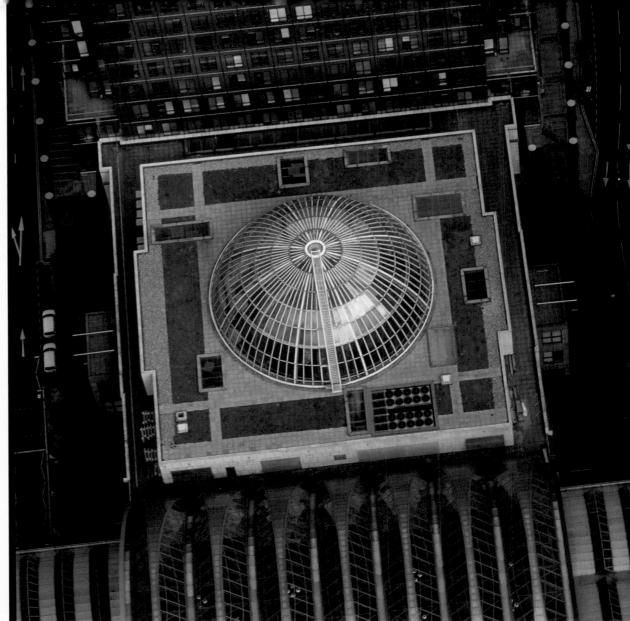

< LEFT

Looking east from the Millennium footbridge down to Docklands

The River Thames brought London to life when the Romans built its first bridge, and since then the city's history is told by its bridges. The distinctive Tower Bridge stands downstream from London Bridge, where the Romans built their first wooden Thames crossing almost 2,000 years ago, and which remained the only Thames crossing till 1729. Below that the Cannon Street Railway Bridge of 1866 harks back to the expansion of the railroads. Southwark Bridge was built at a spot where Thames watermen once moored their boats, and at the bottom of the picture is London's latest bridge, the Millennium footbridge.

^ ABOVE

Shopping at Canary Wharf

The top of this shopping centre in Canary Wharf looks like a modern take on the dome of St Paul's Cathedral, in the bottom left of the opposite page. One is a temple to God, the other a temple to commerce and progress. The cathedral was a major construction project in its day, begun in 1675 and completed in 1708. By comparison, work on Canary Wharf began in 1988 and within two years the UK's tallest building, One Canary Wharf (whose workers frequent this shopping centre), was finished.

< **LEFT**

Factory rooftop in Barking

The tops of these factories in Barking conceal an important part of London's, and Britain's, history in a place many only think of as an industrial and commercial suburb in east London. The historian monk, the Venerable Bede, recorded that back in 666AD the Bishop of London, Erkenwald, founded Barking Abbey here. This was destroyed by the Vikings but later rebuilt, and in 1066 William the Conqueror, after being crowned King of England at Westminster Abbey, came to Barking Abbey to celebrate the New Year.

> **OPPOSITE**

Cannon Street Station

From the air one of the secrets of London's Cannon Street Station is revealed: a 1-acre private roof garden which not surprisingly has superb views of the river, the south bank and of nearby St Paul's Cathedral. Those not lucky enough to be invited to an event here must make do with the mainline station beneath, which was opened in 1866 and built on a viaduct, beneath which are Roman remains. The remains are a Scheduled Ancient Monument, so from rooftop garden down to the Romans, we see the layers of London's history.

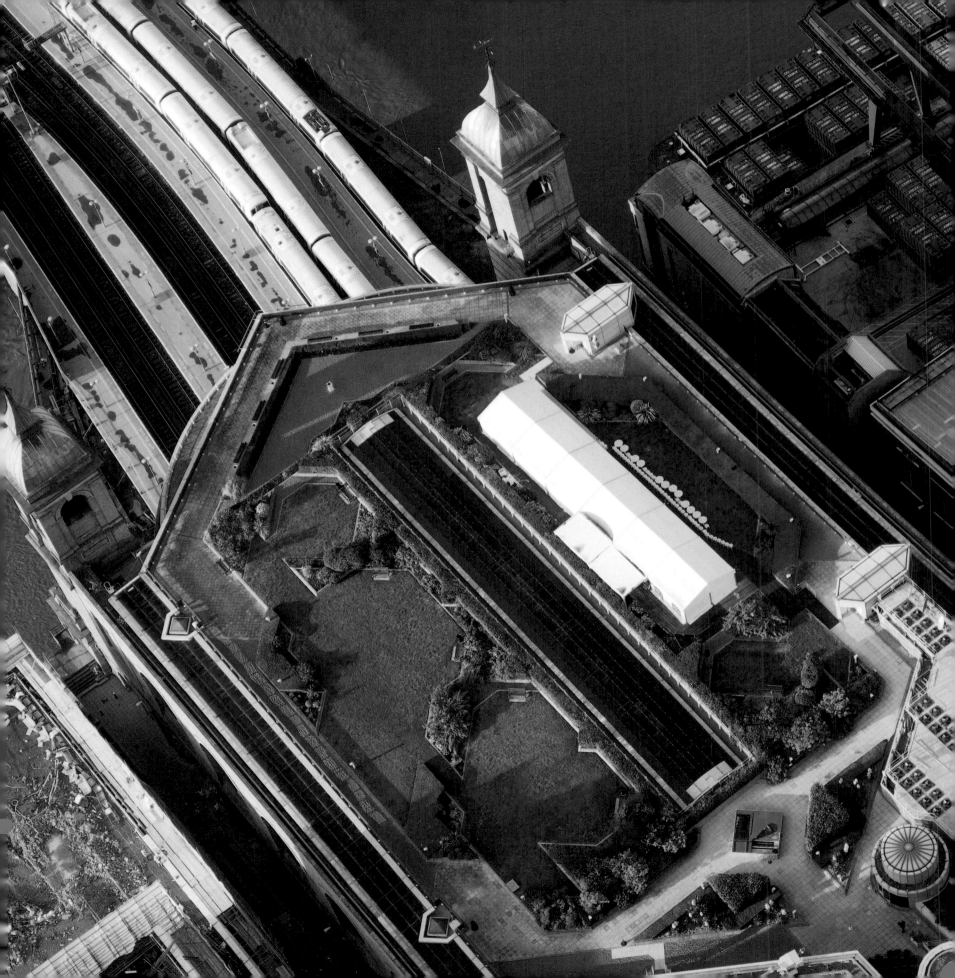

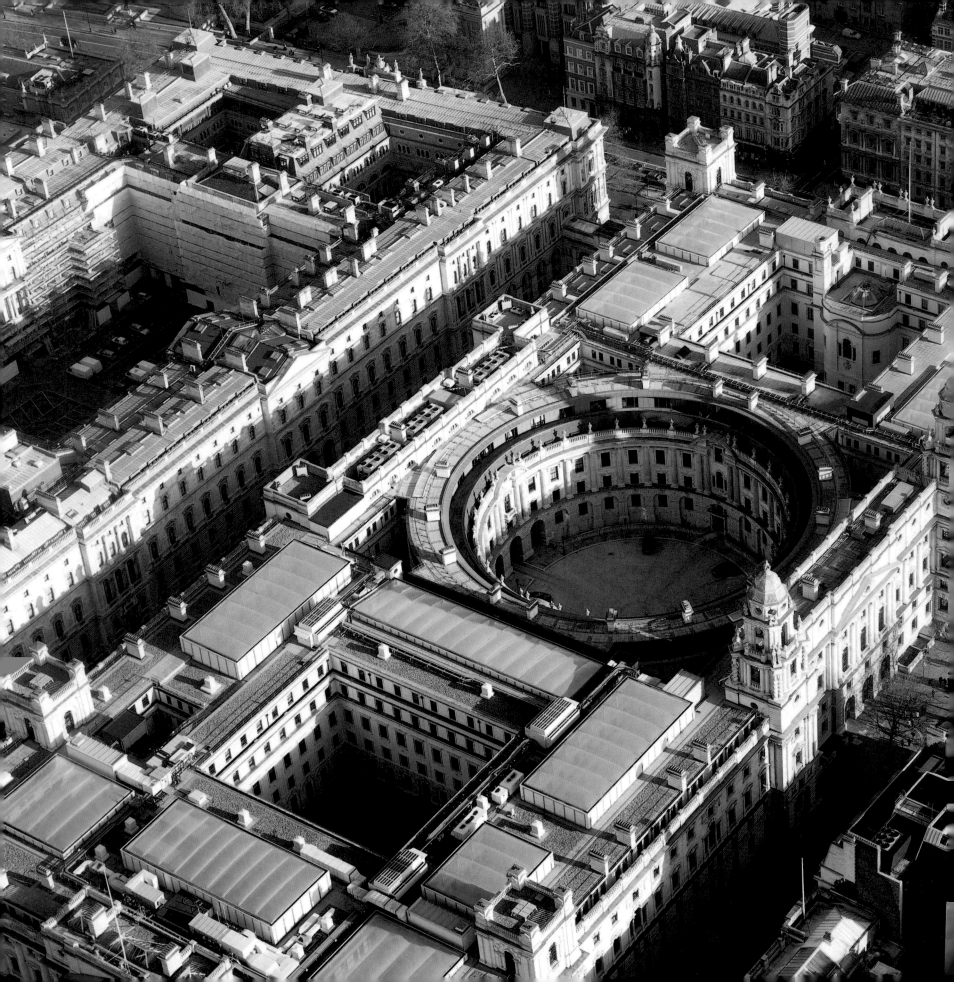

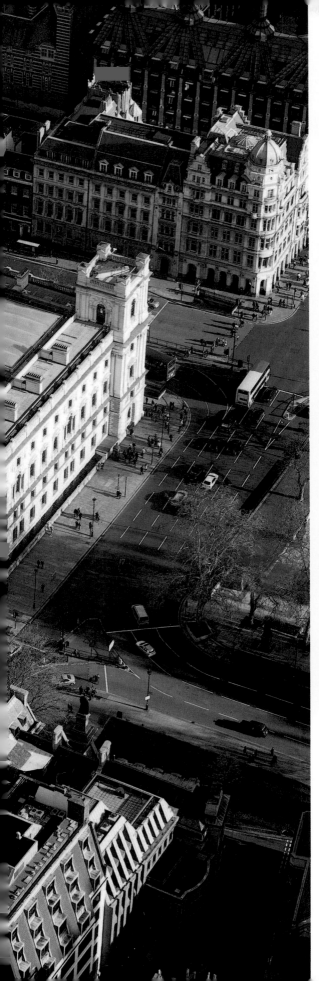
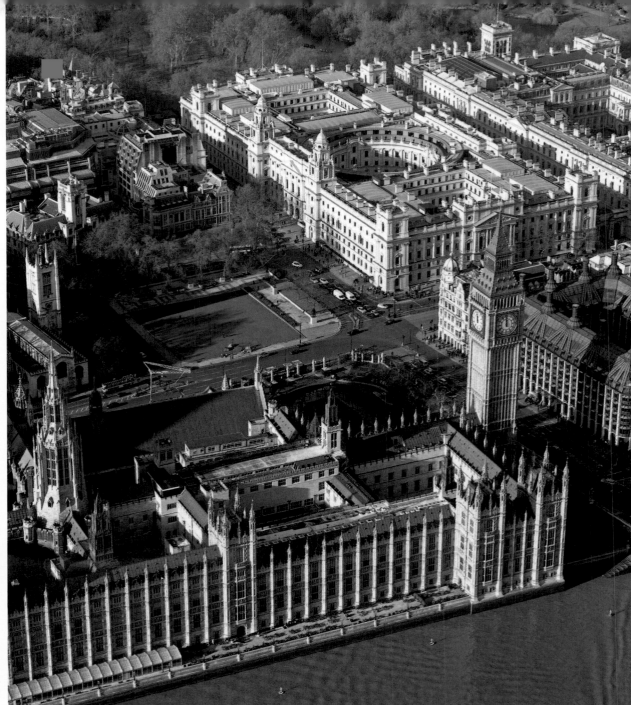

◁ LEFT AND ABOVE ^
Cabinet War Rooms and their proximity to the
Houses of Parliament

The imposing presence of the Cabinet War Rooms (left) and their close proximity to London's heart of government, the Houses of Parliament (above) can be clearly seen in these two photographs. The iconic tower containing Big Ben, whose time signal goes out around the world, can almost cast a shadow on the War Rooms. The option of having these highly protected underground rooms was first considered back in the 1920s when air raids on important cities during wartime had already begun. A horrific scenario of the possible damage to London and its seat of power caused them to be completed, and it was from this building in 1940 that the new Prime Minister, Winston Churchill, announced to the nation: 'This is the room from which I will direct the war.'

Mudflats in the Thames Estuary

The once dirty Thames has been turned into one of the world's least polluted city rivers, and as it leaves London its estuary and its mudflats are an important haven for wildlife. In the city centre it might not seem possible that the Thames is home to dolphins, porpoises and seals, but they do swim in the estuary waters and act as a barometer to the health of the river. Seals and dolphins have been seen in Docklands and near the Millennium Dome. Dover sole and sea bass are among the fish which breed in the estuary, and its mudflats are teeming with animal life which in turn act as a feeding ground for migrant birds.

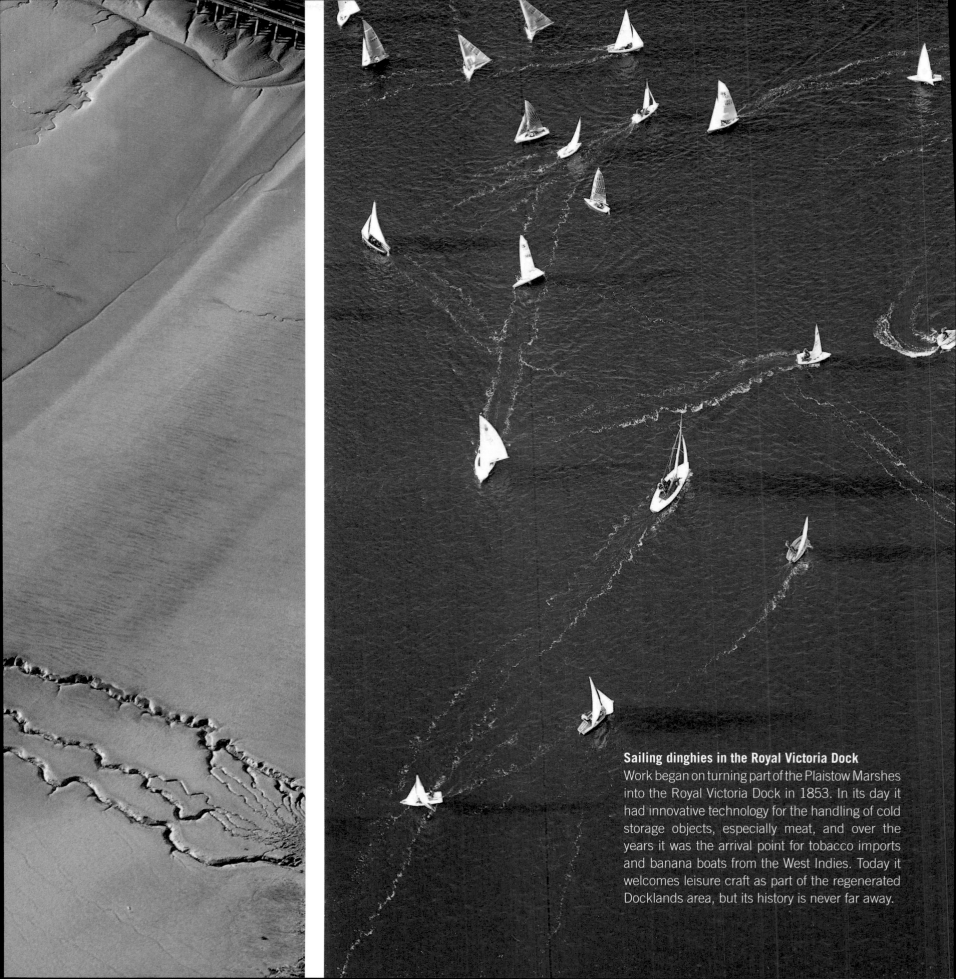

Sailing dinghies in the Royal Victoria Dock
Work began on turning part of the Plaistow Marshes into the Royal Victoria Dock in 1853. In its day it had innovative technology for the handling of cold storage objects, especially meat, and over the years it was the arrival point for tobacco imports and banana boats from the West Indies. Today it welcomes leisure craft as part of the regenerated Docklands area, but its history is never far away.

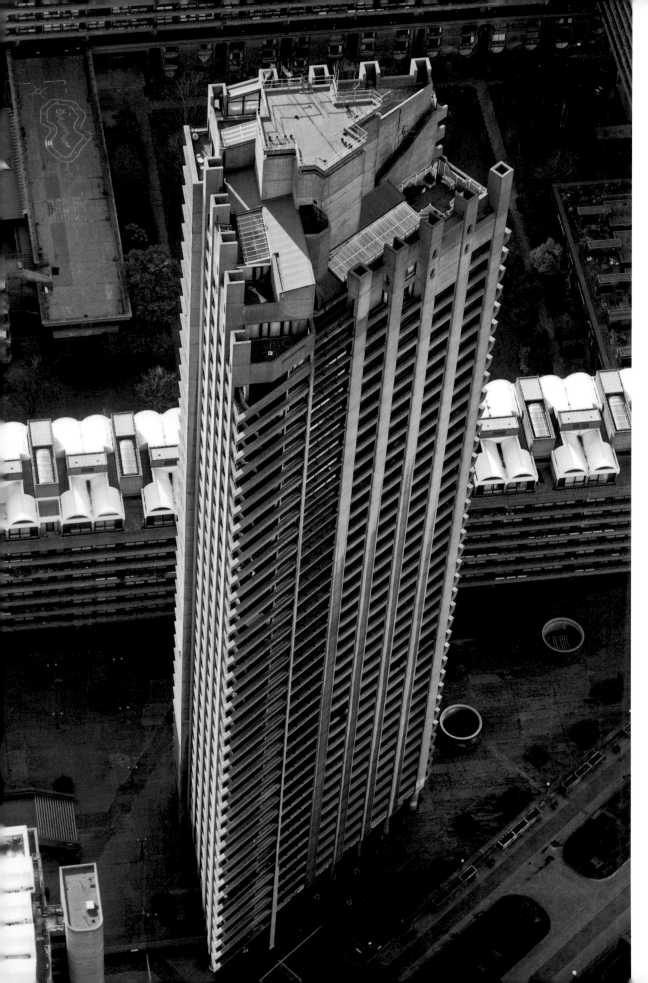

< LEFT
Barbican

Three of the tallest apartment towers in London are in the Barbican complex, and they rise 42 storeys high, giving unrivalled views over central London. The penthouse flat takes up the top two floors in each tower, and they look down on the Barbican complex, with its arts centre, Museum of London, library, school and other facilities, the whole area having been given a Grade II listing due to its architectural significance.

> OPPOSITE
Apartment Blocks at Fannystone Road, next to Holloway Road Tube station

As more and more people move to London from around Britain and abroad, housing is always in demand and new developments are being built on every available space. The differing styles of these apartment blocks makes an interesting contrast, especially when seen from above.

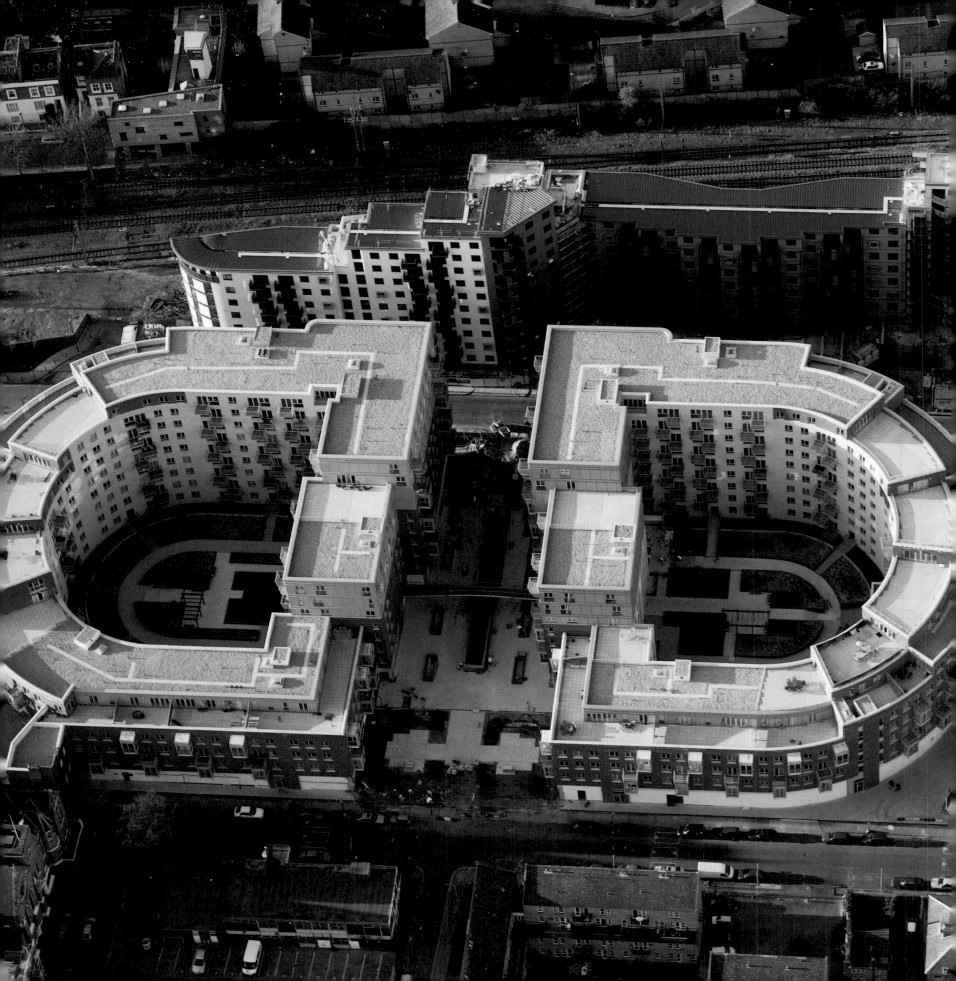

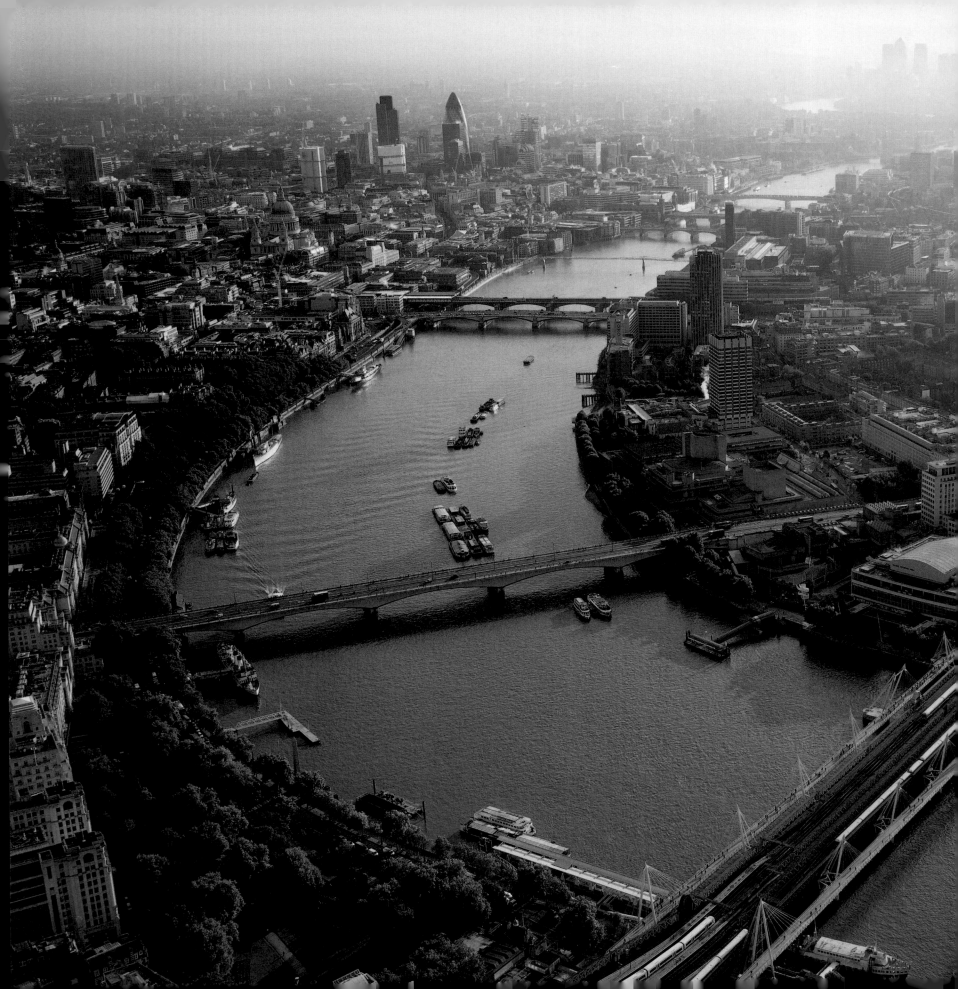

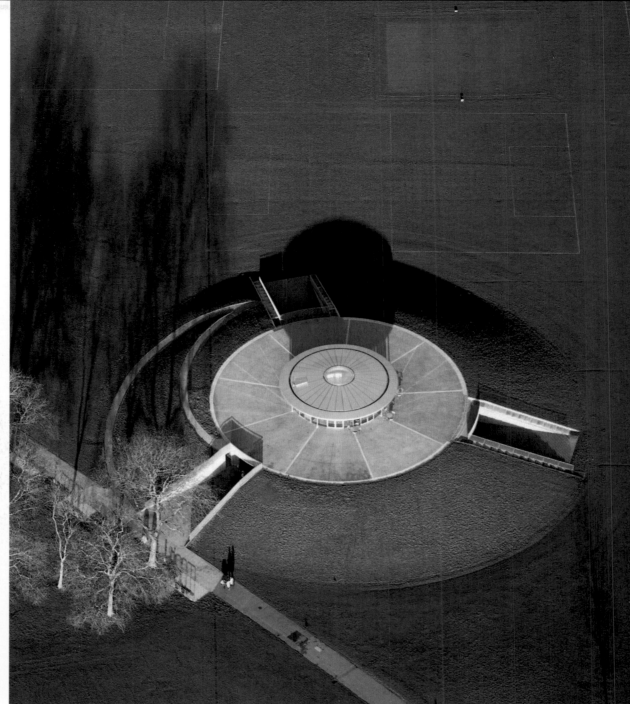

< LEFT
Hungerford Bridge looking down to Docklands
The busy Hungerford Bridge (bottom) takes trains from Charing Cross Station, while the next bridge downstream, Waterloo Bridge, gives walkers impressive views in both directions, situated as it is on a curve in the Thames. It has inspired poets and painters, as well as the singer-songwriter Ray Davies of The Kinks, who sent Terry and Julie across the river here in his *Waterloo Sunset*, an evocative song about London.

^ ABOVE
The Hub, Regent's Park
The Hub in Regent's Park is the aptly-named centre for many of the park's sports facilities. Beneath what looks like a flying saucer is a network of changing rooms and exercise rooms, Beneath the central silver circle is a cafe that has 360-degree views around the park and its numerous sports fields including football, rugby, cricket, tennis, hockey, athletics, softball and, for some, the delights of Ultimate Frisbee.

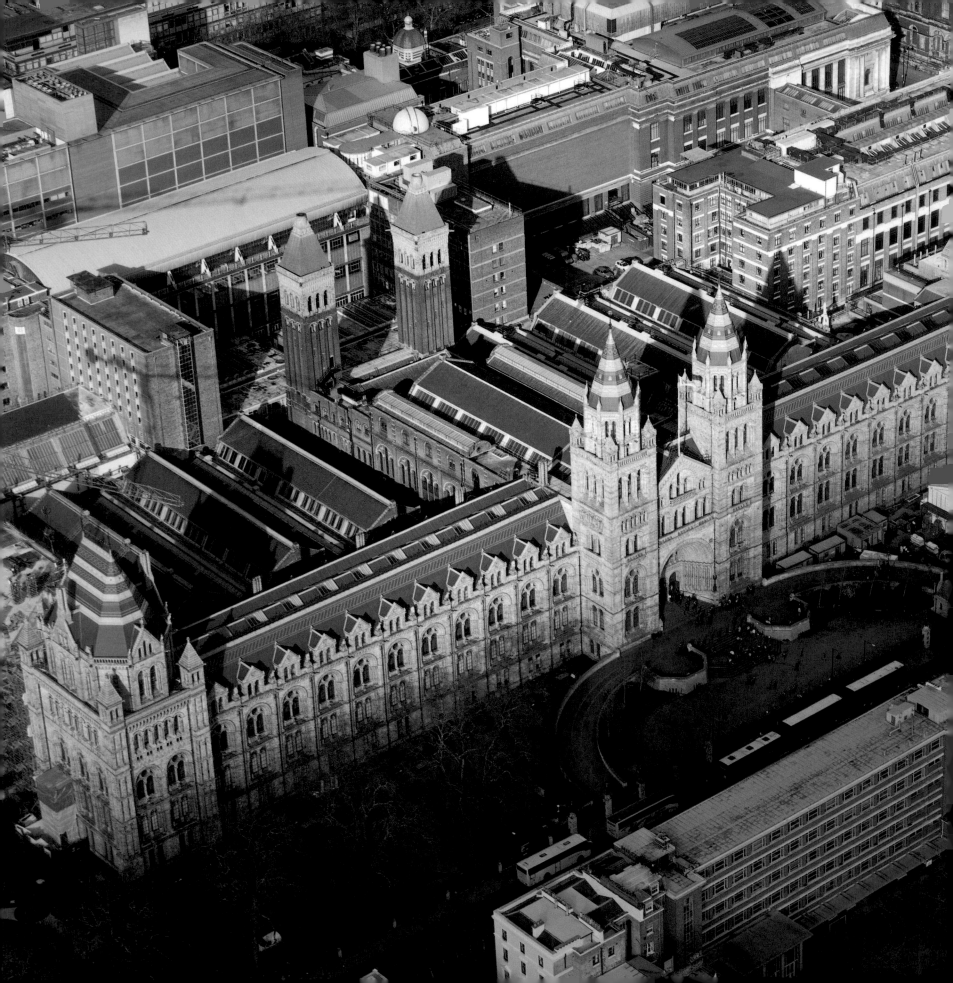

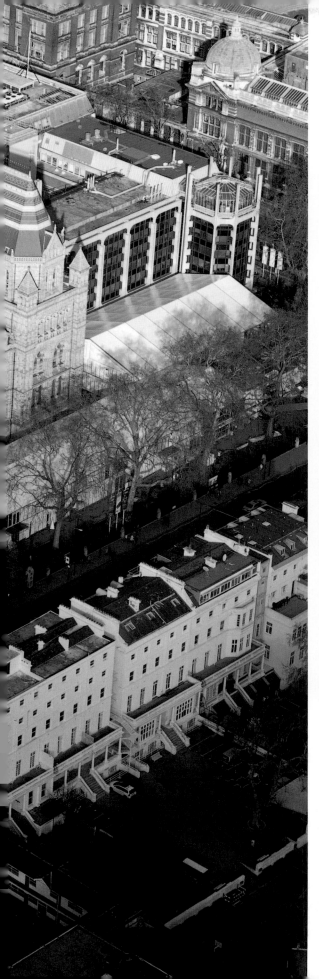

< LEFT
Natural History Museum

London's wonderful Natural History museum opened in 1881, its collections having been separated off from those of the British Museum. Many opposed the move to split the natural sciences from the arts, including Charles Darwin, but the result has been a building which surpasses the British Museum in its architectural style and now houses over 70 million items – including some collected by Darwin himself.

^ ABOVE
Soho Square

Soho has a well-known reputation for being the red-light district of London, but that is only a tiny part of what goes on in this fascinating historic area. Soho Square, shown here, was first laid out in 1681 and named King Square, after King Charles II, whose statue stands in the centre. Today it's known for housing the offices of Sir Paul McCartney, the Football Association and 20th Century Fox, among others.

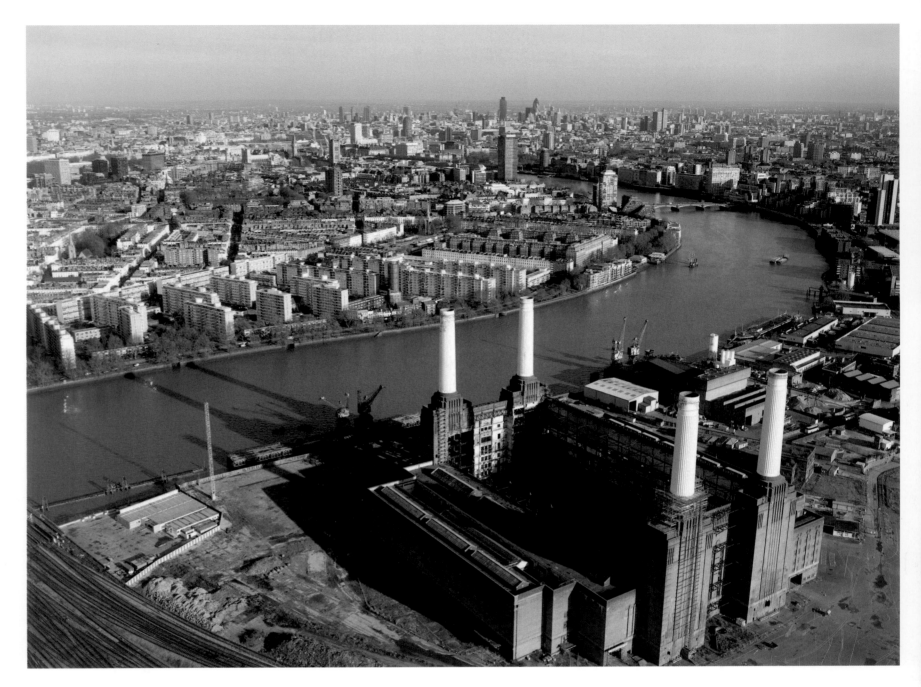

^ ABOVE

Battersea Power Station's location on the Thames, looking towards the City

The Battersea Power Station has been called a cathedral of power, once supplying electricity to much of the city it looks out upon. It has been a familiar figure to Londoners, with its monumental industrial authority, since it was opened in 1933. It remains an unlikely London icon, despite closing in 1983, since when it has been allowed to fall into disrepair despite several plans to develop it.

> OPPOSITE

Battersea Power Station

Battersea Power Station was designed by Sir Giles Gilbert Scott, a London-born architect whose work showed an incredible range. It was Scott who designed the red telephone box, and at the other end of the scale the monumental Liverpool Anglican Cathedral (the second-largest Anglican cathedral in the world). He also produced several more modest churches, and the Bankside Power Station, now housing the Tate Modern Gallery.

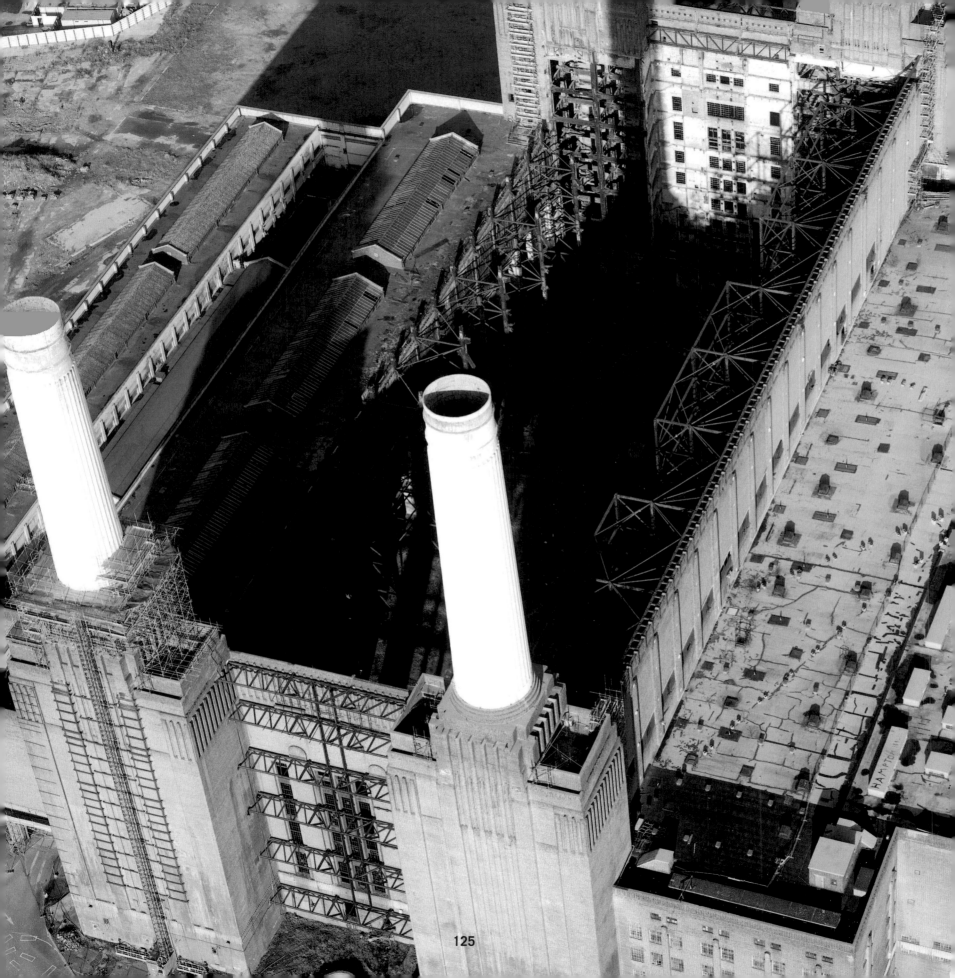

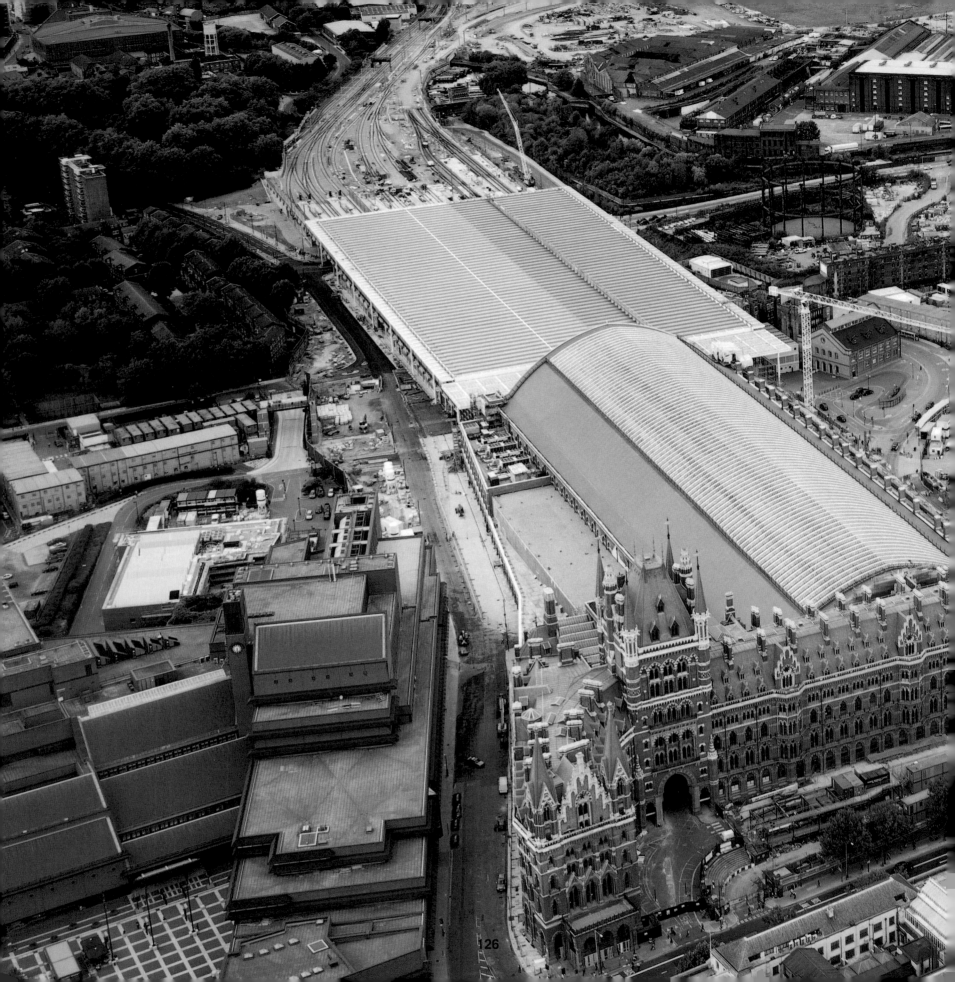

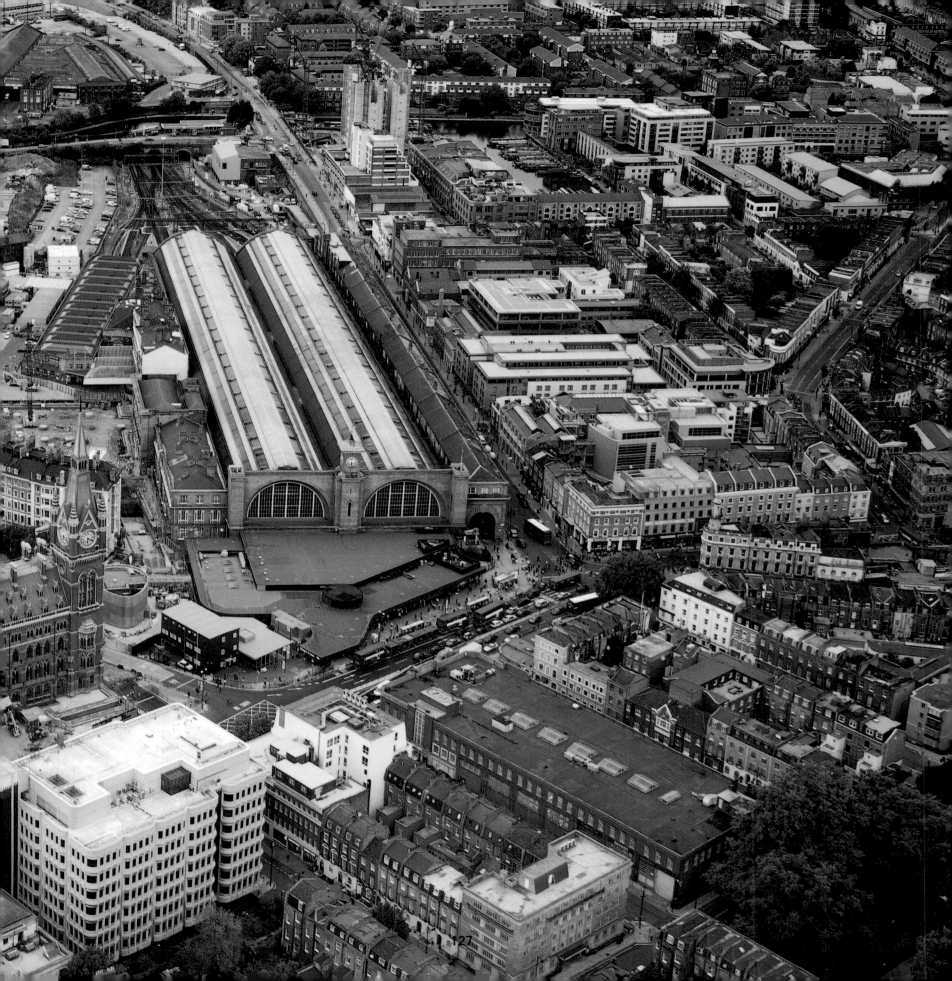

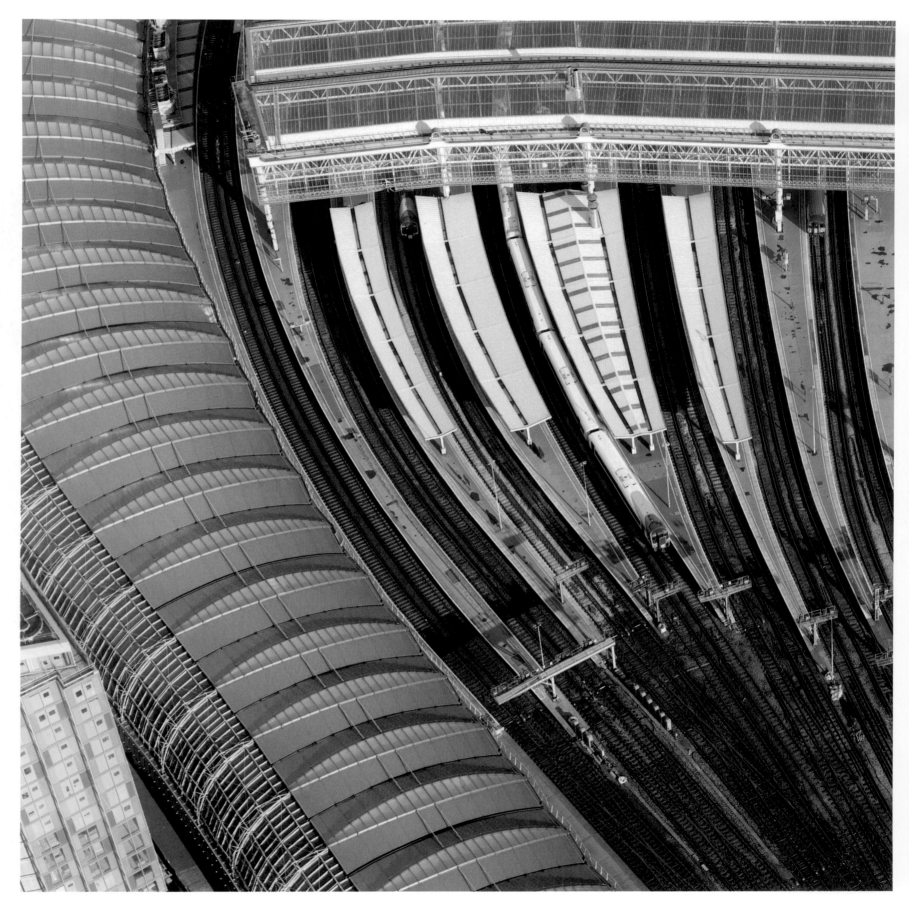

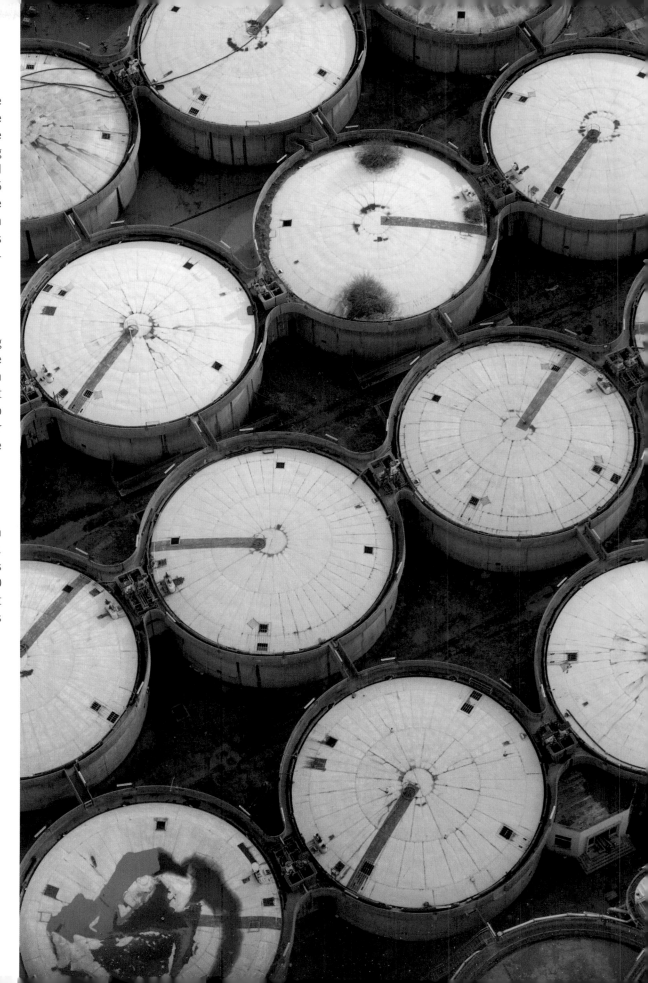

« PREVIOUS
King's Cross and St Pancras stations

Flanked by the British Library building on the left, and King's Cross Station on the right, the immense scale of St Pancras Station can be really appreciated in this aerial shot. The building dwarfs King's Cross, which is itself a good-sized station. The ornate front was originally the 1876 Midland Grand Hotel, which sadly didn't survive for long, and the building became rather forlorn and used as railway offices. At last some life is being breathed back into it, with Marriott re-opening it as a hotel in 2008.

< LEFT
Waterloo and the Eurostar terminal

The graceful lines of the Eurostar trains, taking passengers between Paris and London, are disappearing from the Waterloo terminal shown here, and will instead use the new terminal at London St Pancras (see previous page). Waterloo will continue as one of London's main stations for trains heading south, and the largest station in the UK covering a site of 24.5 acres.

> RIGHT
Tanks, East of City Airport, Newham

These water treatment tanks at the Beckton sewage works do more than just clean the water. A generator powered by the sludge produces enough energy each year for more than 7,000 households. Proposals for a desalination plant at Beckton to meet London's growing water needs will also focus on using 'green' energy.

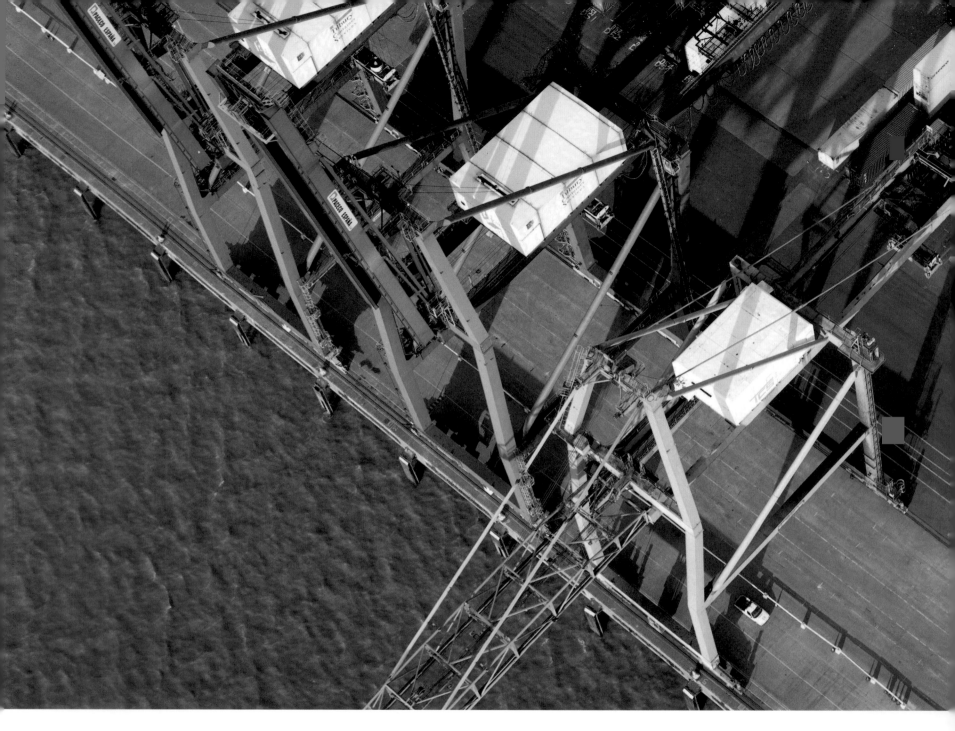

∧ **ABOVE**

Container Cranes at Tilbury Dock and Northfleet Hope, River Thames

In order to stay in business, London's docks had to change with the times. Among the £30 million of improvements at Tilbury Docks was the state-of-the-art Northfleet Hope container terminal, which opened in the 1970s. Here, massive cellular container ships dock in deep berths along the river, and with the help of gigantic, automated cranes, turn their cargo around in just 36 hours.

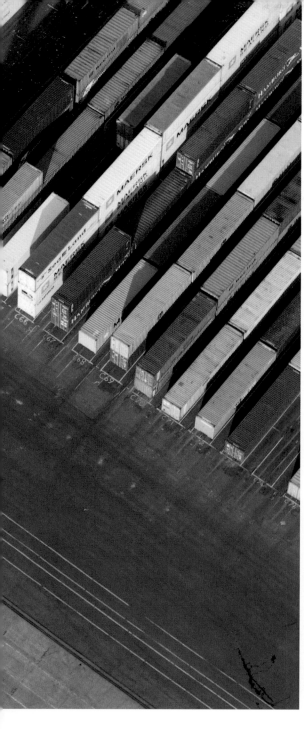

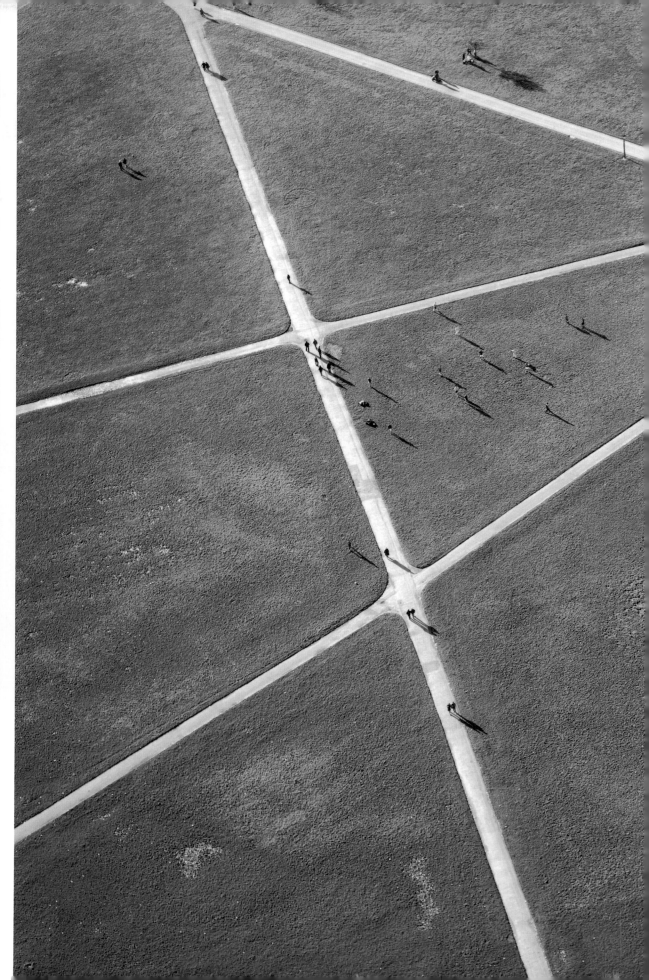

> RIGHT
Hyde Park in the spring
Hyde Park in the spring tempts Londoners out of doors, after the dark winter months. Along these paths increasing numbers of walkers and joggers can be seen, including occasionally celebrities like Madonna, jogging with her minders while staying at nearby prestigious Park Lane hotels like the Dorchester and the Hilton.

< LEFT
Lorry containers, Creekmouth, Barking

Creekmouth was once a tiny village of just 50 cottages, on the banks of an inlet off the River Thames near Barking. It was surrounded by marshes, with a lake and two duck ponds. There could hardly be more of a contrast with the busy trading area that it is today, as these container lorries show. It is destined to get busier, too, as the arrival of the Olympics in 2012 causes some businesses to relocate further east to here, followed by the arrival of a new extension to the Docklands Light Railway.

> OPPOSITE
Roof garden near Three Cranes Walk and Southwark Bride

It's good advice when walking round London to look up, and see the tops of the buildings, but no amount of looking will reveal the secret rooftop world that looking down can provide. This building on Three Cranes Walk, on the east side of the northern end of Southwark Bridge, looks very ordinary from the street but its roof conceals a secret garden whose symmetry and angles are best appreciated from above.

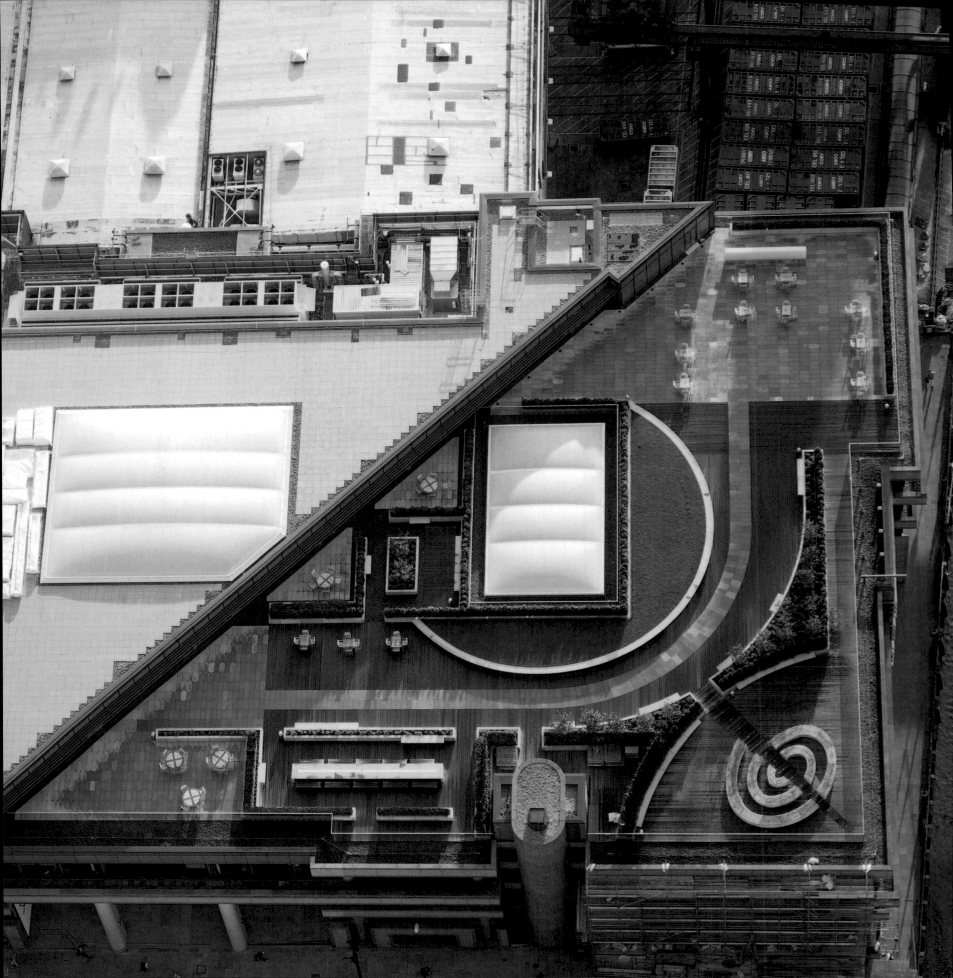

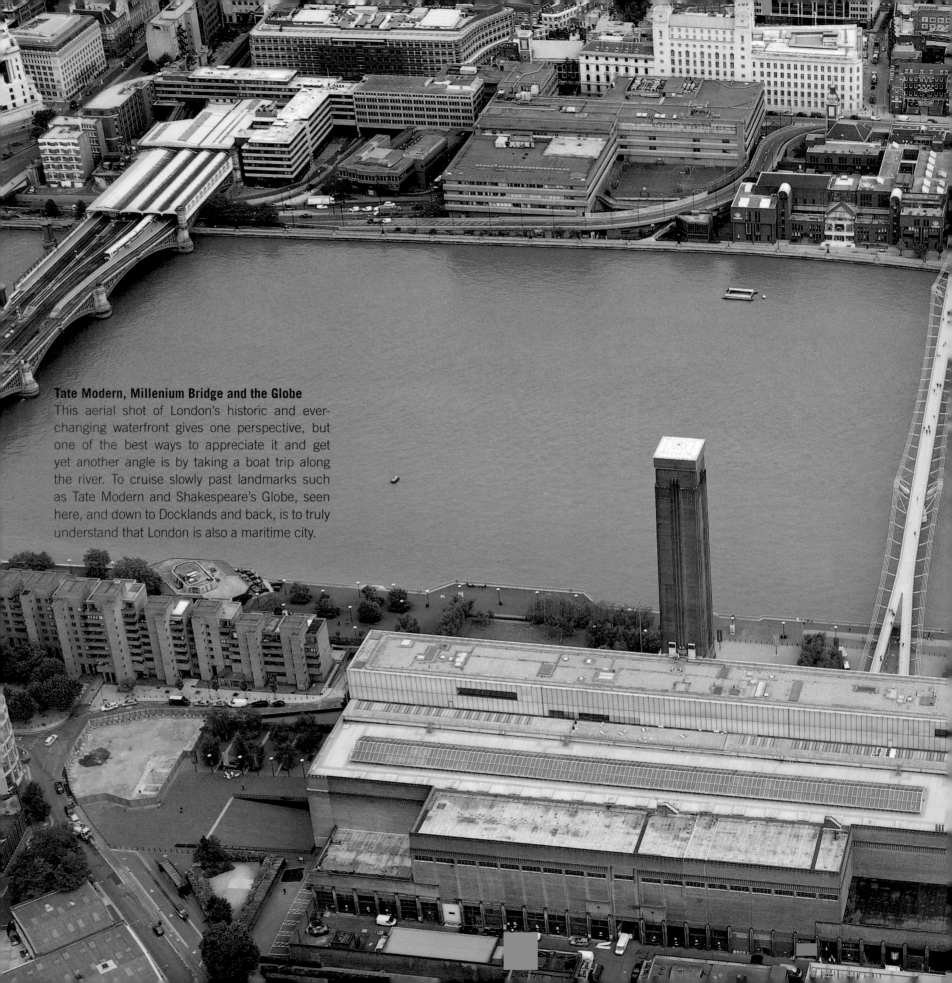

Tate Modern, Millenium Bridge and the Globe
This aerial shot of London's historic and ever-changing waterfront gives one perspective, but one of the best ways to appreciate it and get yet another angle is by taking a boat trip along the river. To cruise slowly past landmarks such as Tate Modern and Shakespeare's Globe, seen here, and down to Docklands and back, is to truly understand that London is also a maritime city.

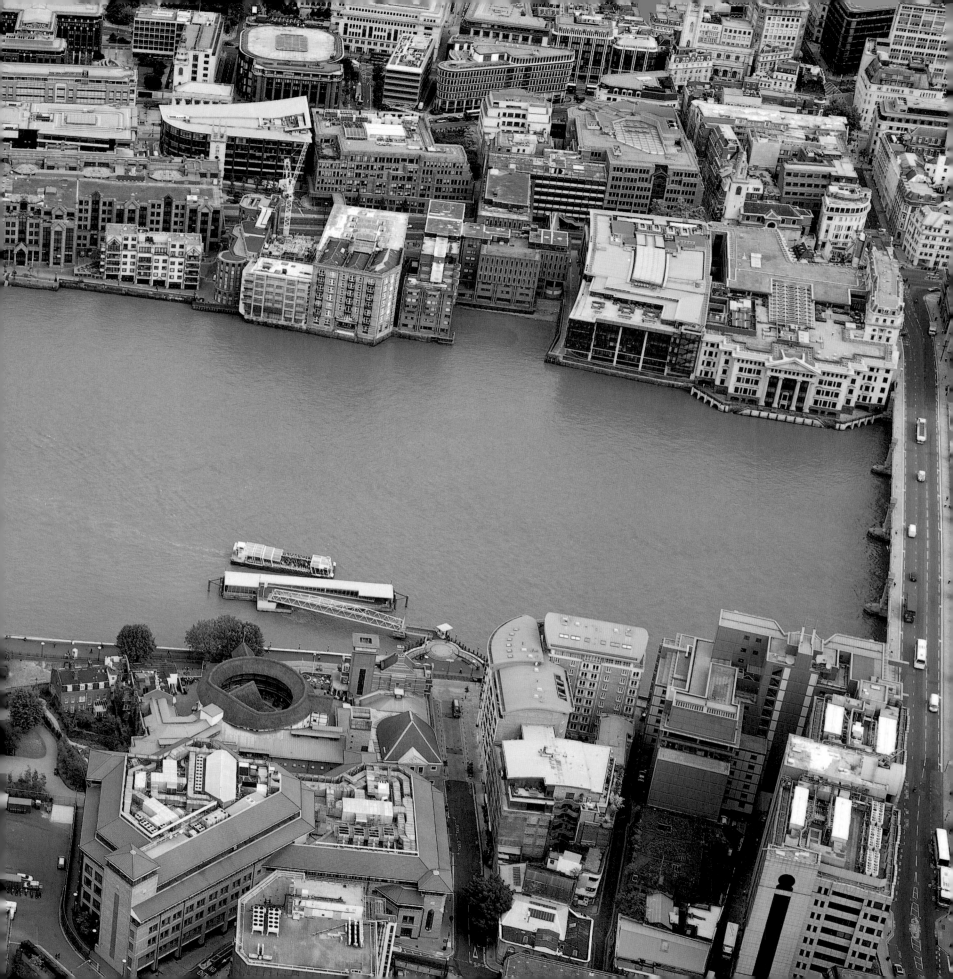

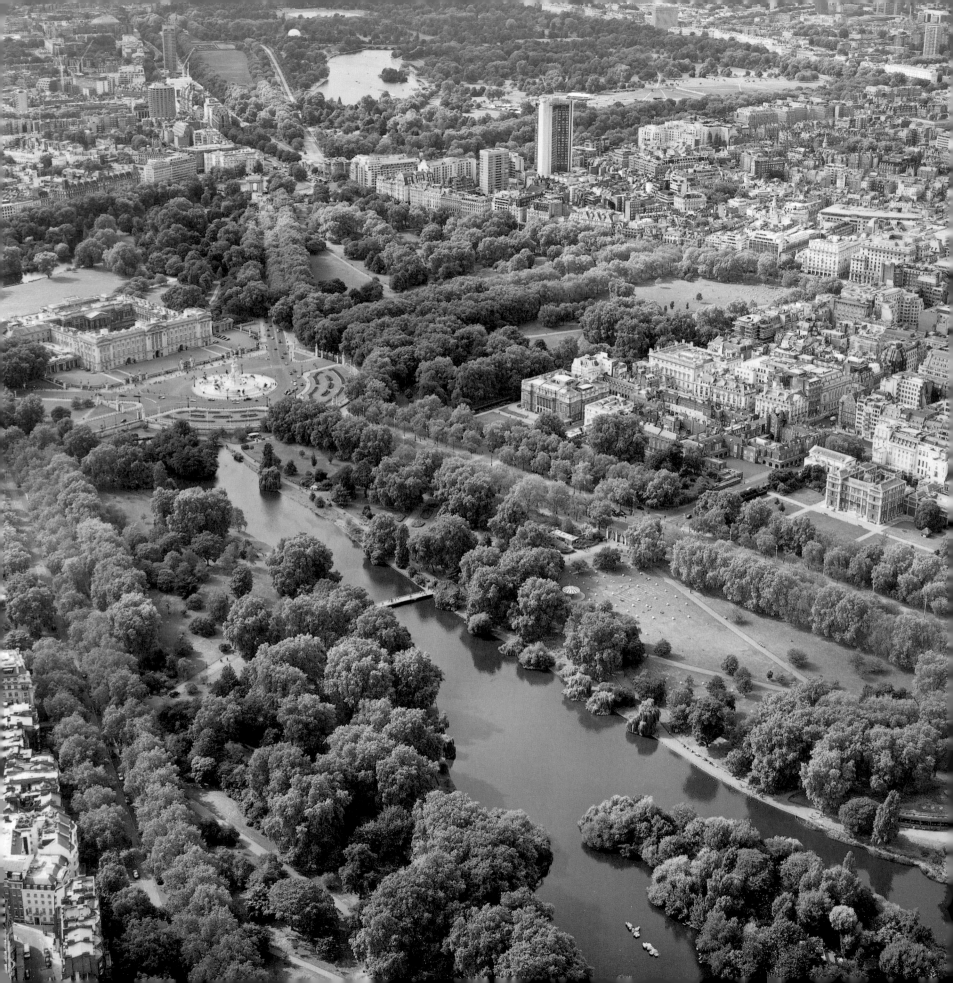

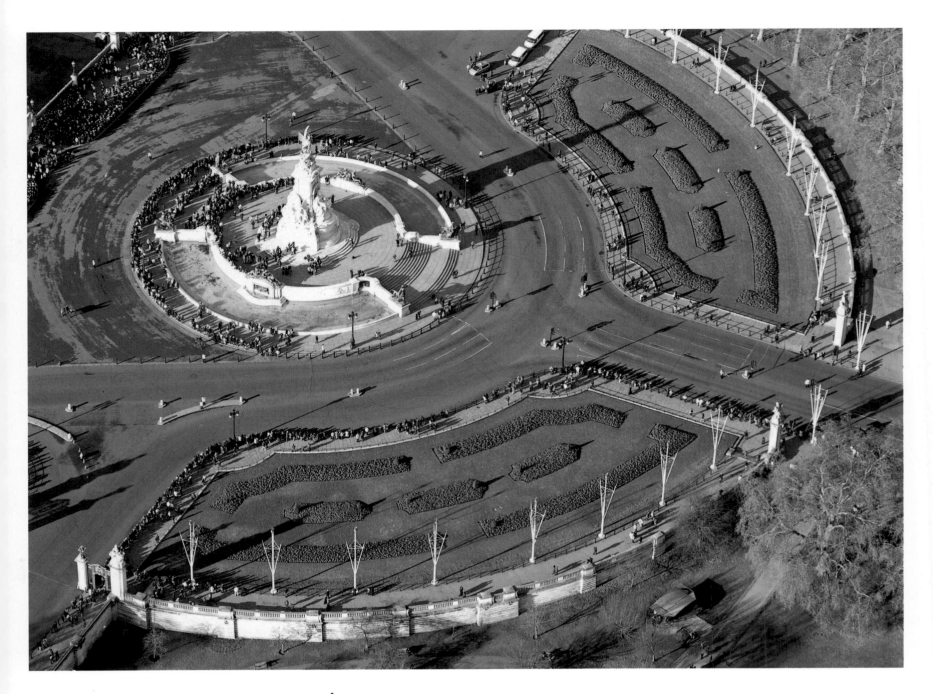

< OPPOSITE
St James's Park, the Mall, Buckingham Palace and Mayfair

The tree-filled expanses of St James's Park, Green Park and, in the distance, Hyde Park, give London the look of a leafy estate, focussed on the royal residence at Buckingham Palace. In fact some two-thirds of London is covered by either green spaces or water, while the lake in St James's Park in the foreground is home to ducks, geese and even some pelicans.

^ ABOVE
The fountain outside Buckingham Palace

The Victoria Memorial is more than a gathering point outside Buckingham Palace. It is a tribute to Britain's longest-reigning monarch, and the Queen who turned Buckingham Palace into a royal residence. For that reason it seems strange that the sculpture by Sir Thomas Brock has the Queen facing away from her home and down the Mall, but its 2,300 tons of white marble are as imposing as Queen Victoria herself once was.

^ ABOVE
Imax Cinema

Inside the British Film Institute's IMAX Cinema near Waterloo Station on London's South Bank is the largest cinema screen in the British Isles, almost the height of five London double-decker buses. The building was opened in 1999 and is a glass-enclosed cylinder, which is a striking sight when illuminated at night. The award-winning architect's design had to ensure that, despite being surrounded by traffic, underground and overground trains, it was totally soundproof.

> OPPOSITE
Oxo Tower

The white-topped Oxo Tower, overlooking the Thames, has an interesting history and has recently been revived. Despite its rather staid and ordinary exterior, the inside is filled with bright and innovative shops and galleries. The rooftop Oxo Tower Restaurant, Bar and Brasserie have also become a magnet for London diners who are keen to enjoy the superb food with breathtaking views across the river and a blue-lit ceiling which creates a moonlight effect at night.

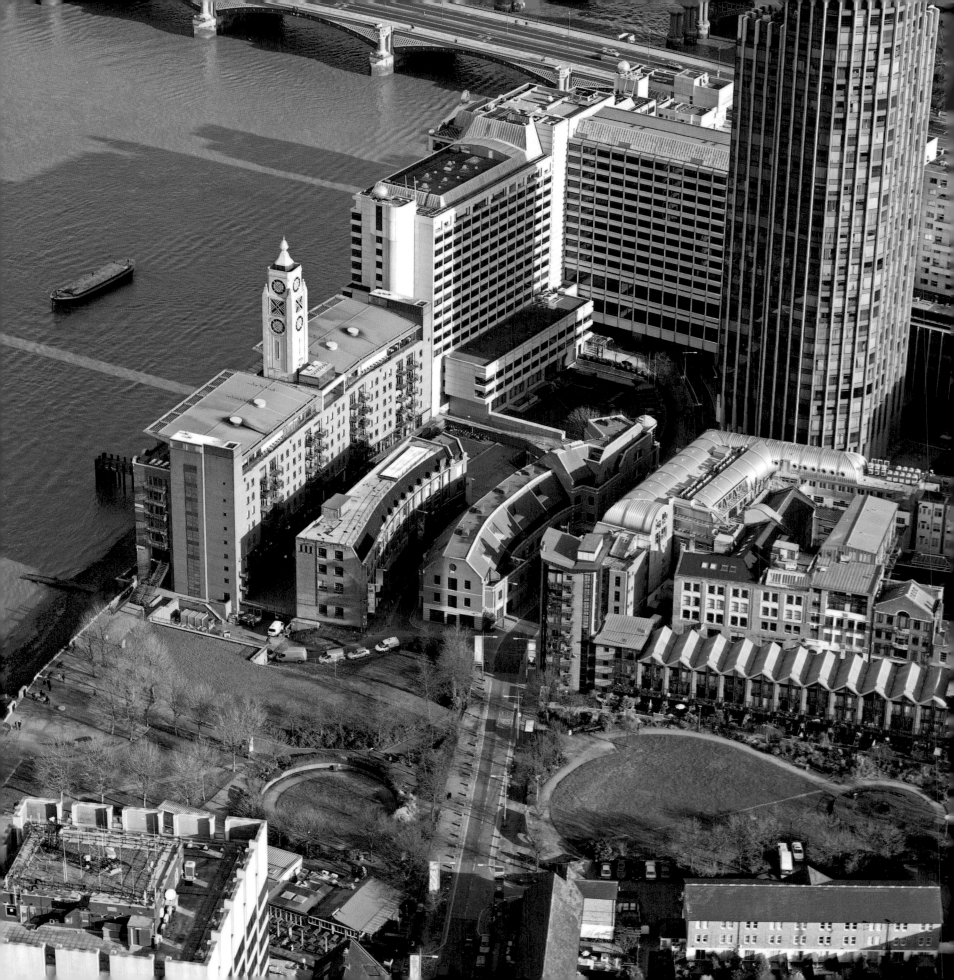

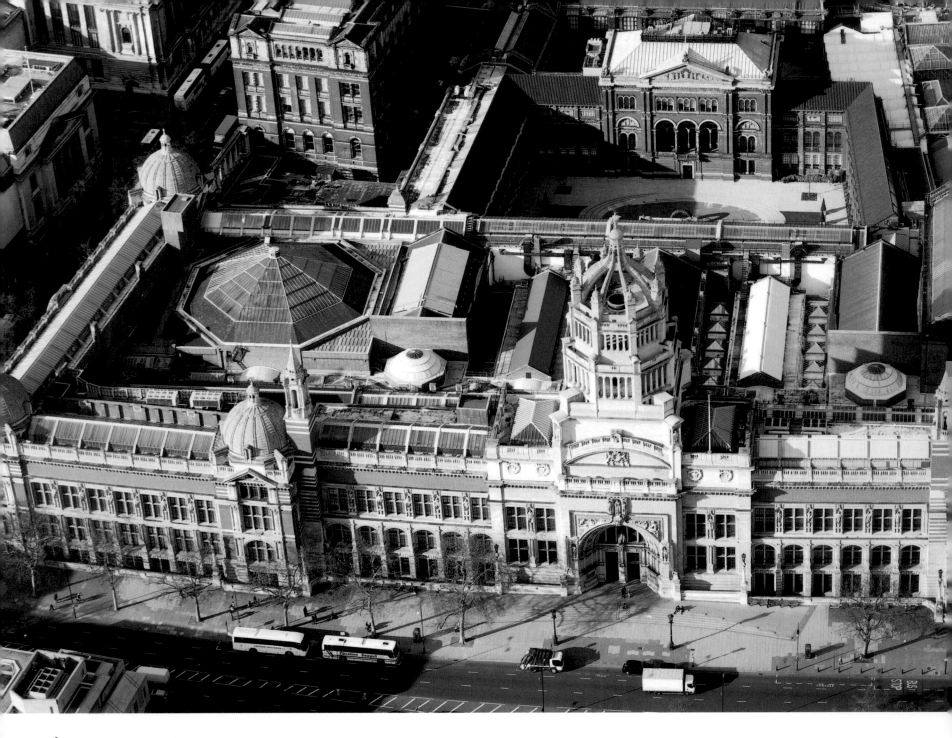

<ABOVE AND OPPOSITE >

The Victoria and Albert Museum

The Victoria and Albert Museum rivals the nearby Natural History Museum in the size of its collections, the affection with which Londoners regard it, and the sheer grandeur of its exterior. It houses over 4 million items in the applied and decorative arts, spread around 147 galleries covering a floor space of some 7.5 acres. The space is needed to accommodate the 2.4 million visitors a year who come to see its paintings, sculptures, photography, ceramics, jewellery, metalwork, glass, books, costumes and other items from every part of the world. The museum began life as the more general-purpose South Kensington Museum in 1852 and in 1857 it added a revolutionary feature which the world had never seen before in a museum: a cafeteria. The following year another ground-breaking feature was brought in: late-night opening, made possible by the use of gas lighting. The museum collection moved to its present grand building in 1909, having by now acquired its new name in memory of Queen Victoria and Prince Albert. Laying the foundation stone for the V&A, as it is popularly known, was Queen Victoria's last official public engagement in 1899.

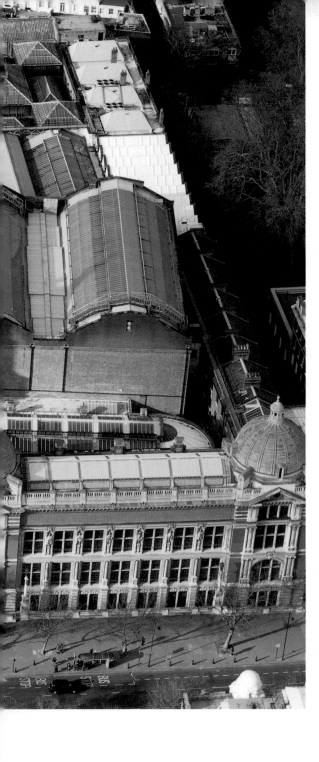
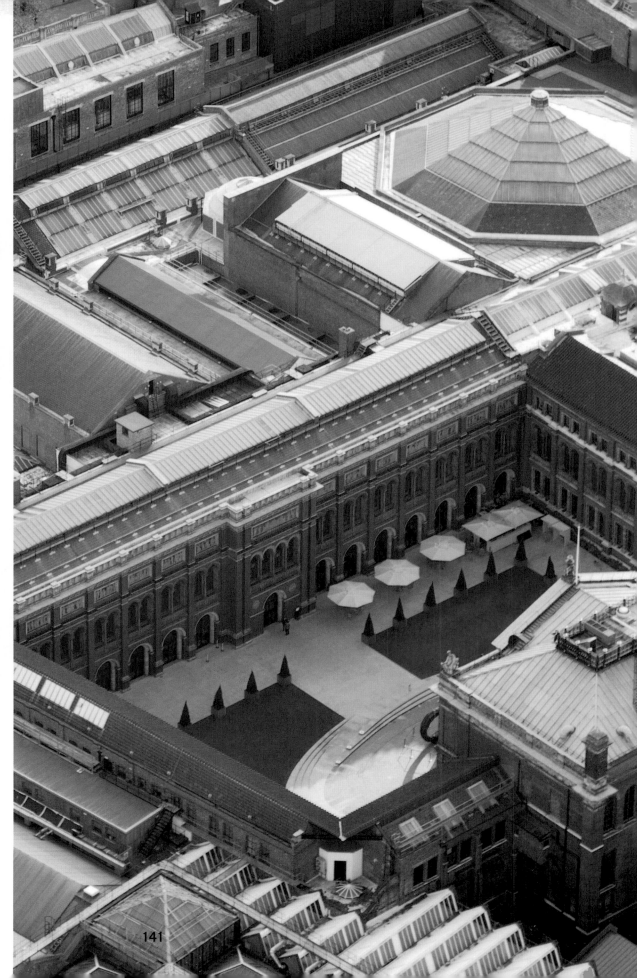

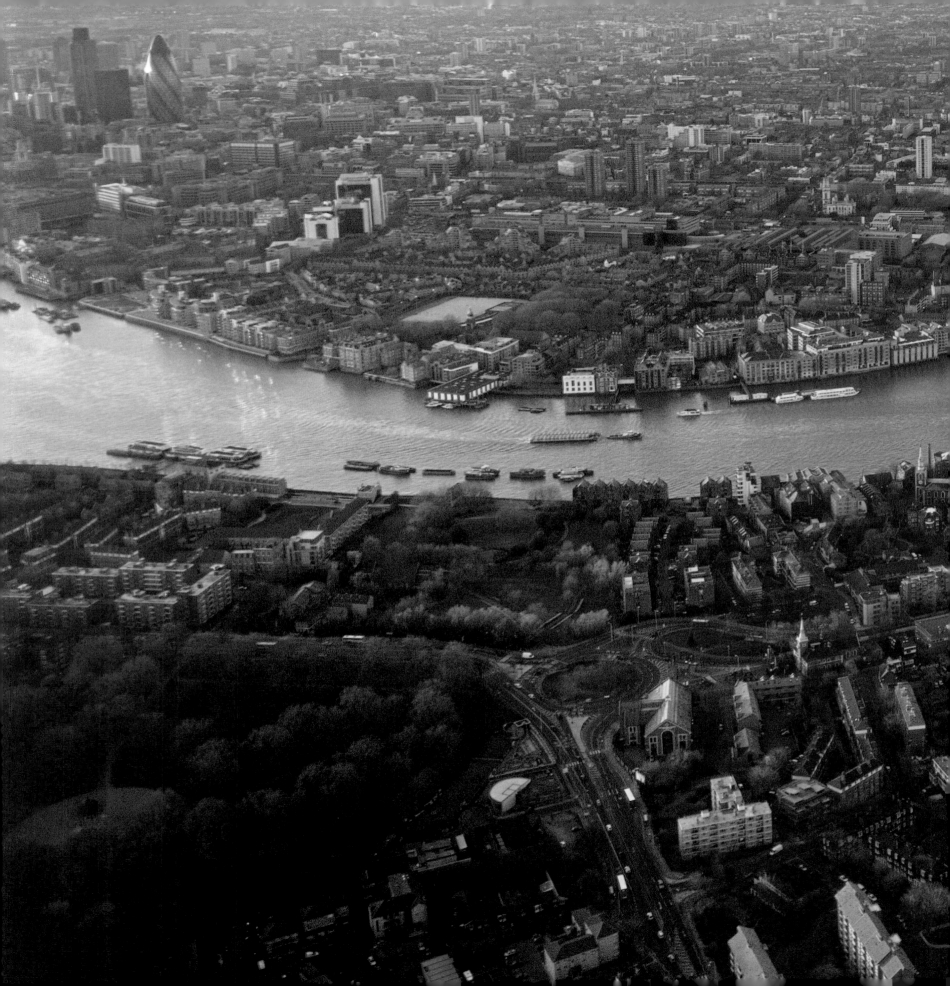

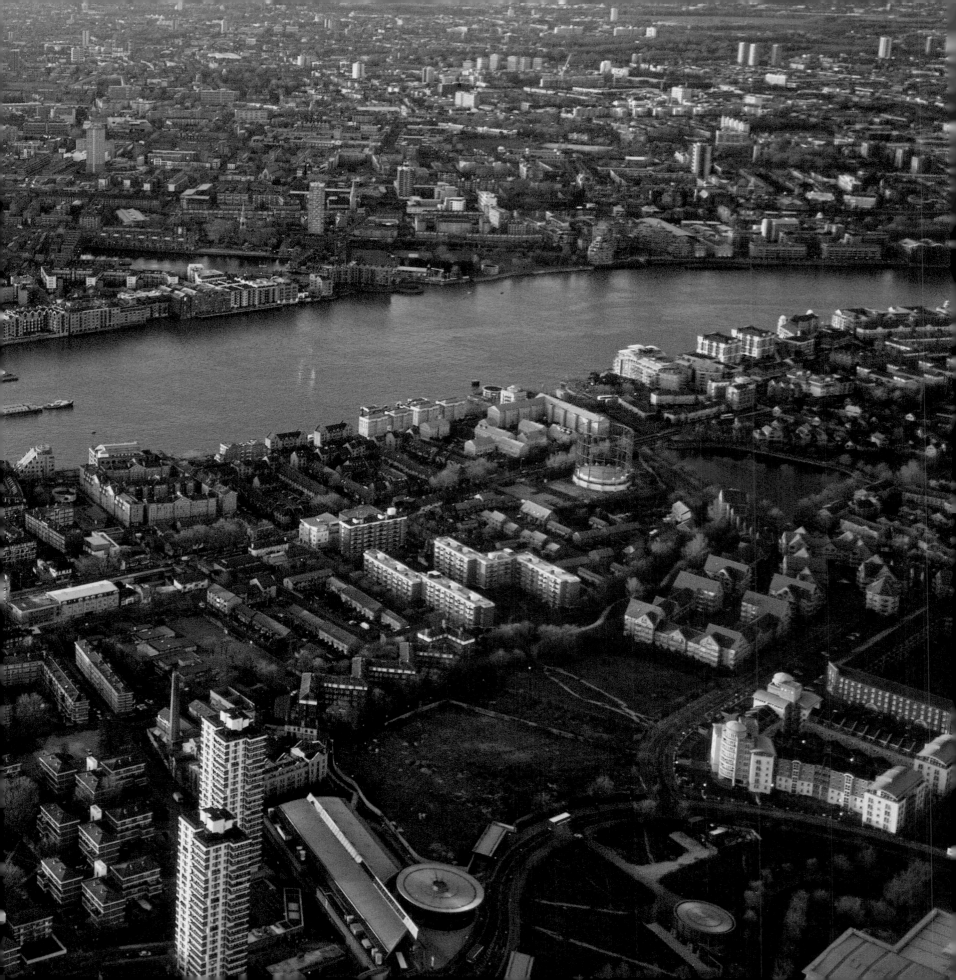

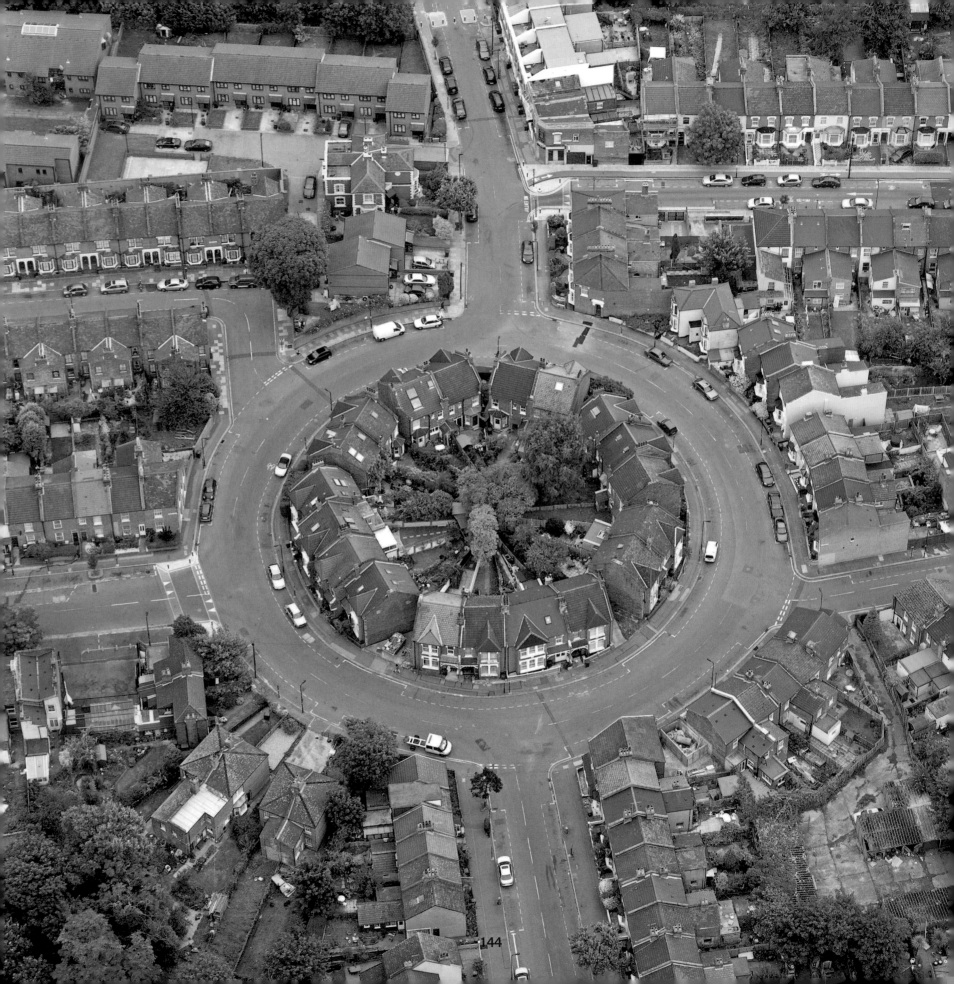

« PREVIOUS

From Southwark, looking north to Spirit Quay, Wapping and Shadwell

When the sun sets to the west of London and its last rays paint the city, the river seems to belong to the working boats and pleasure craft which glide through its waters. To take an evening pleasure cruise on the Thames provides another quite different view of the city, when the houses, restaurants, pubs and offices which line the banks come alive with lights and life.

< LEFT

Tottenham

It was the 1870s expansion of the railways out from central London into the further suburbs which caused a boom in housing, as people were able to live further away from their work and the age of the train commuter began. Not all housing was monotonous terraces, as this traffic circle of houses in Tottenham shows, although when they were first built it was probably easier to cross the road from your home.

∨ BELOW

Ilford

Looking at these regulated rows of houses in the north-east London district of Ilford, it's hard to believe that creatures like wolves, mammoths and rhinos once wandered freely here. It was the arrival of the Great Eastern Railway in 1839 that brought about the beginnings of a population boom and today the whole area of Redbridge in which Ilford stands has a population of about a quarter of a million people.

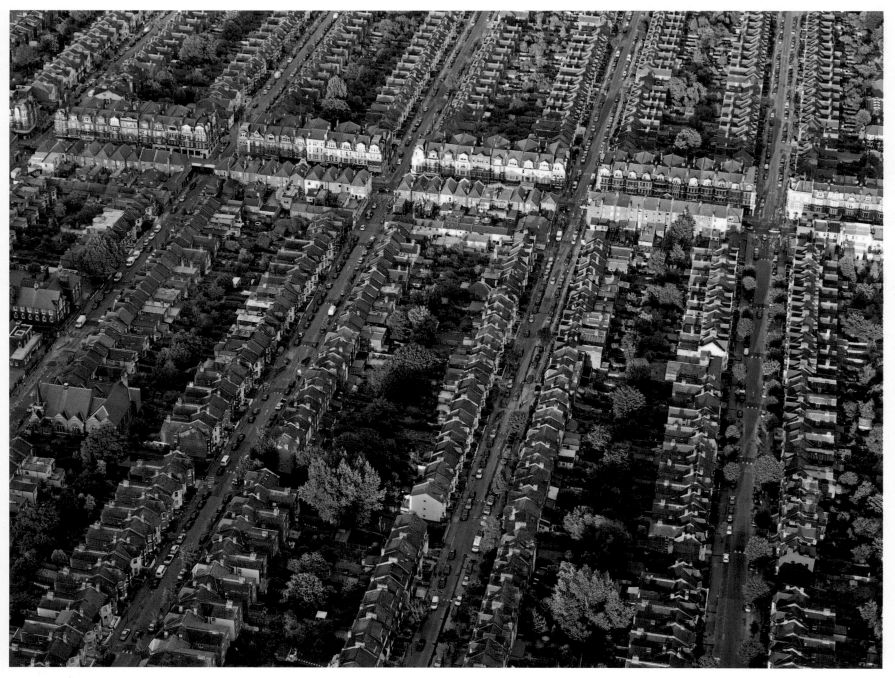

LONDON'S GREEN SPACES

London is one of the greenest cities in the world. From the grassy swathes of Hyde Park to the rolling expanses of Hampstead Heath and Richmond Park, Londoners have more places than most city dwellers to breathe fresh air, picnic and play, and feel the earth, rather than pavement under their feet. Even in the very heart of the city, you can walk the two miles from Westminster to Notting Hill entirely through parkland.

Altogether there are 1,700 parks in Greater London, covering some 70 square miles (181 sq km). In addition, dozens of leafy squares are dotted throughout the urban blocks of brown brick and concrete grey like a patchwork quilt. Some are private, for residents only. But many are public squares, where couples rendezvous and office workers eat their lunch on park benches. Gardens along the banks of the Thames, playing fields and commons, and ancient churchyards also provide peaceful green retreats from the noise and pace of the city.

Much of London's green space was once the private domain of Britain's monarchs, comprising land surrounding historic palaces and royal hunting grounds. Today there are eight Royal Parks – Bushy Park, Green Park, Greenwich Park, Hyde Park, Kensington Gardens, Regent's Park, Richmond Park and St James Park – covering 5,000 acres. They have given the city not only a great natural legacy but also some delightful history.

At nearly 2,500 acres, Richmond Park in west London is the largest of the Royal Parks. It is the oldest as well, dating back to the reign of Edward in the 13th century. Charles I moved the court to Richmond Palace in 1625 to escape an outbreak of the plague, and enclosed the land 12 years later to create a park for red and fallow deer. The deer remain a highlight of the park to this day. The landscape has changed very little over the centuries, encompassing grasslands, hills and giant oaks, some

of which are more than 600 years old, and a beautiful woodland garden in the Isabella Plantation. Because of its rich flora and fauna, Richmond Park has been designated a National Nature Reserve.

Richmond is not the only London park to shelter wildlife. A small herd of deer also lives in Greenwich Park in the southeast of the city. They were introduced by Henry VIII, who was born here in the former palace, long ago demolished. From the hilltop, crowned by the Royal Observatory, there are sweeping views across the Thames.

With its long lake, islands, and footbridge, St James Park is the most romantic of central London's parks. This was another of Henry VIII's old deer parks, but Charles II had it landscaped in the French style and opened it to the public so that he could stroll the tree-lined grounds with his mistresses. Charles also set up an aviary along Bird Cage Walk. When the Russian ambassador gave the king a pair of pelicans, his gift established the park as a wildfowl sanctuary. Today some 30 species, including black swans, make their home here.

The adjacent Green Park is the next link in a chain of open green spaces in central London. It was a notorious duelling ground until the mid-17th century. Later it became a fashionable pleasure garden, though the buildings from that era are long gone. The aura lives on, however, in the rather incongruous sight of green-and-white striped deck chairs spread out across the sweeping lawn where, on fine days, Londoners catch the sun just yards from the bustling traffic of Piccadilly.

Opposite Green Park is central London's great green lung, Hyde Park, which covers 350 acres. With its lake, lido, trails for horseback riding and more than 4,000 mature trees, it's an instant escape from urban

pressures. From games of football and baseball on the vast lawns, to swimming, rowing, roller-skating and cycling, Hyde Park is the great playground for residents of the city centre. Outdoor music concerts featuring artists from Pavarotti to pop bands are staged here, too. Across the Serpentine, the long lake created in the 1730s by Queen Caroline, Hyde Park merges seamlessly with Kensington Gardens. Anchored at the west end by Kensington Palace, it features ornamental flower gardens, the Round Pond, and famous and popular landmarks such as the Albert Memorial and the Peter Pan statue.

Rose gardens are the highlight a mile north in Regent's Park. More than 30,000 roses of 400 varieties bloom in the 17-acre circle that forms Queen Mary's Garden, planted to honour George V's wife in the 19th century. Bordered on the north by the Regent's Canal, the park also has a boating lake. There's wildlife here, too, in the form of the menagerie at the London Zoo.

A variety of gardens is on display in Holland Park, tucked away among the mansions of the surrounding neighbourhood. Along its pretty paths are formal gardens, a rose garden, iris garden, Dutch garden, a Japanese Kyoto garden and woodlands blooming with azaleas and rhododendrons.

The prime place for Londoners to indulge their passion for gardens is the Royal Botanic Gardens at Kew — better known simply as Kew Gardens. What began as a centre for horticultural research following the exploratory voyages of the 18th century has become a magnificent green monument spread over 300 acres, showcasing trees and plants from around the world. Glasshouses shelter palms, orchids, and numerous tropical and temperate species, while the grounds are laid out with mature trees, gardens and grand vistas that offer something to see in every season.

A public outcry saved Hampstead Heath from developers in 1829. After 40 years, the conservation battle was finally won, saving nearly 800 acres in north London for the enjoyment of all. Its elevation affords fantastic views over the city, and on a clear day you can see Canary Wharf, the London Eye and beyond to the North Downs. The Heath has large, undeveloped areas of grassland, mature woodland, hills and bog, which support a variety of wildlife. The lack of signposts adds to the rural feel of the more remote sections. There are also several ponds, three of which are used for swimming. Today Hampstead Heath is one of London's most popular green spaces, and people come from all over the city to walk, picnic, fly kites on Parliament Hill or attend summer concerts on the lawn at Kenwood House.

In contrast to the parklands for royalty or the genteel folk of London's suburbs, Victorian sentiment in the mid-1800s led to the creation of other green spaces to improve life for the working classes. Swampy fields on the south side of the Thames became Battersea Park in 1858, giving what one contemporary writer called 'tens of thousands of mechanics, little tradesmen, apprentices, and their wives and sweethearts' a place to stroll on Sundays. Victoria Park, which had opened a decade earlier, was another such People's Park, bringing a breath of fresh air to the poor of London's East End.

With housing at a premium in the capital today, 'green space' takes on a new meaning for the 21st century. In 2007, London began building the country's first green eco-suburb at Gallions Park, a toxic piece of wasteland in Docklands. The three-acre estate is designed to be energy self-sufficient, using non-polluting carbon-free renewable sources. It is hoped that London's East-End 'ecopolis' will help to lead the way to a green and pleasant future for the city.

∧ ABOVE
The Grove, Highgate

London is often said to be made up of a collection of villages, and this view of Highgate in north London shows how accurate this statement can sometimes be. Highgate was once a village, adjoining the hunting estate of the Bishop of London. This view of the church surrounded by trees and green spaces could easily be a village deep in the English countryside.

> OPPOSITE
Victoria and Westminster RC Cathedral

In contrast to Highgate. this could be nowhere else but the centre of a thriving metropolis. The River Thames flows by the ancient Palace of Westminster, and the modern London Eye. In front of the Houses of Parliament is Westminster Abbey, the centre of the Church of England, and in the foreground Westminster cathedral, the mother church for the Roman Catholic community.

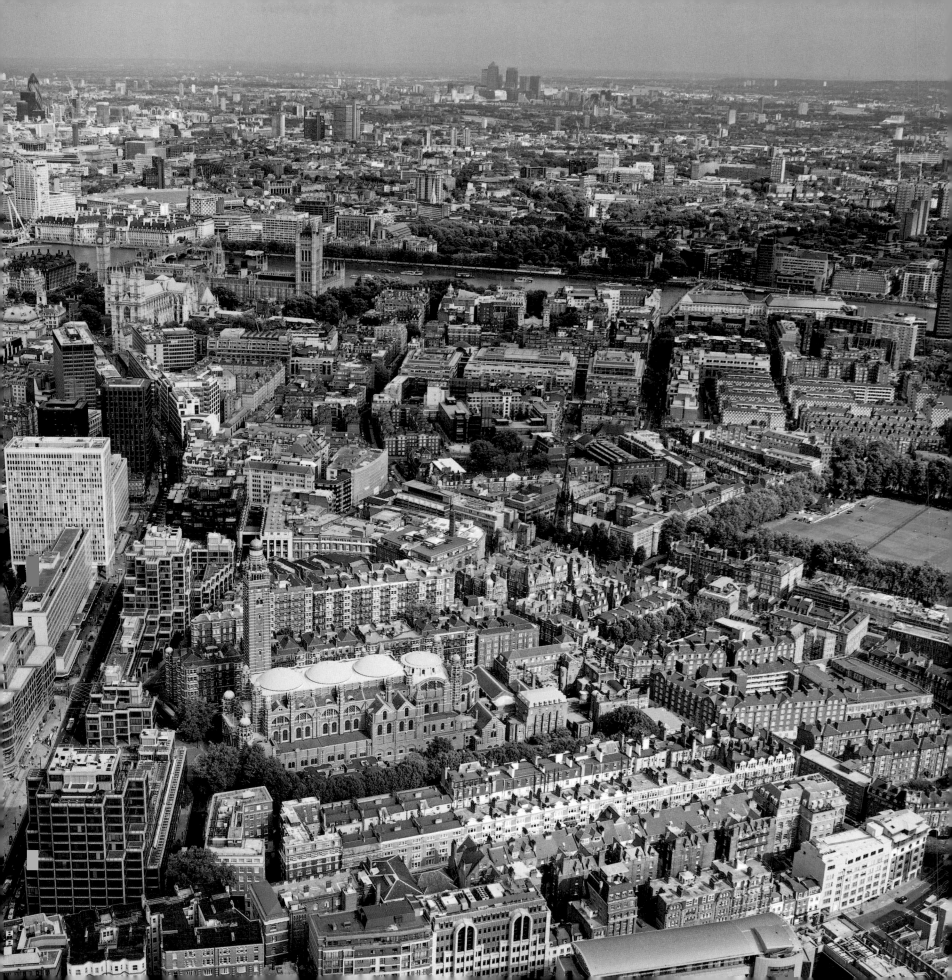

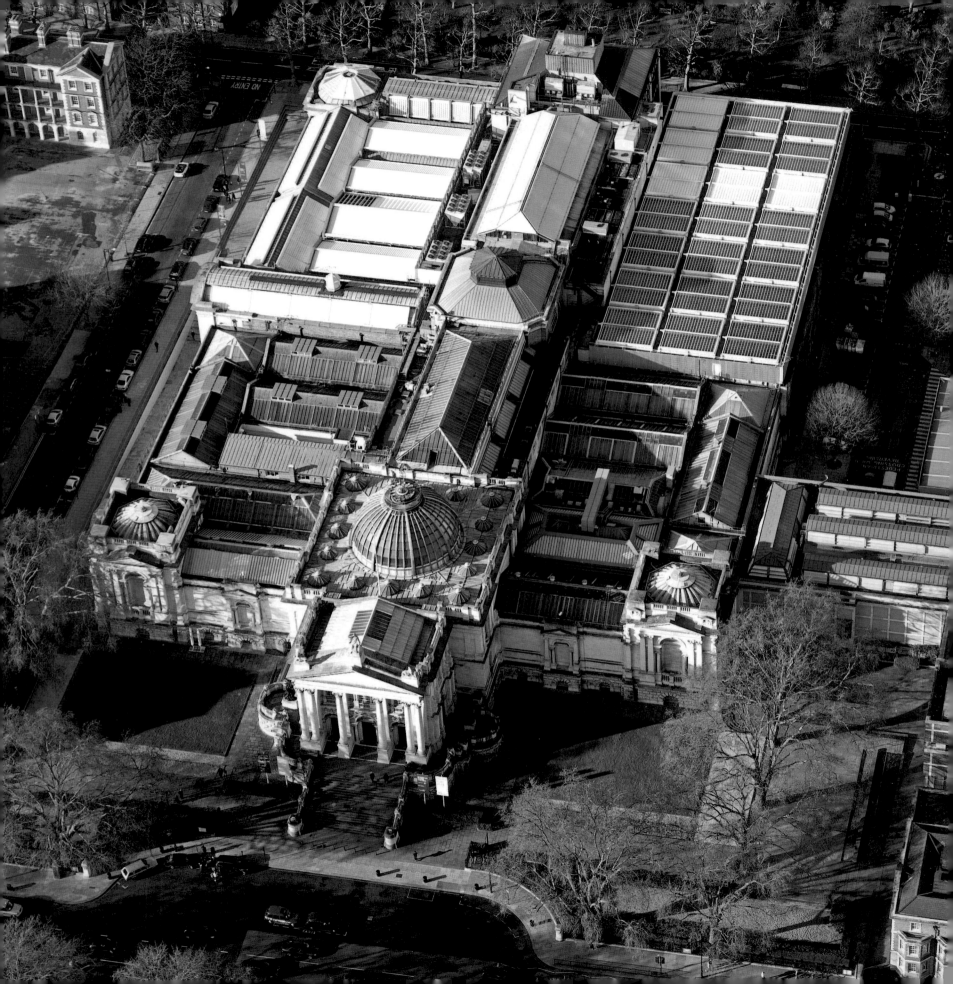

< OPPOSITE

Tate Britain

Looking down on the Tate Britain art gallery like this, it isn't difficult to conjure up an image of Millbank Prison, which once stood on this site. The present building was opened in 1897 as the National Gallery of British Art, and it owed its existence to the funds and the dream of Henry Tate, the sugar millionaire. He paid for the building and donated his collection of art, and despite the designated name it was always referred to as the Tate Gallery. In 1932 that became the official name.

^ ABOVE

Ministry of Defence

The imposing Ministry of Defence building on Whitehall was built in the 1950s during the Cold War, and could ironically be mistaken for a Russian housing block. It was in fact the largest office block in London when it opened in 1957. Below the building, and obviously well-protected, are Cardinal Wolsey's wine cellars, which later became Henry VIII's wine cellars when Wolsey fell from grace. They are all that survive of Whitehall Palace, destroyed in a huge fire in 1698.

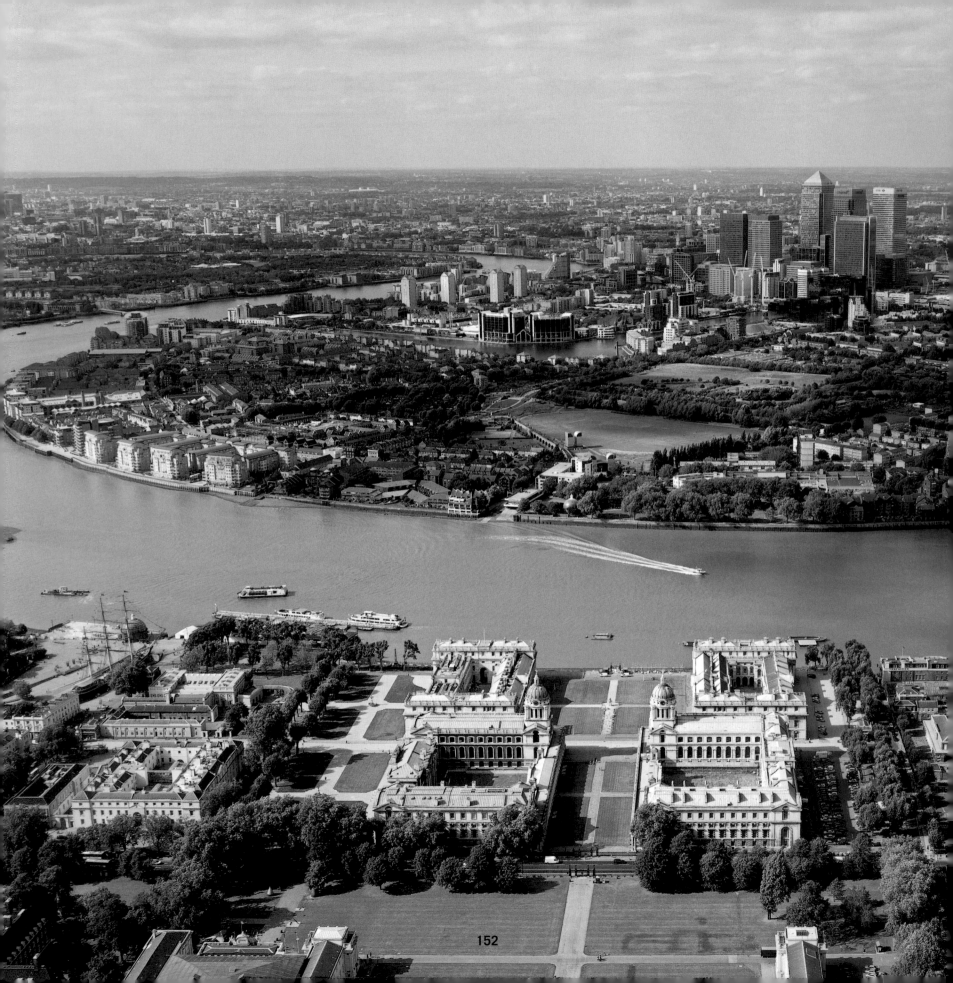

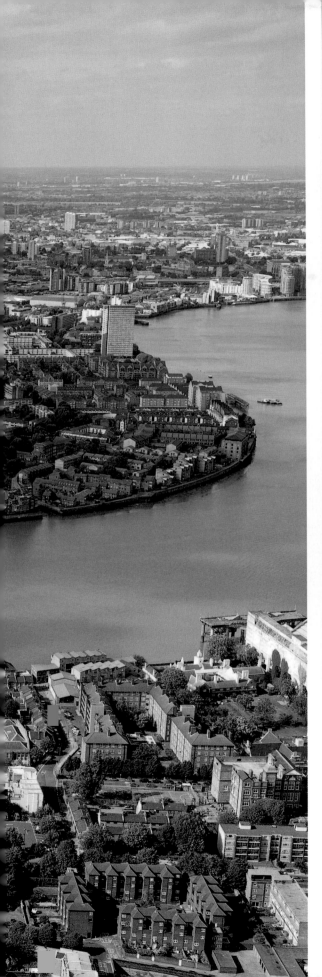

< LEFT
Greenwich Royal Naval College, Cutty Sark, Thames Reach and the Isle of Dogs
Remove the distant tower blocks from this view over the Old Royal Naval College at Greenwich, and you are transported back in time to the days of the British Empire, when Britannia ruled the waves. The Naval College was originally built as Greenwich Hospital between 1696 and 1712, and designed by Sir Christopher Wren.

^ ABOVE
One Canada Square, Canary Wharf
The tallest of the buildings visible in the picture to the left is One Canada Square at Canary Wharf, the tallest inhabitable building in the British Isles. Up close it seems to be a building that belongs in the future, not the present, and to see the view from the top you will have to work for one of the financial institutions that occupy the tower, as there is no public access.

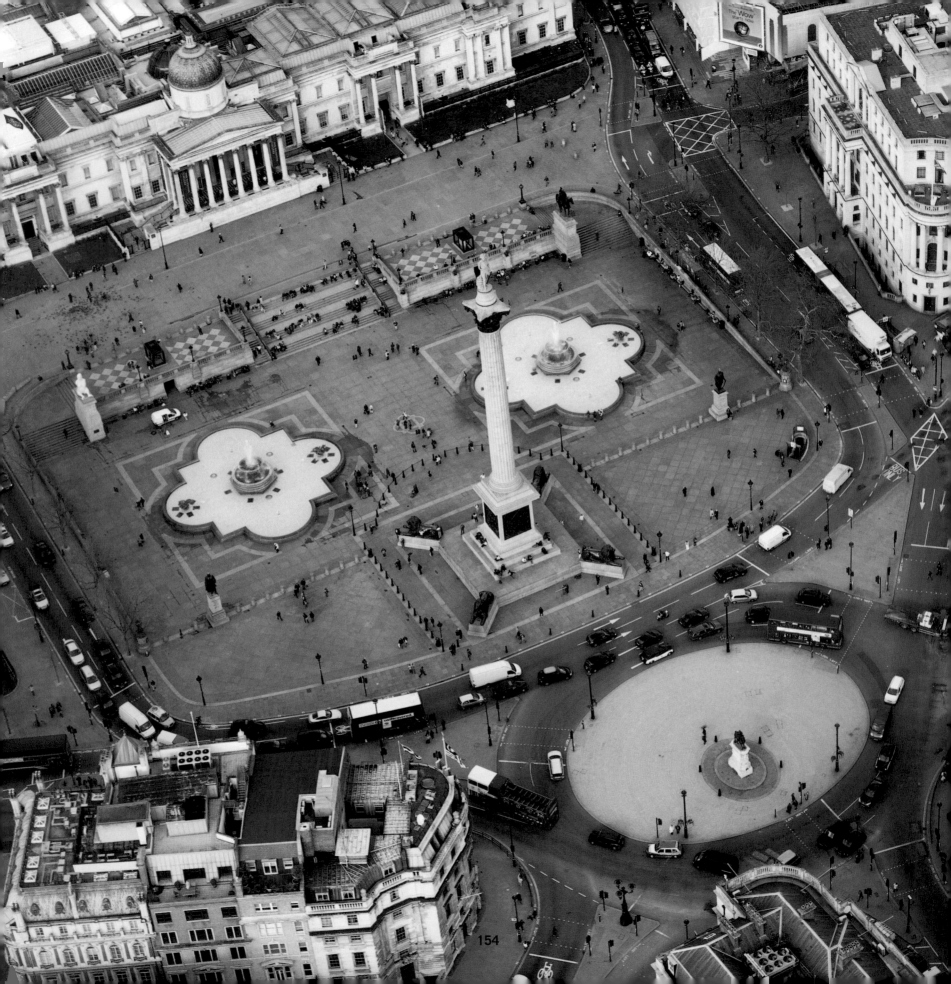

154

< OPPOSITE AND RIGHT >

Trafalgar Square and Nelson's Column

Every great city needs a great square, and London's is Trafalgar. Although the name commemorates Lord Nelson's famous 1805 victory over the French and Spanish navies in the Battle of Trafalgar, during which he lost his life, the square itself was not opened until 1845. It's impossible to say that it was completed then, as it is constantly changing, in ways both large and small. The busy road which once ran across the top of the square, cutting it off from the National Gallery, was recently closed and the area pedestrianised. The feeding of pigeons was also banned, with not a little controversy, but it has cleaned up the square, which is popular for political rallies, demonstrations, speeches and for New Year's Eve celebrations.

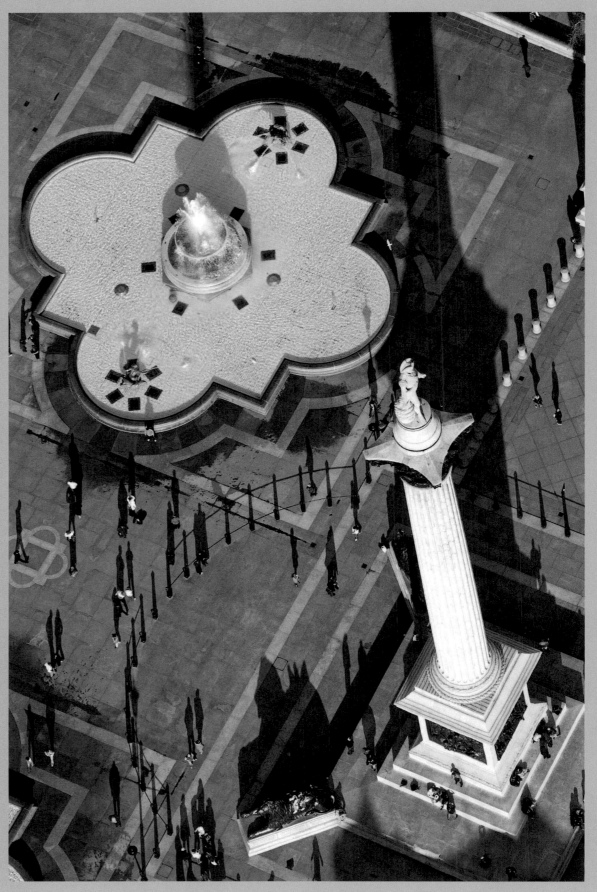

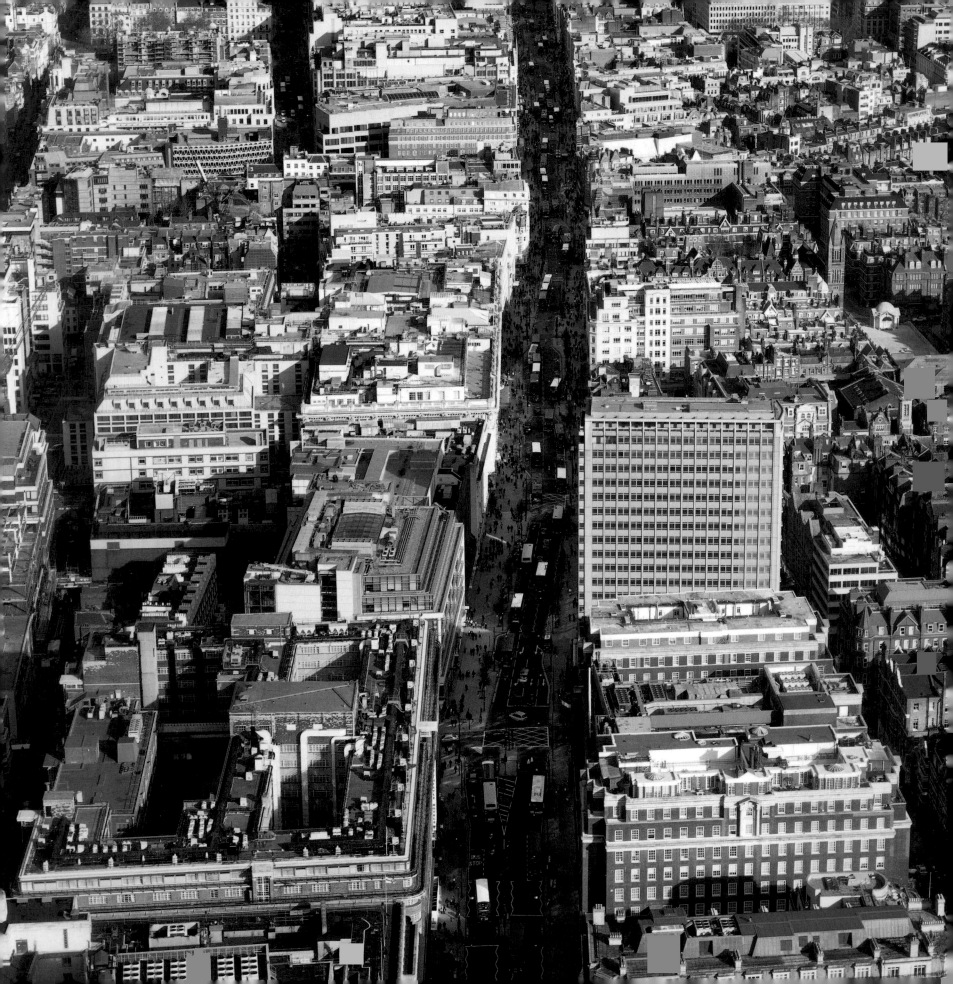

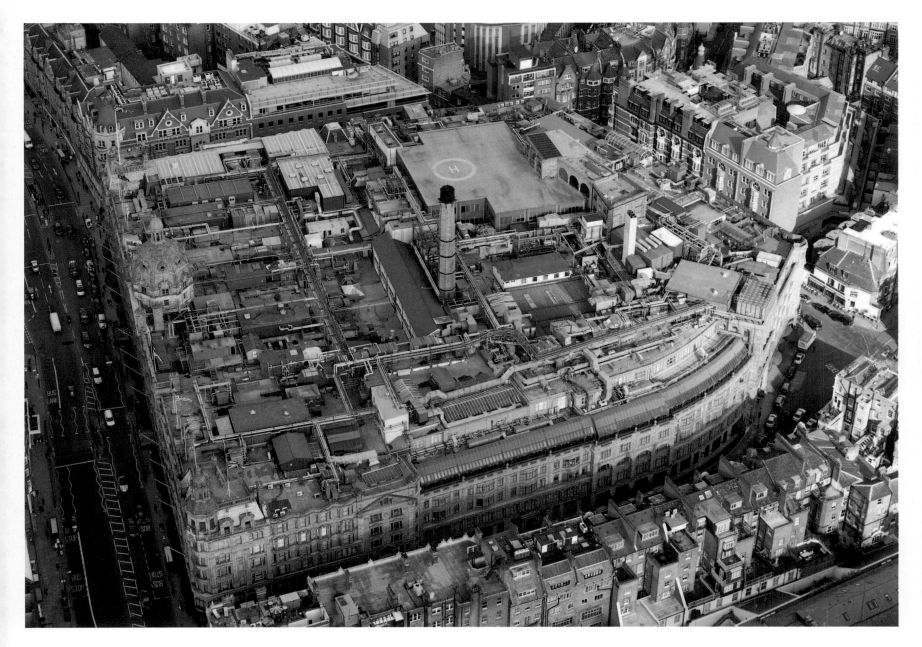

< **OPPOSITE**
Oxford Street

London's famous Oxford Street looks better from a distance than it does up close, and has an illustrious history but a fairly mundane present. Its straightness is due to the fact that it was the start of the original Roman road from London to Oxford, and it later became home to London's wealthy as the West End began to develop as London's centre. Today, though, its pavements are packed with shoppers and visitors, with the good stores outnumbered by fast food places and a shop from every chain store in the country.

^ **ABOVE**
Harrods, Knightsbridge

The history of London's magnificent Harrods store goes back to 1834 when a young man called Charles Henry Harrod opened a grocery store in Stepney, with a large selection of teas. In 1849 he took over a shop on the present site of Harrods in Knightsbridge, anticipating the 1851 Great Exhibition planned for Hyde Park. It was a canny move. From these small beginnings the store now covers 4.5 acres, and contains Europe's largest health and beauty salon, and a £20 million Egyptian escalator.

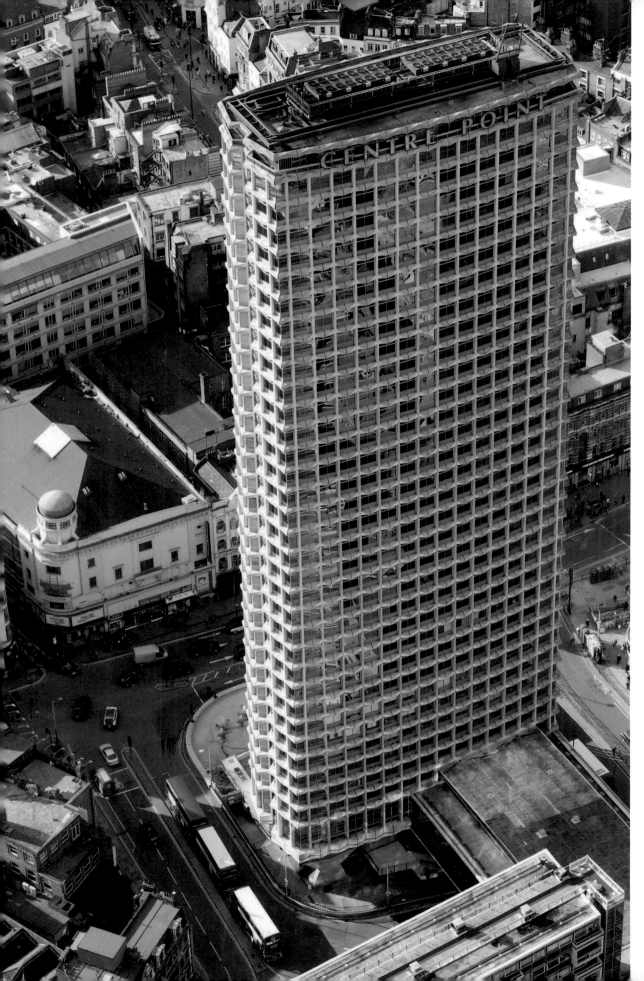

< LEFT
Centrepoint Tower

Where Centrepoint Tower stands should have been an open roundabout, at the end of Oxford Street. But in a convoluted story, the property tycoon Harry Hyams obtained permission to build instead this 1960s office building. At 35 storeys, it was one of London's first high-rises. Not only was it immediately decried as an eyesore, it was left empty for over ten years as Hyams refused to let it to anyone but a single tenant. The area around it remains, after 40 years, one of the ugliest traffic junctions in London.

> OPPOSITE
British Museum and Centrepoint Tower looking towards City of London

The impact of the Centrepoint Tower on the London landscape can be clearly seen in this panorama, showing it to be the only building of its kind within miles, even after 40 years of city development. Almost at the centre of the photograph the green-tinged roof of the British Museum's new Great Court shows a more sympathetic feel for the London skyline, blending in rather than bullying the buildings around.

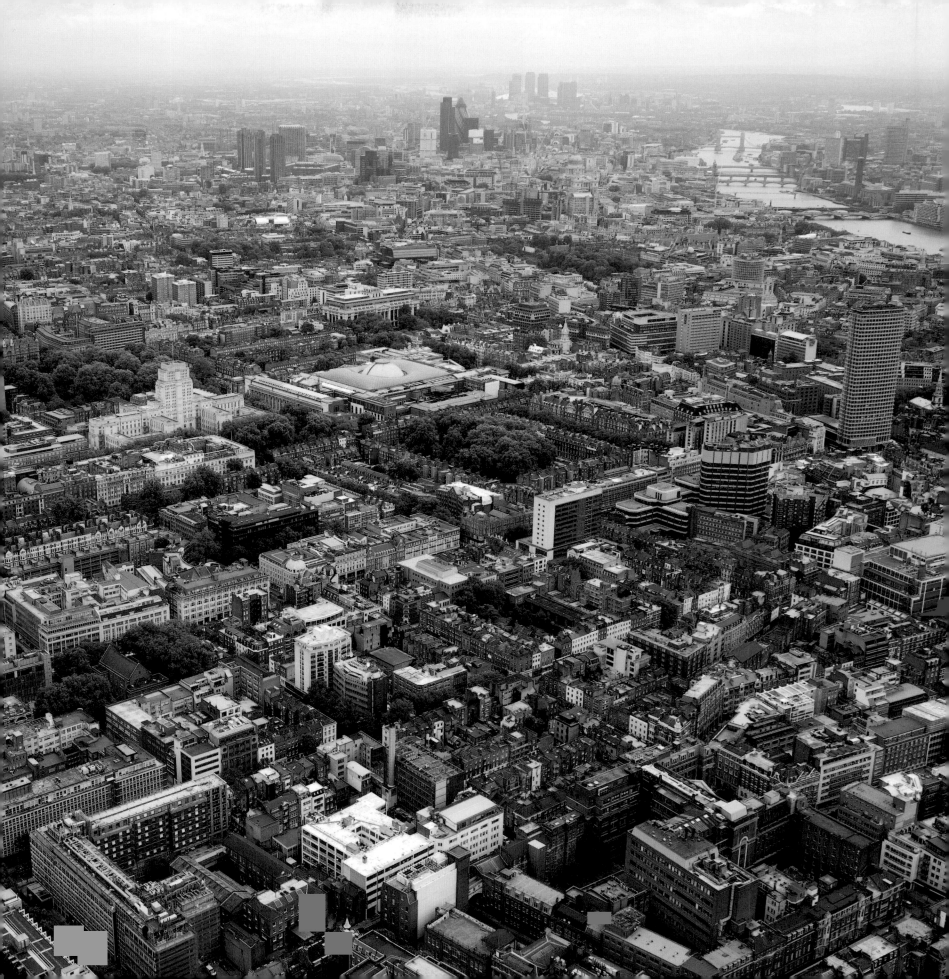

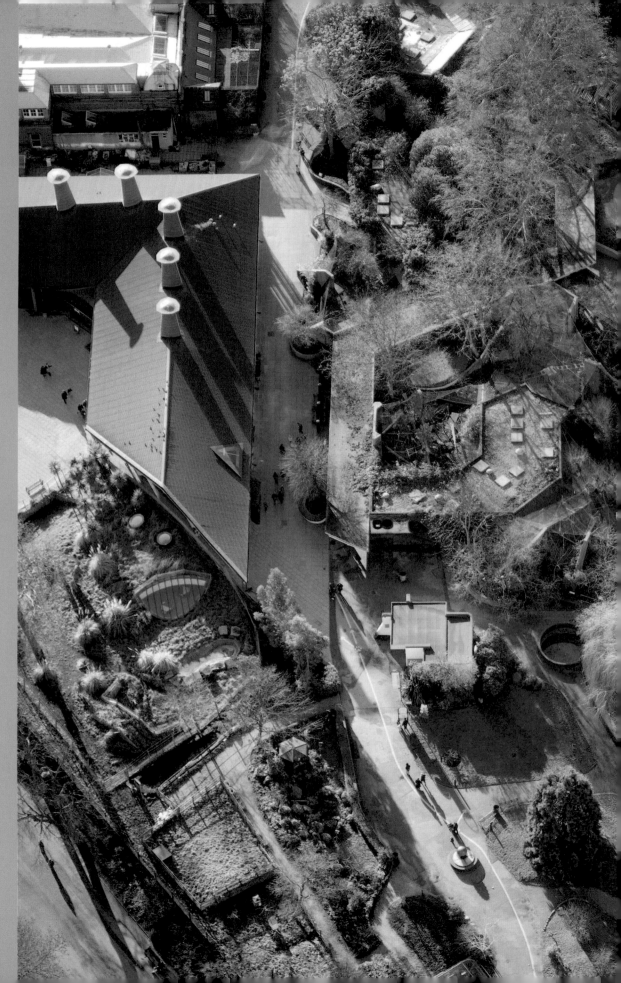

> **RIGHT**

London Zoo

When London Zoo first opened in 1828 as a private centre for scientific study, there was just a small collection of animals, and one keeper who wore a top hat and a striped waistcoat. He diligently recorded information about the animals in his Day Books, which have been kept ever since and are now stored online, keeping detailed daily records on all 7,000 animals in the zoo today.

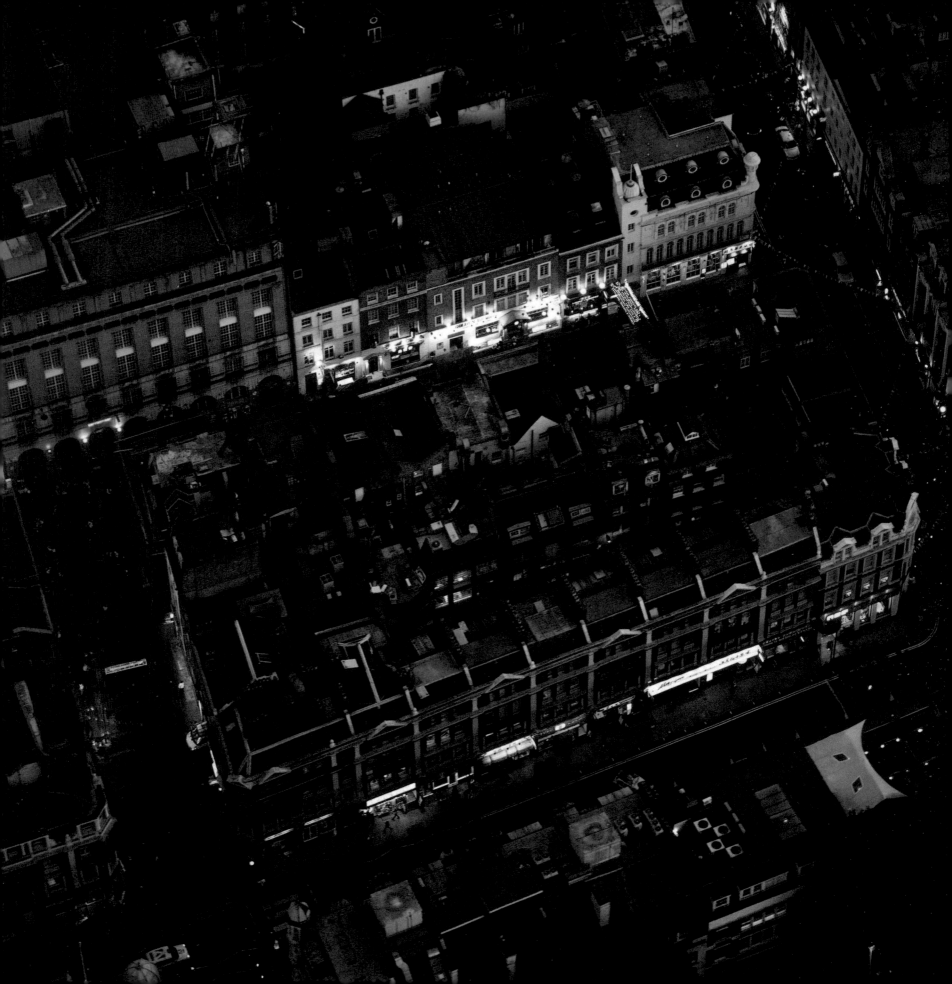

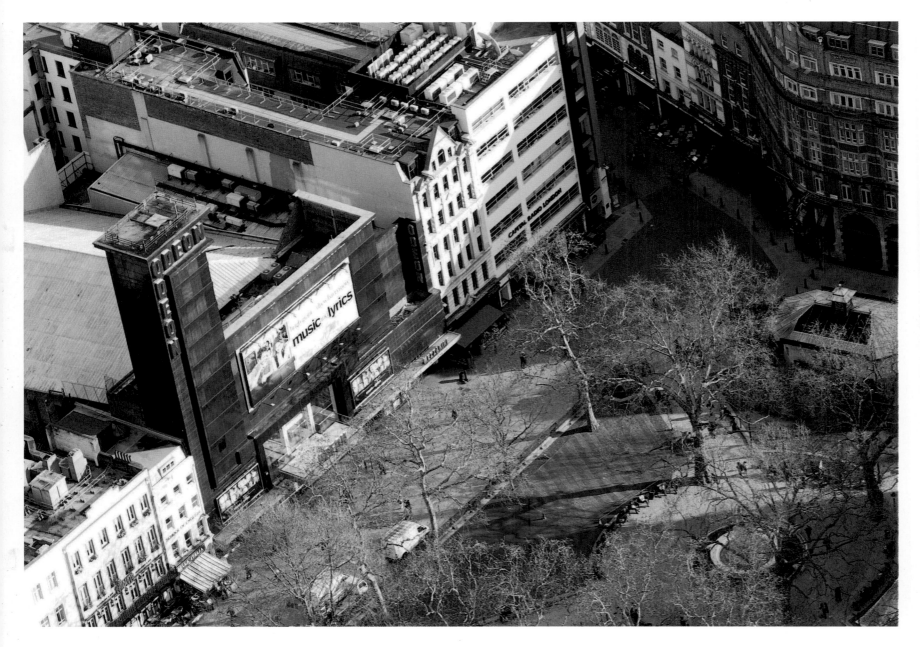

< **OPPOSITE**

Soho

The evening lights come on in Soho, one of London's liveliest areas for bars, cafes, restaurants and clubs. There might be a few red lights visible in the streets, but they are more likely to come from bars and Chinese restaurants than from the dubious premises which Soho was once more famous for. That sleazy reputation goes back to the 18th century, when prostitutes and artists moved into the area as the gentility moved out. The area became anything but genteel, and it still retains its bohemian atmosphere even today.

^ **ABOVE**

Leicester Square's Odeon cinema

At the southern end of Soho, Leicester Square is a public commemoration of a man who didn't deserve to be commemorated. In 1635 Robert Sidney, the 2nd Earl of Leicester, built Leicester House not far from where the Odeon Cinema stands today. He decided to enclose the common land in front of the house, preventing the local people from using it. They appealed to King Charles I, whose Privy Councillors ruled that the Earl of Leicester should leave some of the area open for the public.

Commuters on London Bridge

The present London Bridge was opened in 1973 but the first stone bridge to cross the Thames on this spot was finished in 1209, having taken 33 years to construct. It had 19 arches, and was a busy thoroughfare, packed with shops and houses, some of them seven storeys high. At the southern end of the bridge commuters daily walk past the spot where the heads of traitors were hung and left out to rot. The heads were first boiled and then dipped in tar, and one of the most famous was that of William 'Braveheart' Wallace.

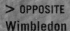 **OPPOSITE**
Wimbledon

Iron Age settlers once lived in the southwest suburb of Wimbledon, where today thousands of people descend early every summer to watch one of the world's major tennis tournaments. It is the oldest tennis championship in the world, and the third of the four Grand Slam tournaments to be played each year. The main courts here look suitably dramatic in the angled light – arenas awaiting the arrival of the combatants.

164

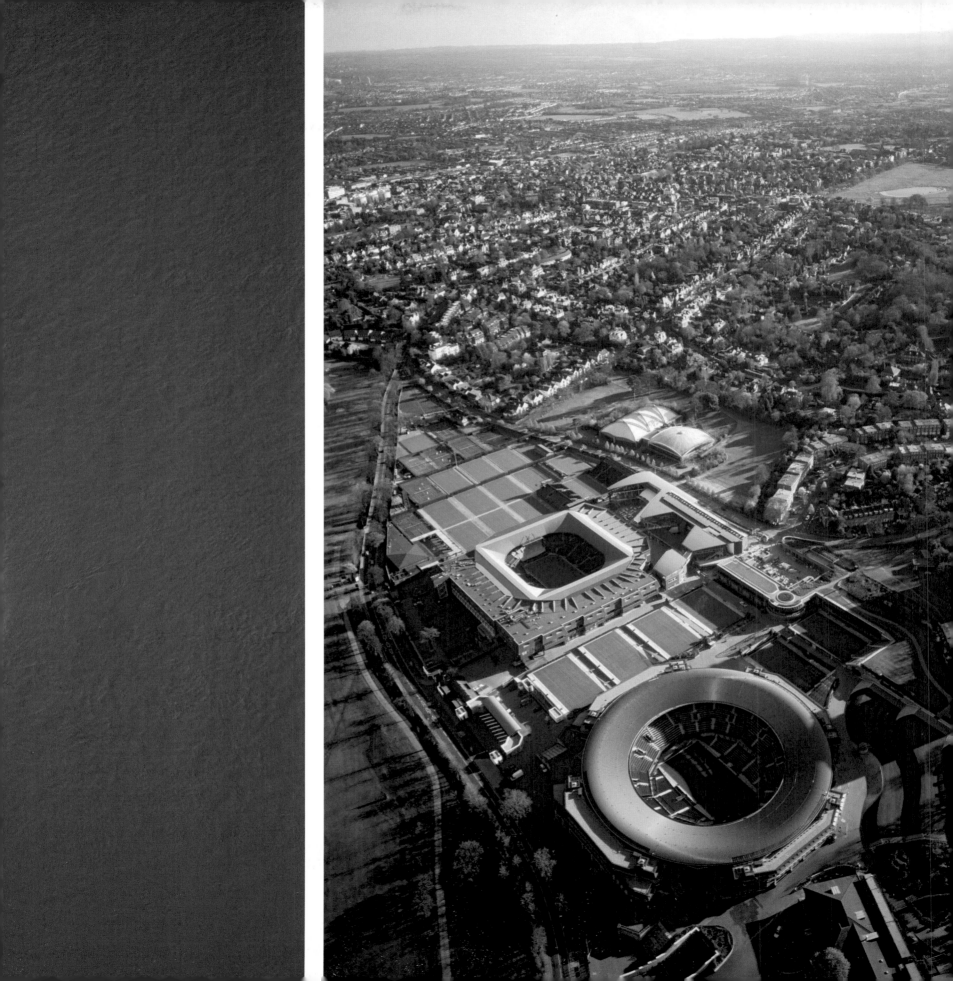

∨ BELOW

British Museum and Senate House, looking towards King's Cross and St Pancras

The dome of the British Museum stands next to the equally distinctive Senate House building, which is the heart – or the brains – of the University of London. Around them spread the streets of Bloomsbury, one of London's literary centres where some publishers still have their offices and whose houses are haunted by the ghosts of former residents such as Virginia Woolf, Charles Dickens, WB Yeats, Vanessa Bell and, briefly, Bob Marley!

> OPPOSITE

Senate House

The graceful and imposing Senate House building would not look out of place among the skyscrapers of New York, and indeed it is sometimes referred to as London's first skyscraper, having been opened as far back as 1937. Its 19 floors include the offices of the University of London. The top 15 floors, however, are given over to the Senate House Library, the second largest library in London after the British Library, housing over two million volumes.

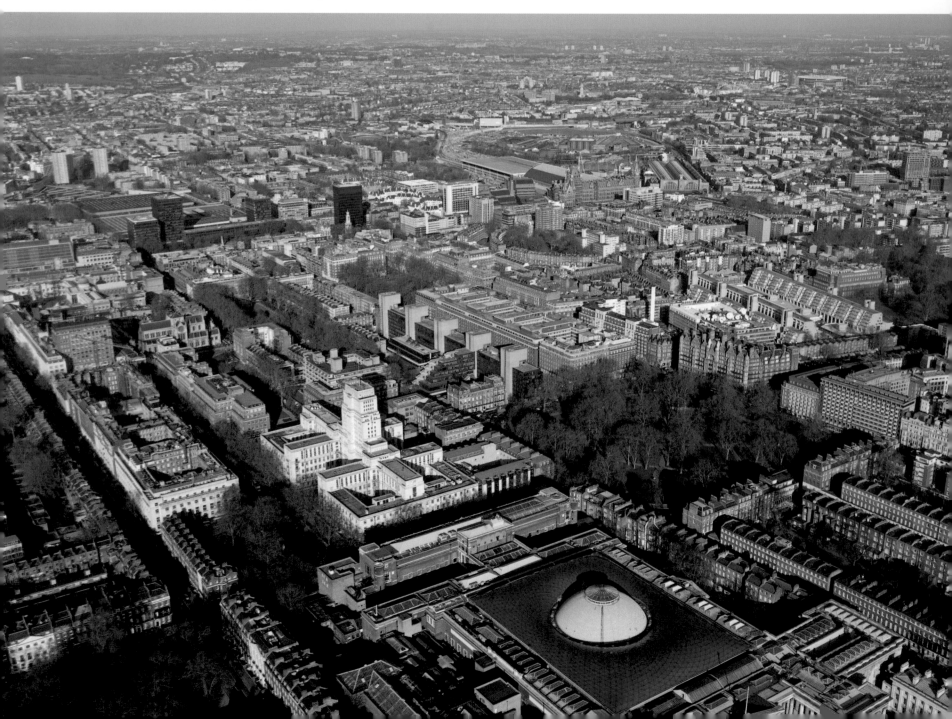

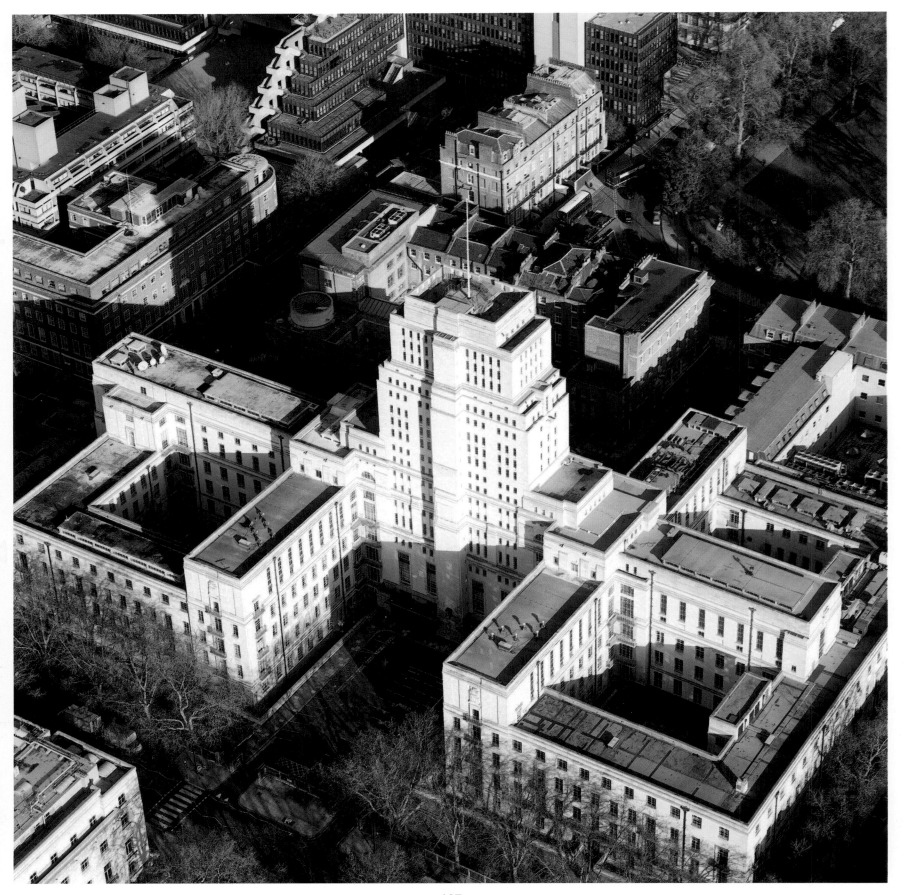

MODERN LONDON

For most of its long history, London was a largely a low-rise city. Other major world cities like New York and Chicago had embraced the skyscraper in the early 1900s, but London's lofty towers were limited to a few venerable landmarks such as Big Ben and the dome of St Paul's Cathedral. World War II devastated the city both physically and economically. Thousands of Londoners were left homeless by the Blitz, and for a long time, the phrase 'modern architecture' brought to mind the soulless, unattractive housing or offices that were slapped up cheaply to alleviate the housing crisis.

The Royal Festival Hall, built on the South Bank for the Festival of Britain in 1951, was the first public building erected in London after the war. With its sweeping steps, huge windows and open foyer, this concert hall was a great success in lifting postwar spirits. But the style of the other cultural venues that were built around it was sharply criticized, often likened to concrete bunkers. A facelift is on the cards for the South Bank Centre.

When it comes to modern architecture, like modern art, everyone has an opinion. In a speech to the Royal Institute of British Architects in 1984, Prince Charles famously likened it to 'a monstrous carbuncle on the face of a much-loved and elegant friend'. While it's true that a lot of the country's new architecture in the 1960s and 70s was callous and downright ugly, there was another sentiment behind the Prince's words. The elegance of Georgian Britain was a hard act to follow, and the stark lines and new materials of modern architecture clashed with earlier styles.

Height restrictions also slowed the development of London's skyline. For many years most buildings were limited to 100 feet (30m) high. One reason was to ensure that fire-fighting equipment could reach every floor. When these regulations were lifted in the early 1960s, building literally soared. Urban planners have maintained some restrictions to preserve protected views, such as St Paul's Cathedral.

At 351 feet (107m) the Shell Centre, built in 1961 on the South Bank, was the first building to surpass the height of the Victoria Tower of the Houses of Parliament. The BT Tower (1964), originally known as the Post Office Tower, is 625 feet (191m) tall and a London landmark. But most of the city's early skyscrapers were still very conservative and not very appealing. Sheer height alone did not capture the public imagination.

Three residential towers built in the Barbican complex in the 1970s rank among the city's top 25 tall buildings. But most of London's skyscrapers were built for business. Even though they are not generally open to the public, they have become familiar markers in the cityscape. These include the 600-foot (183m) Tower 42, erected in 1980 as the NatWest Tower. For over a decade it held the title of the city's tallest office building. It boasts London's highest bar, Vertigo, on the 42nd floor.

One of the most famous modern buildings lacks the height of its contemporaries but makes up for it in style. With its 'inside-out' architecture, the Lloyd's Building is London's answer to the Pompidou Center in Paris. When the 14-storey tower opened in 1986 in the highly conservative financial quarter of the City, it was exciting and controversial. Cubes and cylinders of aluminium and steel are suspended from the exterior, with stairways and ventilation shafts running in between.

The Lloyd's Building was designed by Sir Richard Rogers, one of Britain's foremost modern architects. He and his former partner, Sir Norman Foster, earned an early reputation for high-tech design, and they are responsible for many of London's best-known public buildings. The architects are each designing a tower for the new World Trade Center in New York.

In the 1980s the city embarked on an ambitious plan to regenerate the derelict Docklands. Abandoned warehouses were converted into luxury

apartments. A new light rail line and office space purpose-built for modern business life soon created a new business centre in East London. The symbol of the redeveloped Docklands was One Canada Square, better known as the Canary Wharf Tower, erected in 1990. At 771 feet (235m), it was London's tallest building.

The deregulation of the UK stock market in 1986 – the so-called Big Bang – brought huge changes in the City. The need for new kinds of financial services, coupled with the pressure to keep business in the Square Mile, transformed the face of London's traditional commercial quarter. Half of all the office buildings in the City were rebuilt in just eight years. One of the most successful developments was the Broadgate Centre, built on 9 acres of deserted land around Liverpool Street Station.

As the dominance of the old-boys' network died away, so did the concern over carbuncles. Money was the new power. London was on the fast track to becoming the biggest, richest financial centre in Europe. And much like the monarchs of old who built extravagant palaces to flaunt their wealth, the City fathers wanted buildings that symbolized their place at the top of the hierarchy. Their sky's-the-limit attitude towards making money was reflected in London's architecture.

As they approached the end of the 20th century, Londoners longed for a slice of the bold, cutting-edge architecture that was springing up in European cities, such as the Guggenheim Museum in Bilbao and the Valencia's City of Arts and Sciences. In 2004 they got it, in the form of a bullet-shaped, glass-sided tower at 30 St Mary Axe, better known as the Gherkin. It's sometimes called the Swiss Re Tower after its first owners. Designed by Foster and Partners, this award-winning building spirals out of the heart of the financial district, and at 590 feet (180m) is one of London's tallest buildings. A newspaper dubbed it 'the erotic gherkin'

for its phallic shape, and the name stuck. It instantly became a London icon and is admired round the world. Meanwhile another spherical glass-walled building rose on the South Bank, London's new City Hall, which opened in 2002. Also by Foster and Partners, it is 10 storeys high and, like the Gherkin, was designed to reduce energy consumption. Its sliding-stack shape has also earned it a nickname – the Leaning Tower of Pizzas. Opposite the Tower of London, it makes a striking contrast between two of the city's oldest and newest landmarks.

The Millennium was the spearhead for a number of new public projects that have further changed the cityscape and given London a more light-hearted air. Initially there was an outcry over the Millennium Wheel as many feared the London Eye would be an eyesore, an undignified blot on the hallowed stretch of the Thames opposite the Houses of Parliament and Westminster Abbey. The Eye was intended as a temporary structure for the Millennium celebrations but it has become a much-loved landmark that affords fantastic panoramic views of the city.

Another celebrated piece of architecture is the Tate Modern art gallery. The Swiss firm, Herzog and De Meuron, transformed this former Bankside power station into a dramatic exhibition space for London's first museum dedicated to modern art. Foster's Millennium Bridge links it to St Paul's Cathedral in the City. Richard Rogers' Millennium Dome in Greenwich has been more controversial. It struggled to find a purpose after its initial year, and was relaunched as the O2 Arena entertainment complex in 2007.

With the genie out of the bottle, there's no stopping London's soaring skyline. The London Bridge Tower – known as the 'shard of glass' – is set to become the city's tallest skyscraper at 1,016 feet (310m). It's one of several new towers begun in 2007. With some 30 more skyscrapers also in the planning stages, London's skyline will be changing for years to come.

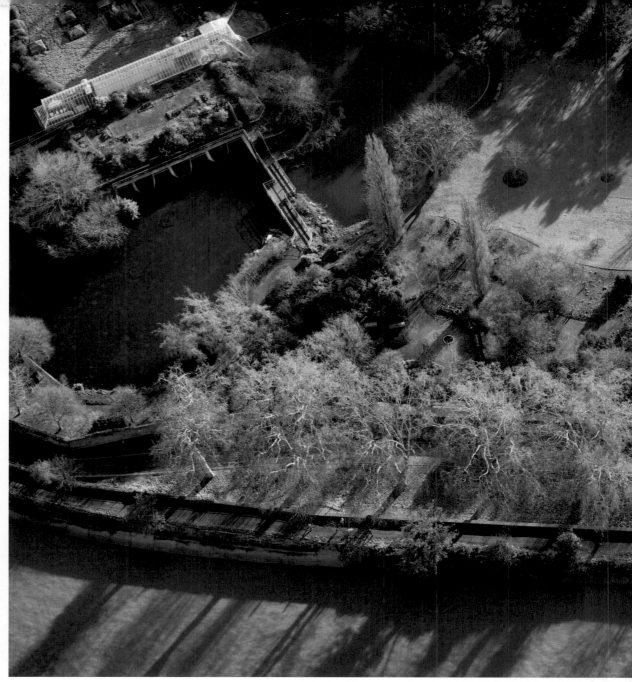

< LEFT
London Wetland Centre
The impressive London Wetland Centre is one of the best urban sites in Europe in which visitors can watch a range of wildlife. The reserve spreads over 43 hectares by the River Thames in Barnes, southwest London, which had previously contained a few small reservoirs. The Centre was opened in 2000, and has been designated a Site of Special Scientific Interest.

^ ABOVE
Ferry Lane and Kew Gardens
Ferry Lane is a small London lane that runs from the edge of Kew Gardens down to the River Thames, where, of course, a ferryman once took passengers across to the north bank of the river before the nearby Kew Bridge was built. A little jetty still exists, where a few boats tie up, another of London's private little corners that few visitors are aware even exists.

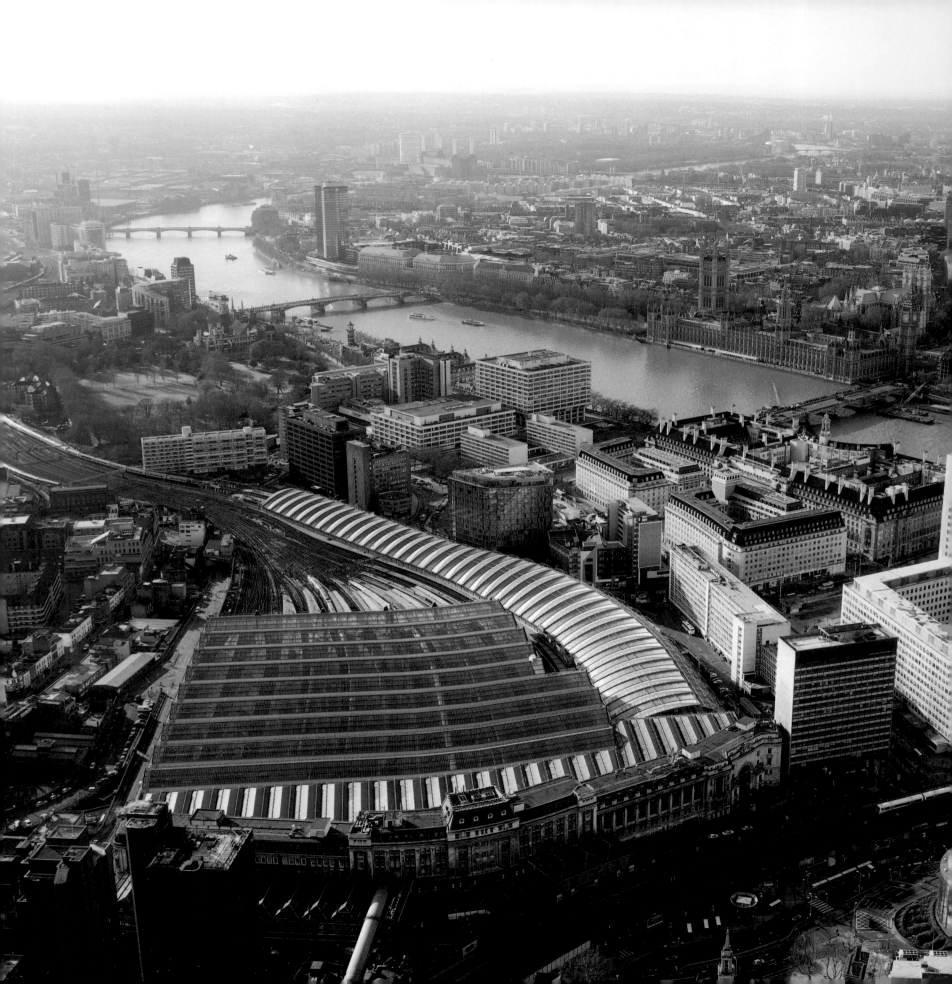

Waterloo Station, looking to Westminster

Waterloo Station near London's South Bank Centre is the busiest railway station in Britain. It can be a confusing place, with four different stations combining, though at one time there was another station here too: the Necropolis Station. This was built in 1854 by the London Necropolis Company to transport coffins and mourners from London to their Brookwood Cemetery out in Surrey. It was a busy service as at that time Brookwood was the largest cemetery in the world. The Necropolis Station closed when it was bombed during World War II, and demand was no longer sufficient to warrant it being rebuilt.

> RIGHT

Hilton Hotel, Park Lane, Mayfair

It was only in the early 1960s that certain building regulations were lifted in London. Before then, buildings were restricted to being 100 feet (30m) high, with only a handful of exceptions. The lifting of these limits saw a boom in skyscrapers, and one of the first was the Park Lane Hilton, seen here towering over Hyde Park. At the time there were outcries that an American hotel chain could move in and put such an imposing structure right by London's main park, but today the Hilton is just another high-rise building.

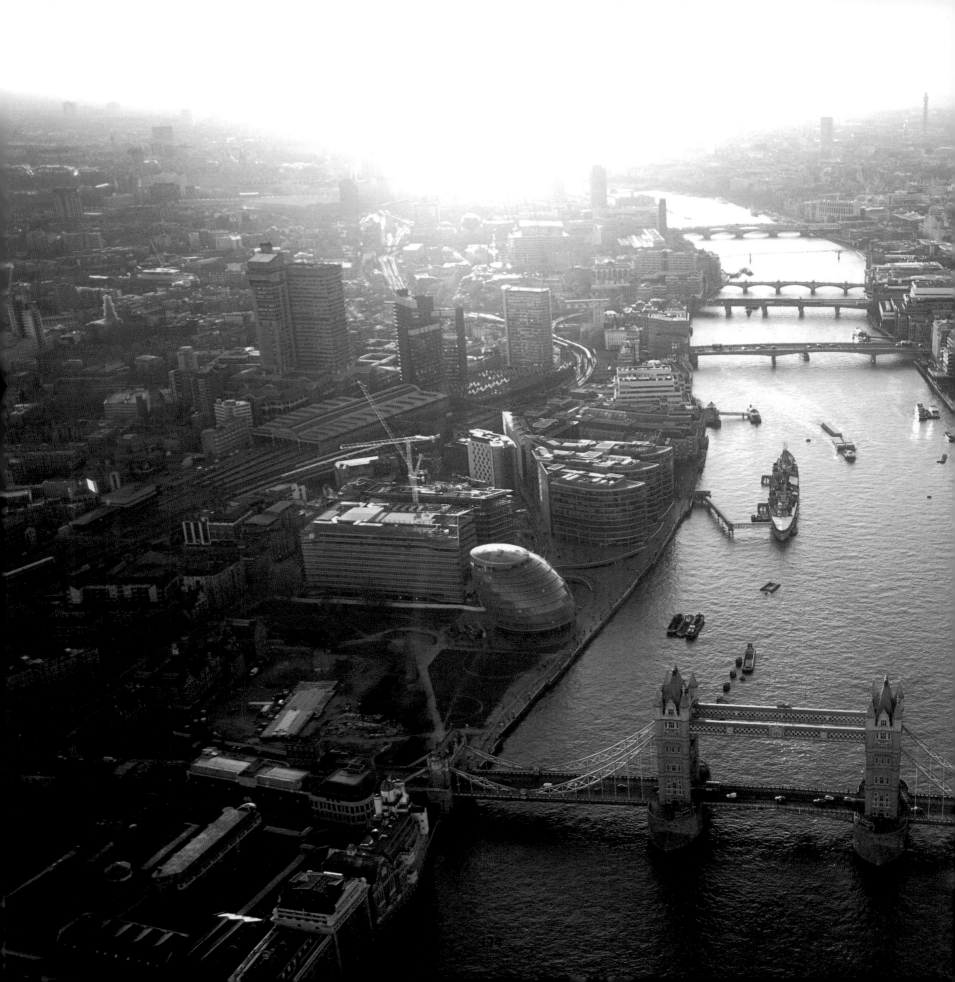

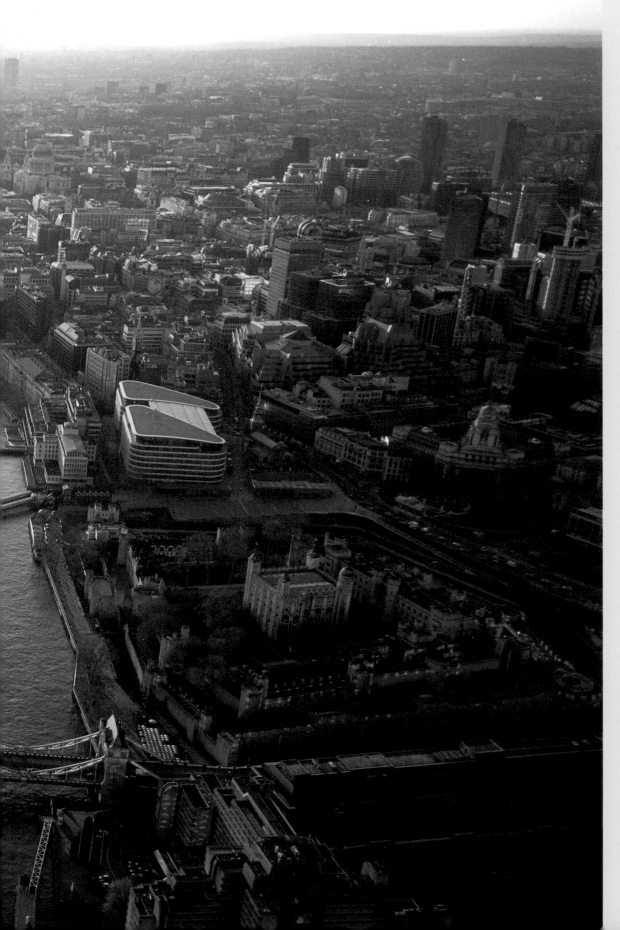

< LEFT

**London at sunset. Tower Bridge, GLR building,
HMS *Belfast* and the Tower of London**

With the ancient Tower of London on the right,
the modern City Hall on the left, and the Victorian
grandeur of Tower Bridge connecting the two, the
one constant in London is the River Thames. It is
permanent and yet temporary at the same time,
flowing past mankind's changes to the city as it
has done for thousands of years, and hopefully
will for thousands more.

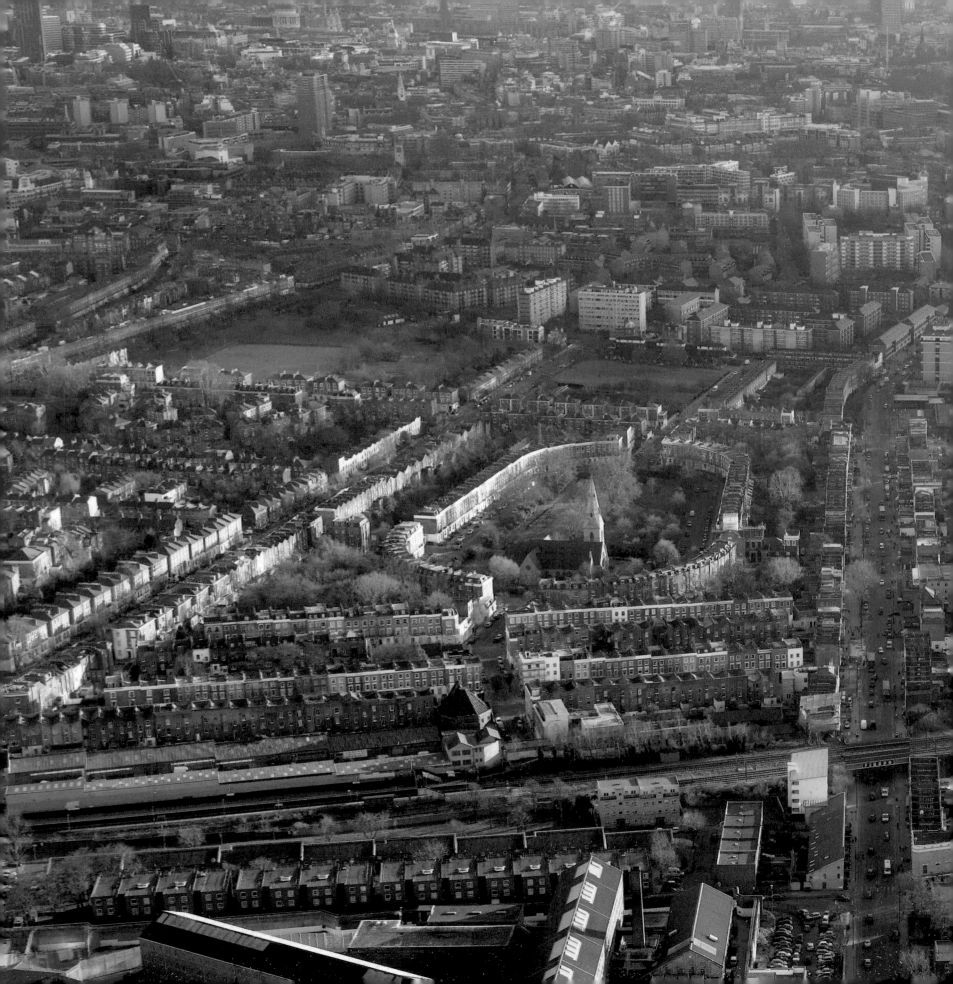

<OPPOSITE

Thornhill Cresent and Square, looking South down Caledonian Road

Thornhill Square in Islington, north London, is a few steps away from the busy Caledonian Road, but seems centuries away in time. It was built in the late 1840s for London's well-heeled professional people, and a gateman was employed to keep 'undesirables' out of the central gardens, which were strictly for the use of residents. Today the gardens are beautifully maintained by the people who live on the square, which has been used as a location in several films including *Four Weddings and a Funeral*.

> RIGHT

Hyde Park in the winter

London's reputation for snowy winters and dense fogs can probably be blamed on Charles Dickens and Hollywood film-makers. In reality it is now a rare occurrence to experience any kind of serious fog in London, and the worst winter in recent times was that of 1962-1963 when Europe's biggest city was brought to a standstill by a fall of two feet of snow. Citizens of cities like New York, Toronto and Moscow would no doubt find that very amusing.

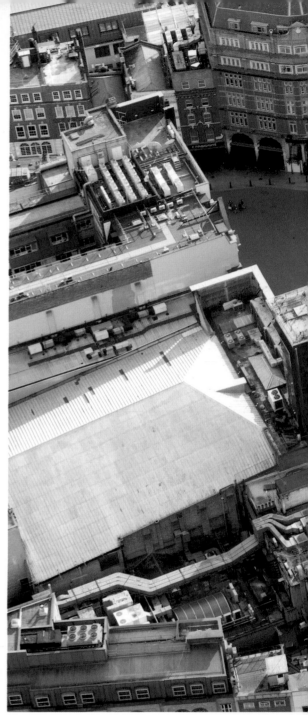

< LEFT
Tottenham Hotspur FC pitch
In 1899 this view would have shown an overgrown and disused nursery, behind the White Hart pub. Tottenham Hotspur Football Club acquired the land and a football pitch was prepared by their first groundsman, John Over. Ever since then, the Tottenham pitch has had a reputation for its quality, and the current groundsman, Darren Baldwin, recently won the award for the Football Premiership Groundsman of the Year.

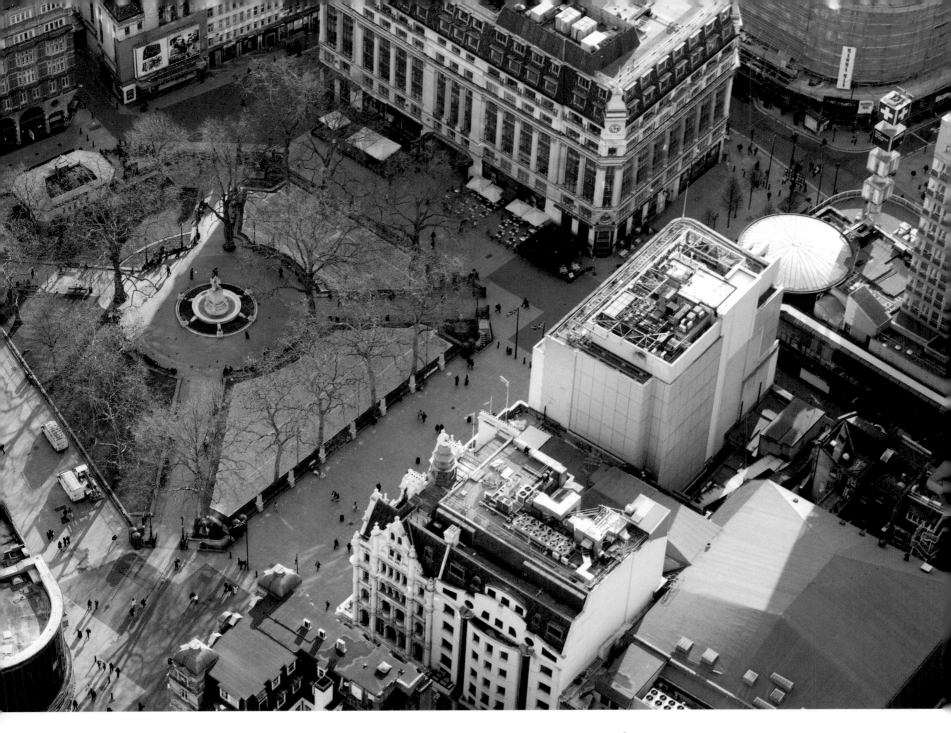

^ ABOVE

Leicester Square

In the heart of London's West End, Leicester Square has long been a centre for theatre. The Odeon Cinema, where movie premieres are held, was built in 1937 on the spot where the Alhambra Theatre music hall had previously stood. In the centre is a statue of William Shakespeare, and nearby another of Charlie Chaplin, while in one corner there are usually queues at the ticket booth which sells half-price theatre tickets.

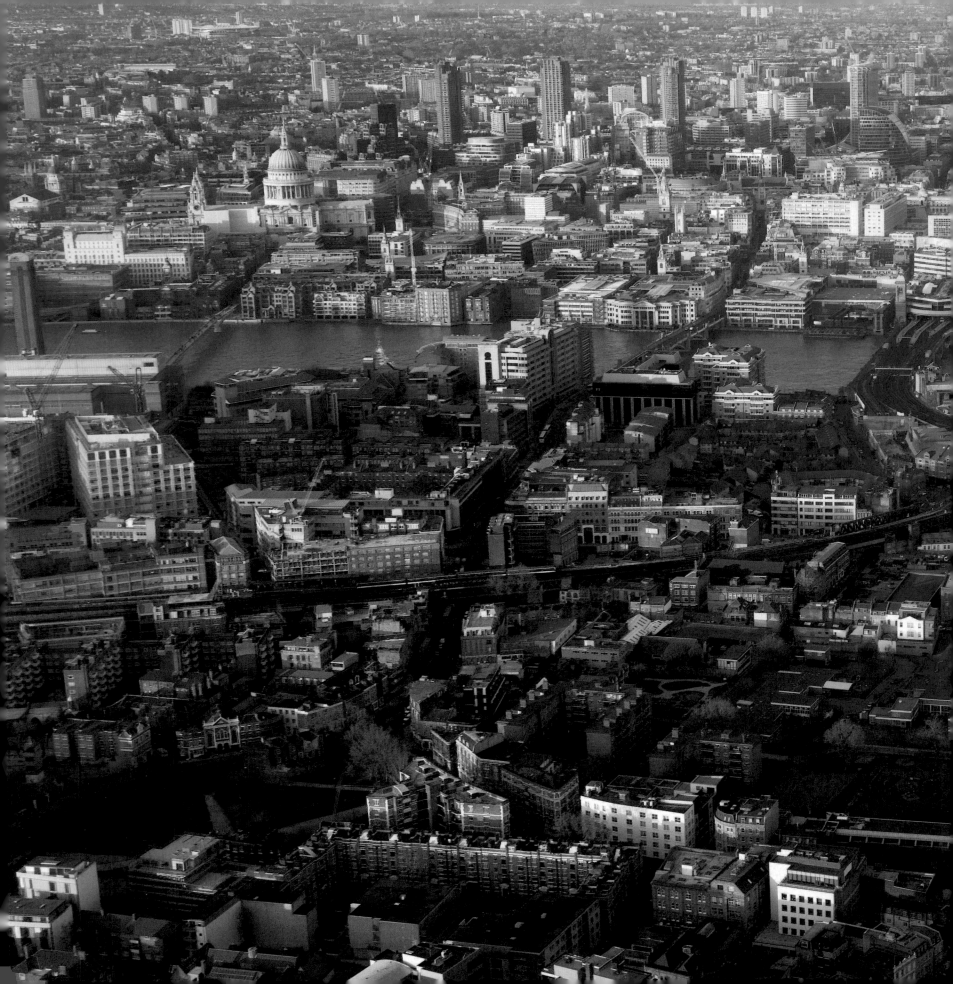

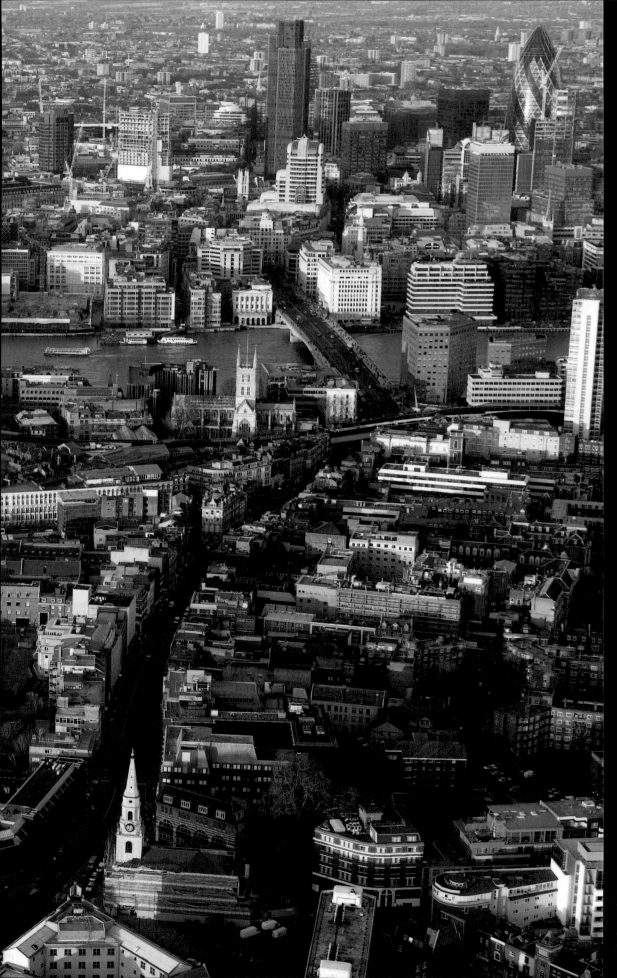

< LEFT
South Bank looking across to Bank and the City of London
7.6 million people live in London, the most densely populated city in the European Union, with another five million or so – and growing – in the Greater London area. It's a long way from when the Romans first arrived in this deserted spot after invading the south coast of England, found a wide river barring their way, and set about seeking a crossing place. Within 200 years London's population had grown to 60,000, an incredible boom for that time in history. London was the first city to have a population of one million, and the first to reach five million, though since then other world conurbations like Tokyo and Mexico City have surpassed its growth rate.

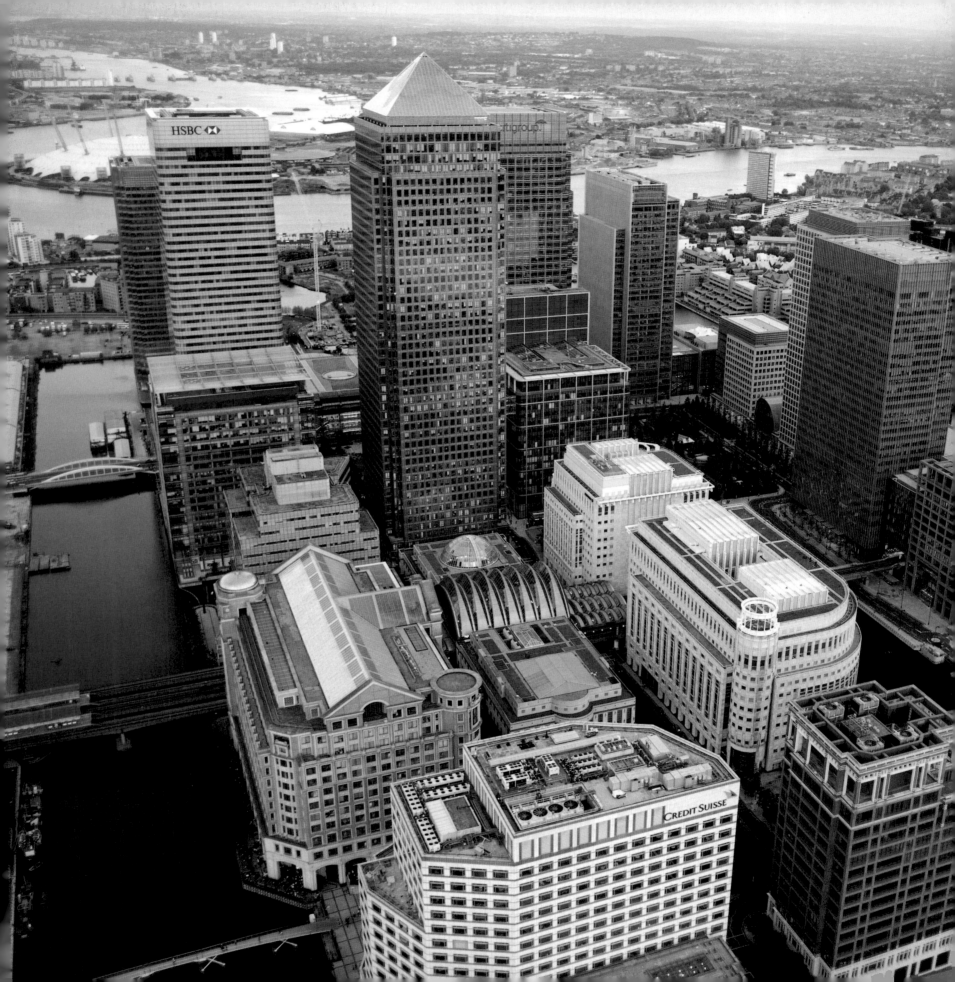

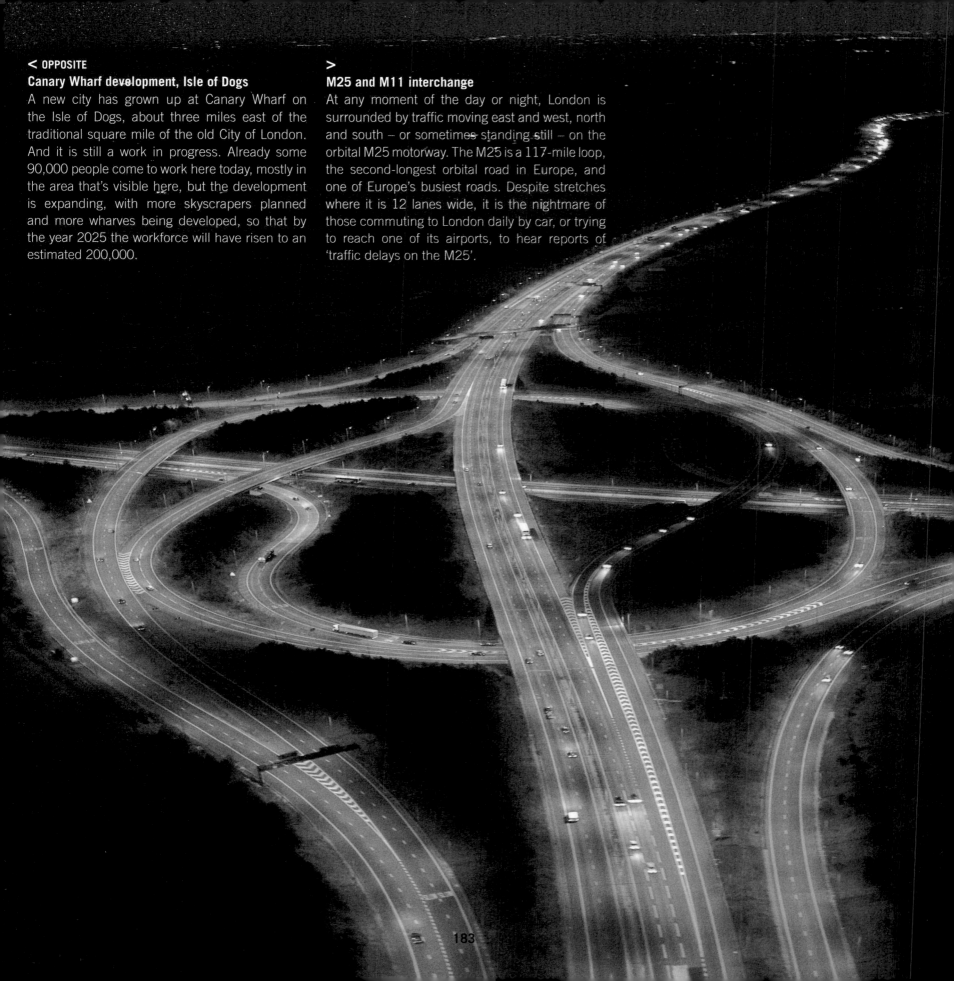

Canary Wharf development, Isle of Dogs

A new city has grown up at Canary Wharf on the Isle of Dogs, about three miles east of the traditional square mile of the old City of London. And it is still a work in progress. Already some 90,000 people come to work here today, mostly in the area that's visible here, but the development is expanding, with more skyscrapers planned and more wharves being developed, so that by the year 2025 the workforce will have risen to an estimated 200,000.

>

M25 and M11 interchange

At any moment of the day or night, London is surrounded by traffic moving east and west, north and south – or sometimes standing still – on the orbital M25 motorway. The M25 is a 117-mile loop, the second-longest orbital road in Europe, and one of Europe's busiest roads. Despite stretches where it is 12 lanes wide, it is the nightmare of those commuting to London daily by car, or trying to reach one of its airports, to hear reports of 'traffic delays on the M25'.

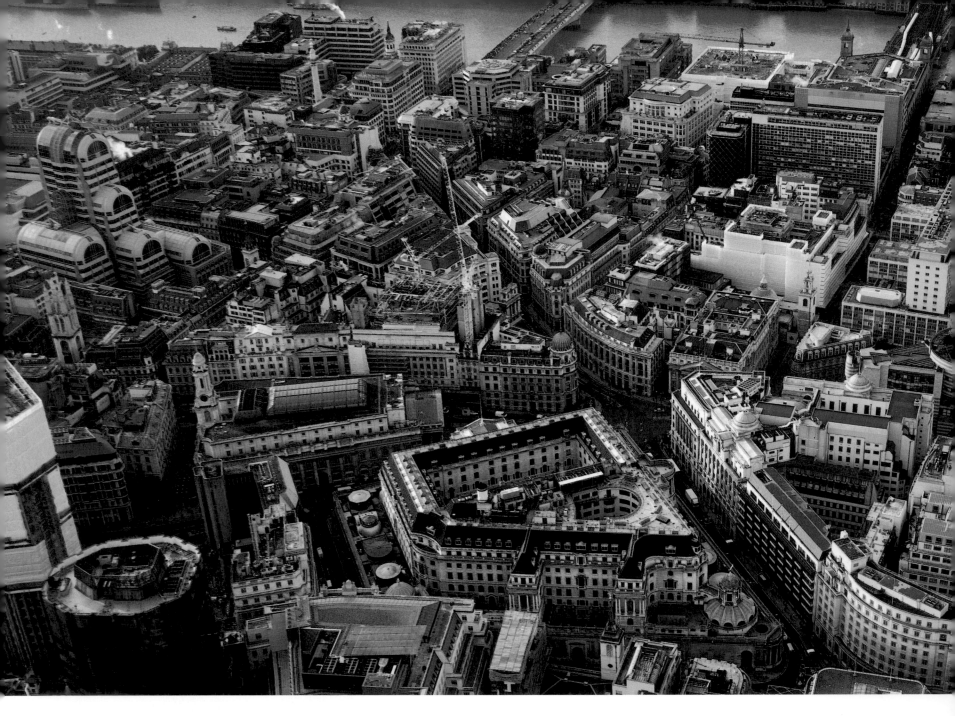

^ **ABOVE**

Bank, Cannon Street and the Thames

King William Street cuts diagonally through London's financial district, running from the Bank of England and down towards the River Thames and London Bridge. At number 46 King William Street there was once an entrance to the underground station of that name, another of the secret stories that lie beneath London's streets. It was opened in 1890, closed ten years later, and was last used as an air-raid shelter during World War II. It is still there today.

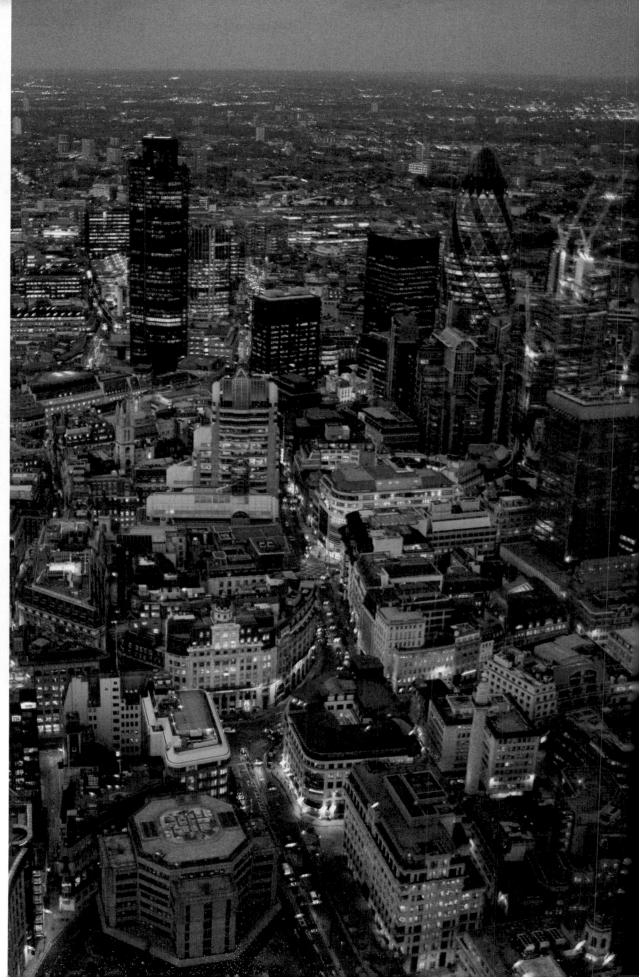

> RIGHT
Bank and City at night
The City of London skyline at night shows, on the left, Tower 42, the tallest building in the City, and to the right the unmistakeable shape of the Gherkin. In between the two runs Bishopsgate, which was one of the seven original gates in London Wall, the defensive wall that the Romans built to defend their city. The actual site of the gate was very close to where Tower 42 and the Gherkin now stand, the stylish and modern new sentinels to the stylish and modern new City of London.

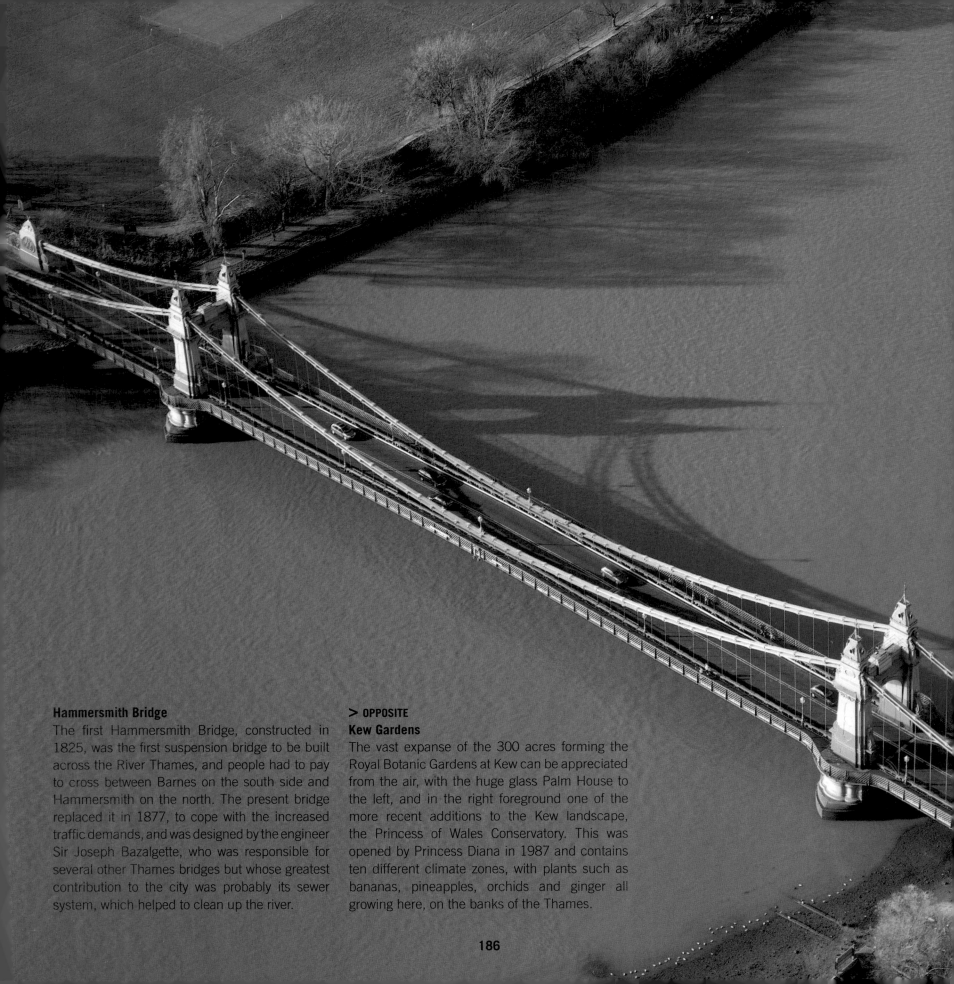

Hammersmith Bridge

The first Hammersmith Bridge, constructed in 1825, was the first suspension bridge to be built across the River Thames, and people had to pay to cross between Barnes on the south side and Hammersmith on the north. The present bridge replaced it in 1877, to cope with the increased traffic demands, and was designed by the engineer Sir Joseph Bazalgette, who was responsible for several other Thames bridges but whose greatest contribution to the city was probably its sewer system, which helped to clean up the river.

> OPPOSITE
Kew Gardens

The vast expanse of the 300 acres forming the Royal Botanic Gardens at Kew can be appreciated from the air, with the huge glass Palm House to the left, and in the right foreground one of the more recent additions to the Kew landscape, the Princess of Wales Conservatory. This was opened by Princess Diana in 1987 and contains ten different climate zones, with plants such as bananas, pineapples, orchids and ginger all growing here, on the banks of the Thames.

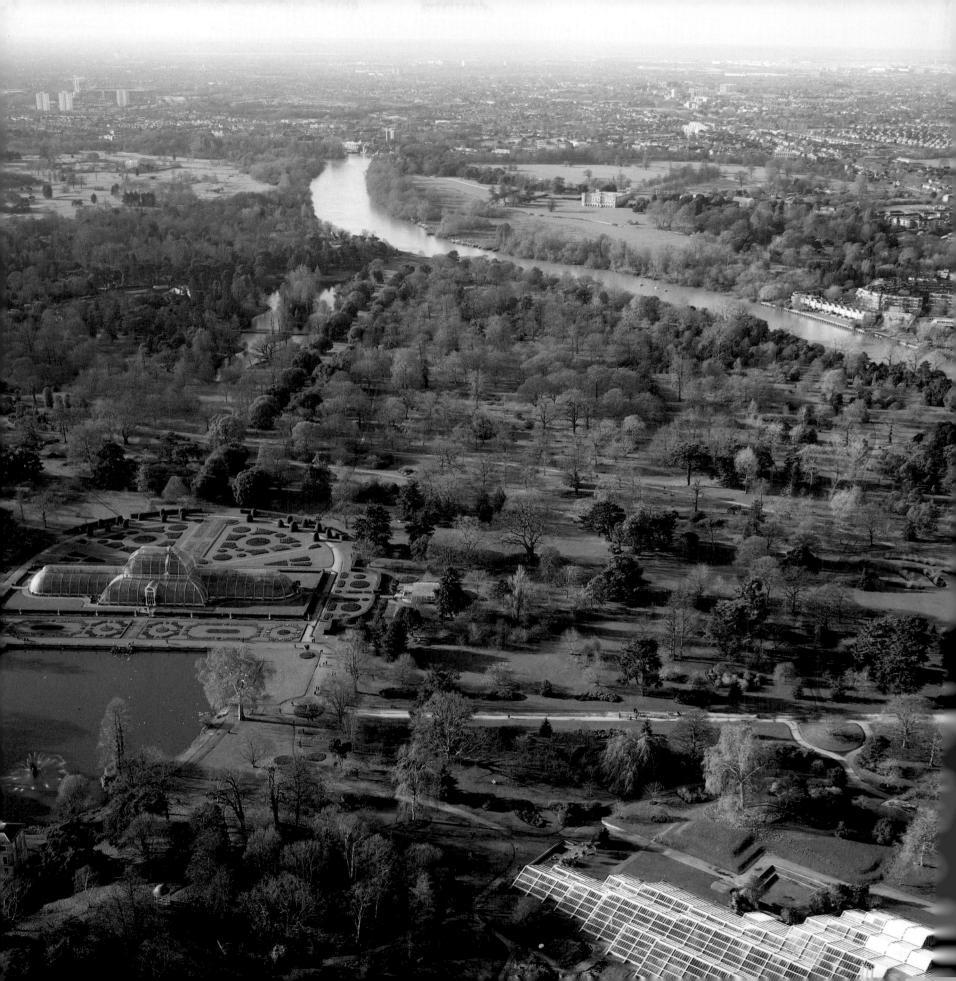

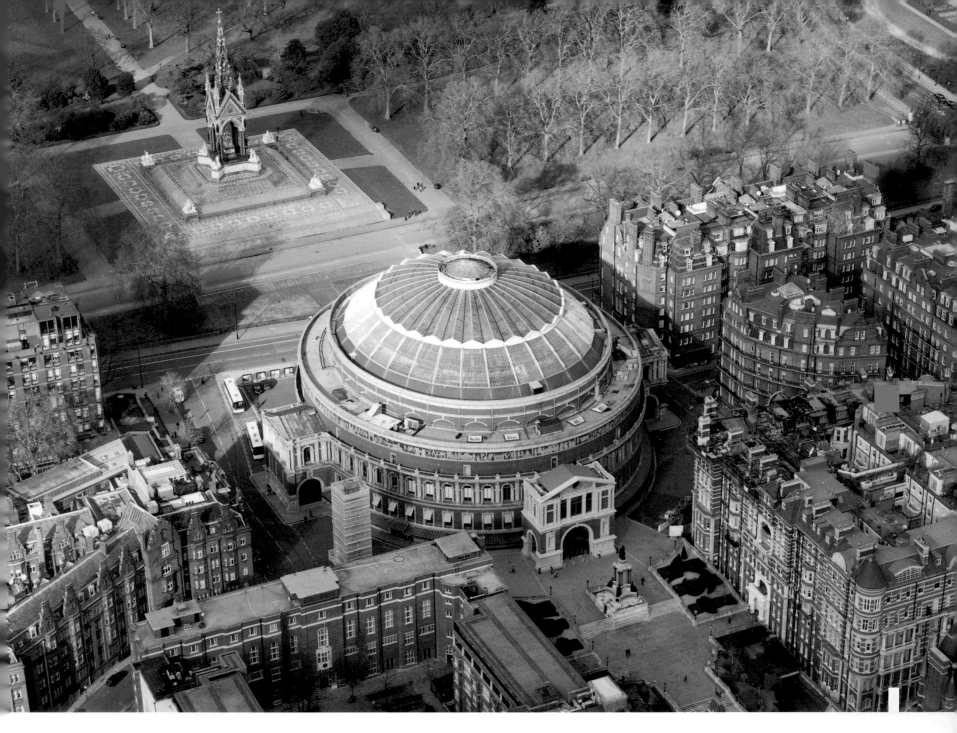

Royal Albert Hall and Albert Memorial, Hyde Park

Glowing with opulent golden hues, the seated statue of Prince Albert in the Albert Memorial faces south from Kensington Gardens to gaze forever at the Royal Albert Hall, named in his honour by Queen Victoria. The Royal Albert Hall stands in Kensington Gore, meaning a triangular piece of land and probably taken from an old dressmaking word for a triangular piece of cloth.

Albert Memorial, Hyde Park

It is one of the ironies of life that despite fighting two World Wars against Germany, Britain has been ruled by the descendants of German immigrants since 1714 when George I, from the House of Hanover, became King. On the death of Queen Victoria in 1901, the title passed to Prince Albert's family, the House of Saxe-Coburg and Gotha, where it has stayed ever since.

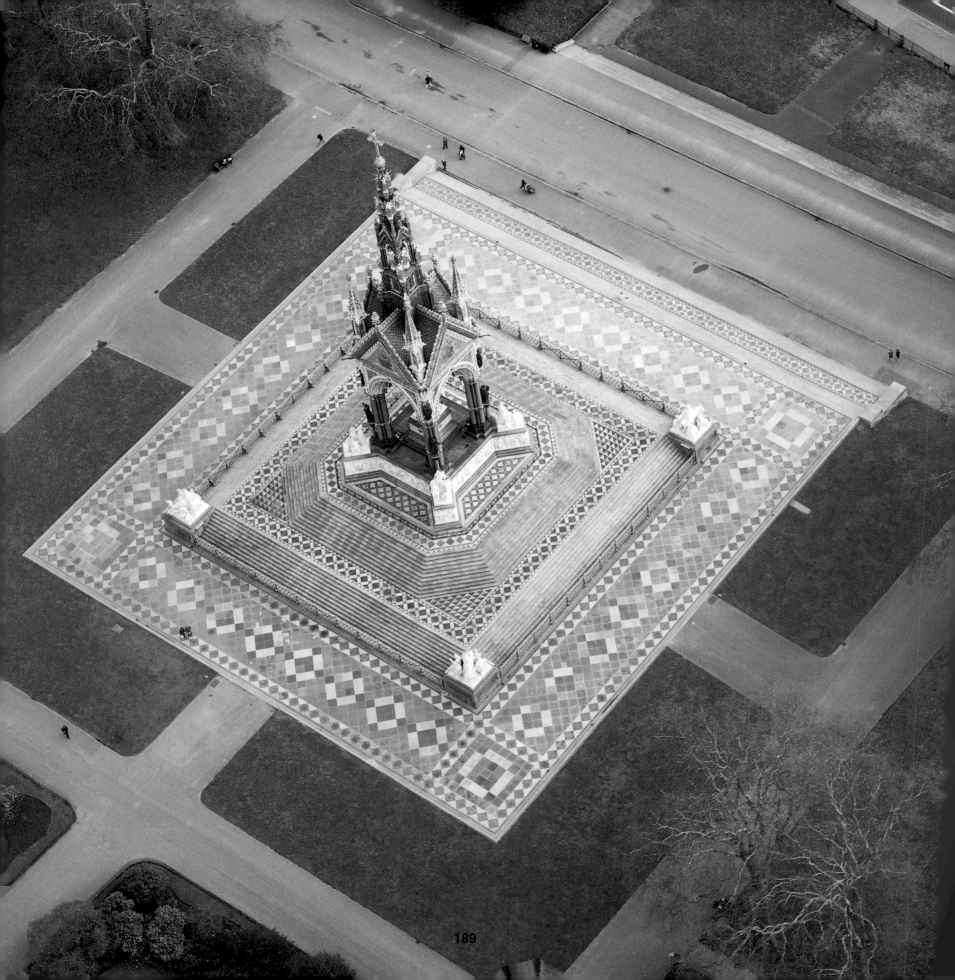

189

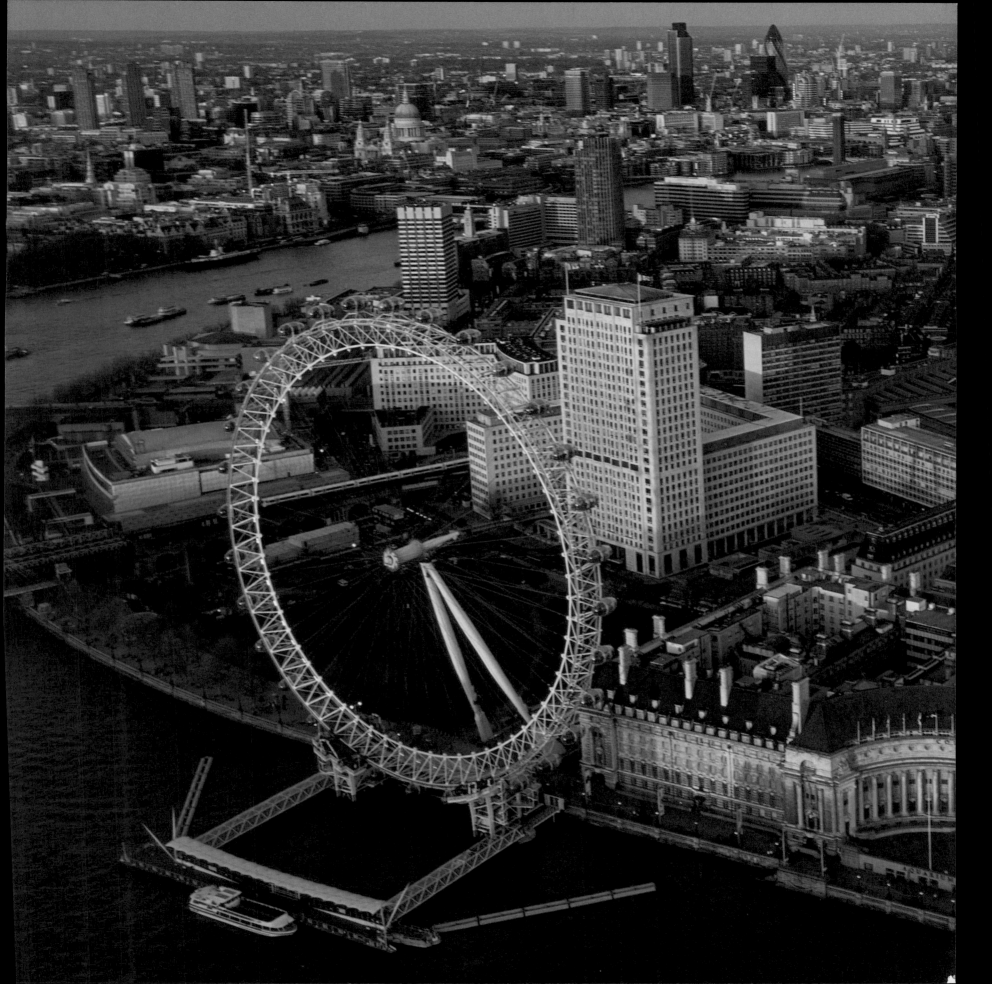

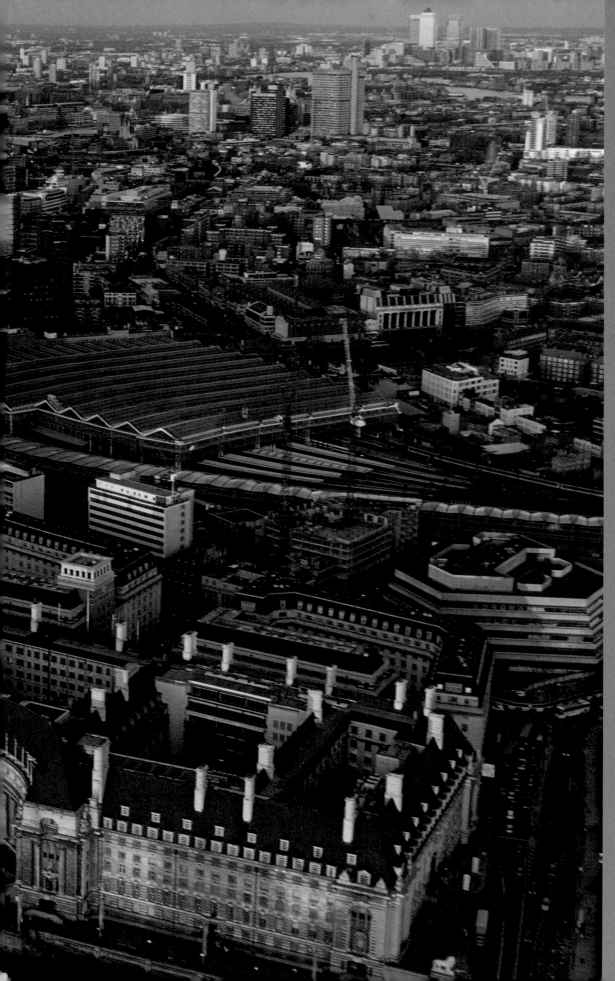

London Eye, the former County Hall, Waterloo station and looking across to the City of London
The London Eye does indeed look like an eye on London in this photo, or a clock face recording the city's progress. The way the river curves can be clearly seen, and this sometimes gives a confusing sense of direction. Ascend in the Eye and landmarks which you thought were to the north, suddenly appear to the east or west. Ascend even higher and the more you discover there is to learn about a majestic city like London.

INDEX